Photo-Imaging

A COMPLETE GUIDE TO ALTERNATIVE PROCESSES

Jill Enfield

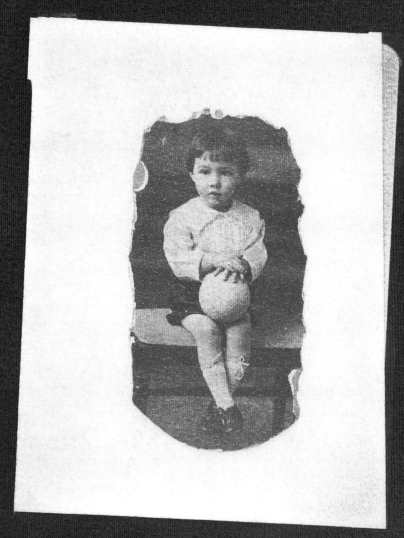

Amphoto Books
An imprint of Watson-Guptill Publications
New York

ACKNOWLEDGMENTS

I feel like I have to hold my breath and speak quickly to get everyone's name out and properly thank them in this short space, but I am going to try. This book has come together with so many people to thank that I hope that everyone knows how truly grateful I am.

Lauren Wendle at *Photo District News* has always given my name a push and I will always be grateful to her for a conversation she had two years ago with Victoria Craven and the discussions (and lunches) the three of us have shared since then. If it were not for Lauren and Victoria, this book would still be in a box. A big thank you goes to Alison Hagge at Amphoto for keeping me going and laughing and for doing a great job editing. Thanks also go to Areta Buk and Jay Anning for designing the book and Hector Campbell for his help with the production.

A special thank you goes to Pete Kolonia who spent time photographing all of the how-to pictures with such ease and Yong Kim who has been a great assistant over the years and has become a part of my family; Nathan Anderson and Beatriz Planelles for being great students, interns, and helpers; David BelleIsle for keeping up with my computer needs; and George Ensinger for building me a wonderful darkroom in a small space and teaching me about ventilation. Kathy Hyde at New York Central Art Supply allowed me to bribe her with cookies to teach me more about papers. Thanks to Burt Keppler for giving me advice over the years and Stuart Fichelson at LIU for putting up with my e-mails and finding a chemist (thanks, Glenn) who could answer my questions. Also thanks to the students at Parsons School of Design, ICP, and LIU

for letting me experiment on them. They were all fantastic.

A lot of the companies that I mention in the sources have been very helpful not only with this book, but in the past as well. They are always available to answer questions, and so thanks go to Lynn Wilson at Photographers' Formulary, Bart DeVito and Steve White at Luminos, John Horowy at Bergger, and Melody Bostick at Bostick & Sullivan. Andy Davidhazy from RIT did not even know who I was but was very generous with his time and information, as were Mark Osterman and France Scully-Osterman in helping me with getting tintype information.

Everyone at Nikon has been particularly fantastic and I want to thank Anna Marie Bakker, Jerry Grossman, Tracie Mack-Jackson, Richard LoPinto, Mike Rubin, Chuck DeLuca, Mike Carrado, and Barry Tanenbaum. Dan Steinhardt at Epson and Lisa Johnson, Terry McCardle, Scott DiSabato, Marianne Somanko, and Audrey Jonckheer at Kodak also went beyond the call of duty. Thank you. A thanks also goes out to Skip Cohen, Soren Gunnarsson, and Steve Simmons.

And last, but most important of all, my family. My husband, Richard Rabinowitz, could win all awards for being the most supportive man on earth and for the wonderful advice he always seems to pass on to me. And much love and thanks to my two daughters, Eve and Sally, for putting up with me working long hours, and to Jennifer Kilberg, who is like a daughter and is a great friend, for stepping in whenever I needed her. And finally, to my Dad, Kurt Enfield, for buying me my first camera and for being there for me.

Library of Congress Cataloging-in-Publication Data
Enfield, Jill.
 Photo-Imaging : a complete guide to alternative processes / by Jill Enfield.
 p. cm.
 Includes bibliographical references and index.
 ISBN: 0-8174-5399-7
 1. Photography—Processing. 2. Photography—Digital techniques.
 3. Photography—Special effects. I. Title.
 TR287.E53 2002
 771—dc21
 2001035786

Title Page Image:
Irving, 1991. *I made this cyanotype using a copy of a photograph of my father-in-law, Irving Rabinowitz, at age two or three. (The original photo was taken in 1923 or 1924.) First I made a 4 x 5-inch negative by shooting the original image with Plus Pan professional sheet film. Then I prepared my support (Rives BFK) with cyanotype chemistry, exposed it for 20 minutes, and processed it without additional toning.*

Senior Acquisitions Editor: Victoria Craven
Senior Editor: Alison Hagge
Production Manager: Hector Campbell
Cover design: Areta Buk, Thumb Print
Interior design: Jay Anning, Thumb Print

Manufactured in China

First printing, 2002

1 2 3 4 5 6 7 8 9 / 09 08 07 06 05 04 03 02

The principal typefaces used in the composition of this book were ITC Berkeley Book and Avenir.

CONTENTS

Montana, 2000. *I left the top half of this ink jet transfer image alone, but blended the bottom half with water so that the reflection would look more muted than the actual trees.*

Montana, 2000. *I printed this version of the ink jet image darker than the one above and brushed water on the entire surface for a different look.*

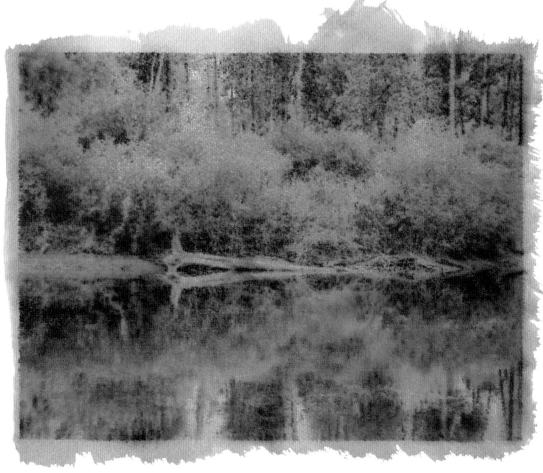

INTRODUCTION

Whenever I read how-to books I tend to find that they list a lot of dos and don'ts, strict rules about what you should and should not do with particular materials and during certain stages of the process. More often than not I find myself questioning one point or another, and asking "why?" or "why not?" Personally, I like to experiment, and I have found that there are very few don'ts that can be proven without exception. In fact, sometimes experimenting with a technique that might be a don't in the hands of another artist can lead to unique and satisfying results for you. Therefore, while writing this book, I have tried to give suggestions for how you might utilize a material or approach a technical problem. However, nothing is written in stone. I would suggest that you become generally familiar with the techniques presented here and then try everything to discover for yourself what does and doesn't work.

To give an example, when I first started to paint on my photographs in 1984, I was told—by more than one source—that you cannot mix oil and water. Period. However, I found that mixing oil and water certainly is possible, but only if you do it in a logical way. If you put oil paint down on your paper first and then try to put a watercolor over it, the watercolor beads up, because the oil acts like a half resist. But if you put the watercolor down first and let it dry, it just becomes another layer on the paper, and then the oil paint goes over it very smoothly. The end product may look a little different (as the watercolor—instead of the original photograph—can show through the oil paint), but this technique works and many people find that they like it.

This same breaking-the-rules rule holds true when working with other techniques—particularly the nontraditional techniques presented in this book. When I was first learning how to work with liquid emulsion, I read that polyurethane should not be used to prepare the glass before applying the emulsion because it could yellow as well as bubble and crack off. My sources said that polyurethane could only be used as a protective coating after the print was developed, washed, and dried. I was having trouble using all the other materials that were mentioned as possible things to try, so I figured it could not hurt to waste a few more pieces of glass and just *try* the polyurethane. So after talking with a very helpful person at my local hardware store and learning about all of the different kinds of polyurethane I selected one that I thought might work and found that it worked great for me. Those first images that I made are now several years old and they still look perfect! After eight years of working with liquid emulsion I am still using polyurethane on glass.

Throughout this book the only rule that exists is that there are no hard-and-fast rules. While the techniques, processes, and suggestions that are presented here are based on 25 years of personal experience (as well as advice from many professional photographers who are also working with these materials) and will certainly be helpful, they should be viewed as jumping-off points. I always encourage people to try new things.

The structure of this book is similar to the approach I take in the classroom, which—after many years of changing syllabi each semester—I feel follows a very natural way of learning. Safety and materials always come first. Then we move on to processes that are not very different from standard black-and-white darkroom techniques. For instance, infrared film is a black-and-white film that just needs a little extra attention. And liquid emulsion is the same emulsion that is used on black-and-white paper, but since you apply it yourself this process allows you to choose your support (which may or may not be paper). Therefore, the liquid emulsion process lets you master the techniques involved with both applying emulsion and working with new materials, while still working with familiar black-and-white developing.

In later chapters we move on to more advanced color techniques that involve both sensitizing your support and learning new development processes. These techniques include cyanotypes, kallitypes, and platinum and palladium prints. Along the way you will also learn how to make enlarged negatives, ink jet transfers, tintypes, Polaroid transfers, and emulsion lifts. Because you can hand paint any of the images that are made with the techniques listed in the book, hand painting images is covered at the very end. As you move through the processes, you might find that some are harder to do than others, but all will have similar attributes and many can be used together. Each process can be defined as a tool or palette with many options, offering you many choices and challenging you to make exciting decisions along the way.

Of course, the newest tool out there is the computer. Some photographers who are really into computers are selling off their darkrooms. I find myself doing the opposite—creating ways to marry the computer and the darkroom. I want to discover ways to utilize every available tool without giving anything up. That is why I discuss digital negatives and alternative digital imagery—such as the ink jet transfers shown on the left—in this book. The amount of experimentation yet to be done on the computer in combination with alternative techniques is endless.

All of the tools available today complement each other and—if you keep an open mind—you will be able to help bring new ideas to your photographic skills. Embrace all of the processes with experimentation in mind so that you can develop the freedom of being able to move between them and choose which techniques work best for you for each particular project.

SAFETY

WHEN WORKING WITH ANY of the chemicals mentioned in this book, safety precautions should be your primary concern. Almost all of the chemicals used during the various stages of the photographic process have some degree of toxicity and therefore should be handled wisely and with care. Learn as much as possible about each chemical you purchase and make sure to find out how each chemical can be used safely—particularly in relation to everything else in your darkroom. Know the antidote for any chemical you are using in case of accidental spills, splashes, or ingestion.

It is important to know what you can do to avoid accidents as well as what to do in case of an accident. The Material Safety Data Sheet (MSDS), which will be included with each chemical that you purchase, contains a lot of general safety instructions as well as specific information that is pertinent to the chemical at hand. File these data sheets in or close to your working area so that you can readily access them if you have questions in the future.

IMPORTANT POINTS TO REMEMBER

The following is a list of things to be aware of as you set up your work areas. Some points may seem like common sense and others may be things that you would never know unless you took a chemistry class. All are very important to keep in mind and to pay attention to and are repeated throughout this book.

- As in all darkrooms, designate one counter as the dry area and another counter as the wet area. This will help to minimize contamination of all surfaces and materials.

- When working, wear an apron or smock to protect your clothing or wear old clothes.

- Always pour acids into water (never water into acids). This will help prevent splashing accidents.

- Avoid working with brushes that have metal parts. Many chemicals used in the processes discussed in this book have adverse reactions to metals, which can cause oxidation and contamination. However, if your brushes have metal on them, covering the metal part of the brush with several coats of nail polish will make them safe to use.

- Store each chemical in a bottle that is relegated for that chemical alone. Use only *brown* bottles that are equipped with *plastic* caps (as metal caps can corrode depending on the chemical stored inside).

- Designate a different tray for each chemical. This will avoid contamination. Make sure you clearly label each tray.

- Dispose of unused cyanotype emulsion by pouring it in kitty litter that has been placed inside a plastic bag; seal the bag well before discarding.

- Potassium dichromate is toxic. Thoroughly wash all utensils that come into contact with this chemical in a sink with running water.

- Silver nitrate (which is used to make Van Dyke brown prints) is highly caustic and can cause skin burns. It is also an oxidizer, which means it can supply oxygen to a fire. Clean up any spilled solid silver nitrate with water to liquefy it and dispose of any excess down the drain. Never dispose of solid silver nitrate in a wastepaper basket.

- Always wash your hands with soap and water after completing a darkroom session, despite the fact that you wear gloves while working. If any staining occurs on your skin, it will go away with repeated washings over time.

- The jelly from Polaroid film is caustic. It is best to wear gloves at all times when working with Polaroids. However, I personally find this difficult, so I constantly wash my hands with soap and water throughout the process. Be careful not to get the jelly in your mouth or eyes.

- Keep all chemicals away from children, pets, and food.

- Always wear sunglasses with UV protection when using UV bulbs and never look directly into the bulbs.

- Make sure to clearly label and date each bottle.

Gramercy Park North, 1999. *I shot this image using Konica 35mm infrared film with a #25 red filter. Note its high contrast and fine grain.*

TAKING BASIC PRECAUTIONS

Even though I discuss how to mix chemicals from scratch throughout this book, I strongly suggest buying premixed chemicals. Many of these mixtures are now readily available, and using the premixed material is safer than mixing the chemicals yourself. (*See* Sources, page 155.) However, even when using the premixed chemicals, you must take precautions to use your materials safely. These precautions involve wearing gloves, goggles, and a mask, properly ventilating your working environment, and disposing of your materials in a way that minimizes their impact on our environment.

WEARING GLOVES

When working in the darkroom, you should wear gloves at all times. Whether you are mixing powder or liquid chemicals or are coating, washing, or drying your paper, your skin should *never* come in contact with any of the chemicals. Sometimes darkroom chemicals can cause people to break out immediately. (I generally start to itch.) Some chemicals can cause burns or boils on contact. Still other chemicals can build up in your system over time and may cause skin and/or breathing problems years later.

To protect yourself from direct contact, you should purchase gloves. A number of different options are available. Many art-supply stores carry reusable neoprene protective gloves. (People who are sensitive to latex should be aware that neoprene is made with latex.) Regular household latex gloves also work and are readily available at supermarkets and home-related stores, but they tend to be a little bulky. Pharmacies and medical-supply stores have latex and nonlatex examination gloves that are thin and easy to use. As they can be punctured easily, these disposable gloves need to be changed often.

Because each of the techniques discussed in this book uses different chemicals, I suggest relegating a different pair of gloves for each process. (You'll probably want to label each pair with an indelible marker to keep them clearly marked.) It is important that you watch when gloves are dirty to avoid contaminating your work area and yourself. Any of these gloves will protect you well enough that you can put your hands into the chemicals. However, it is important to make sure that you do not have holes in the gloves or it will defeat the purpose of wearing them. Even though you wear gloves at all times when working with chemicals, you should wash your hands before you leave the darkroom so that you do not contaminate any other part of your work or home space.

USING A MASK AND GOGGLES

It is a good idea to wear a mask—especially when you are mixing or liquidizing powder chemicals—as this will help to keep your lungs clean. People who are particularly sensitive to chemicals or who have had health problems such as pneumonia may want to wear a mask at all times. You can purchase masks at art-supply, hardware, or automotive stores. The best type of mask to buy is a purifying respirator with two filters, one on each side. The filters will help keep you clear of organic vapors and dust. Some people use their mask only when they are mixing chemicals and others use it all the time as an added safety precaution.

When selecting a mask, look for one that filters out organic vapors. To prolong the life of the filters, you can store them in an airtight container when you're not using the mask; remember to replace the filters frequently. According to the Daniel Smith art-supply catalog, pregnant women should not use this type of mask as it may reduce their oxygen intake and harm the fetus. Generally, men with facial hair cannot get a good fit with a mask.

When mixing chemicals I also recommend wearing standard hardware-store goggles as added protection for your eyes. Some people use goggles at all times for added protection, but that is really up to you. If you do splash chemicals in your eyes, make sure to flush your eyes out immediately with fresh water and call your doctor.

VENTILATING YOUR WORKSPACE

Most of the techniques listed in this book can be done in subdued light (i.e., not the usual darkroom safelights, but regular 40-watt "white light" bulbs). With this said, a lot of people are under the impression that having a window open with the shades drawn is adequate for light (which is true) as well as for ventilation (which is not true). Adequate ventilation is as essential for alternative photographic techniques as it is for conventional darkrooms.

A darkroom should consist of two sides: One is used as a "dry" side, where your paper, enlarger, ultraviolet light box, timers, and negatives can be stored safely. The other is a "wet" side, where all your trays and chemicals can be kept. In the best-case scenario, the wet side would include a large sink where you can also wash everything. To keep down the possibility of contamination, the two sides should not be used for anything else. In other words, your negatives should never be left in the sink and

your chemicals should never be placed on the dry-side table.

The ventilation system needs to be placed in the sink area, as its purpose is to remove toxic fumes and the sink area will be the location of most of your toxins. Specifically, the system should be positioned toward the back of the sink near the back edge of your trays. This positioning is crucial, as the system will produce a draft that goes across the surface of the trays and consistently pulls chemical-laden air away from your face as you work.

Ideally this ventilation is achieved with a long, narrow hood or box called an intake, which runs from one end of the sink to the other. This intake can be built into a box (called a "plenum"), which helps pull the intake of air out of the room. The plenum should be connected to a tube that has an exhaust fan to pull the air up and out of the room, preferably leading to the outside of the building. Since the ventilation system will be taking so much contaminated air out of the darkroom, you also need to make sure you are putting good air back in. Installing light-tight grilles, which are available at most large photography stores, in the door to your darkroom will solve this problem.

You can test your ventilation system by burning incense and watching where the smoke goes. If it goes up and out through your ventilation system, you can assume that the chemical fumes are doing the same. However, building ventilation systems can be tricky. If you are not comfortable with setting up your own ventilation system, consult a ventilation expert. (*See* Sources, page 155.)

DISPOSING OF MATERIALS

Darkroom safety involves not only using your chemicals wisely, but disposing of them wisely as well. Unless you are doing a tremendous amount of printing, the Environmental Protection Agency (EPA) usually does not provide special containers to dispose of your chemical waste. However, it is important to be aware of what these chemicals may do to the environment over time and be smart about your own disposal. The best method of disposal will depend both on where you live and on the type of sewage or septic system that you have. Check with your local EPA to find out more details about the recommendations for your area. A list of the regional offices (with contact information) is featured on the EPA Web site, which can be found at www.epa.gov.

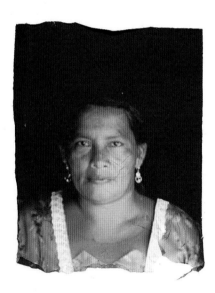

Guatemalan Woman, 1999. *These three emulsion lifts show the effects that can be created by using different filter packs. I exposed one normally, one with more magenta, and one with more cyan. I put the three lifts onto a transparent Mylar because I wanted the light to pass through them to illuminate the portraits.*

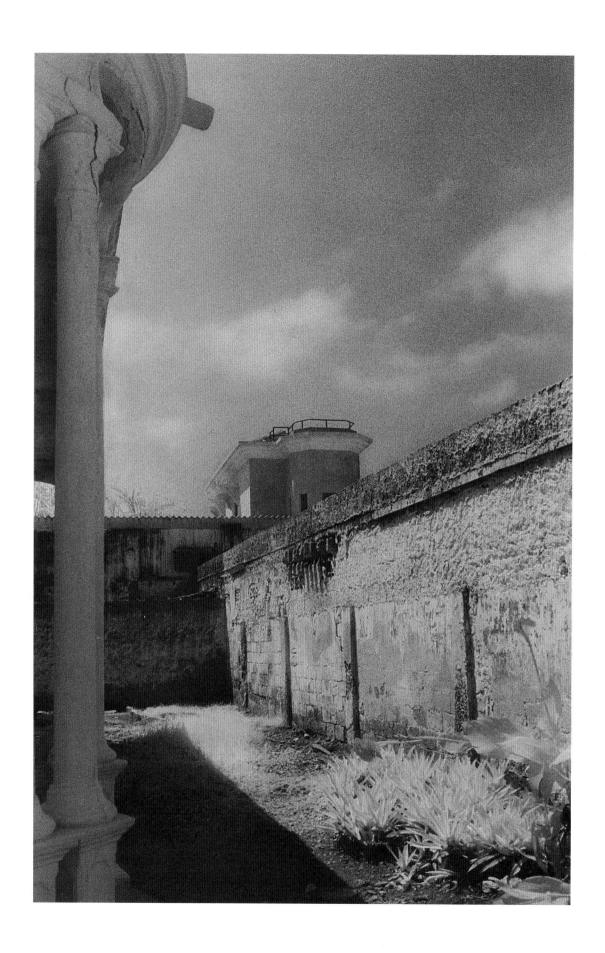

A QUICK GUIDE TO MATERIALS AND TECHNIQUES

EVEN THE MOST EXPERIENCED black-and-white or color photographer/printer should review the basics when it comes to working with alternative processes. While some techniques may seem familiar, each of the processes in this book has its own quirks, so it is best to start at the beginning. This chapter provides an overview of the materials that will be required as well as of the techniques that should be mastered in becoming an alternative process printer.

The first section spells out what is involved with setting up your darkroom for alternative printing processes. This includes an extensive checklist of the basic equipment. You may find that you already have some of these supplies, as many are standard darkroom items. Light requirements, however, are totally different for alternative printing than for silver printing, so this section also discusses the pros and cons of the numerous ultraviolet light sources that can be used. Another difference between standard and alternative printing is that with the latter you have tremendous leeway in choosing your base support—whether it be rubber, metal, or paper. Choice of support is one of the biggest factors that determines the look of your end product. Since most alternative process printers elect to work with paper, a large part of this section outlines the many different options that are available, including how to tell them apart and make educated decisions as to which ones you might want to try.

The second section covers the basic techniques that are shared by many of the various processes discussed in this book. Unlike standard silver printing, alternative process printing involves preparing your base support, which often includes sizing, sensitizing, and drying it. While sensitizing chemicals vary from process to process, the basic techniques for preparing and putting these sensitizers on your support remain the same, so they are explained in depth on these pages. Every printer has his or her own tried-and-true suggestion for how to apply the sensitizer to the chosen support. I have explained all of the different techniques so that there are no mysteries. Try them all and make your own decision as to which one works best for you.

This chapter ends with a few hints on how you can combine multiple processes for some beautiful results. Of course, it goes without saying that experimenting is a key factor in getting across your own vision and style. So once you have the basic techniques under your belt, feel free to play around and use them to their best advantage.

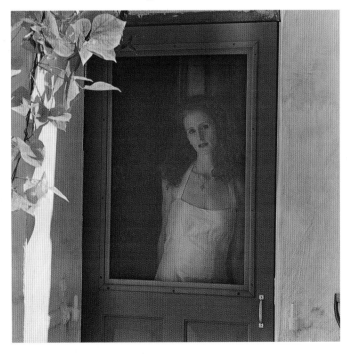

Cartagena Prison, 1986. *I used a Nikon 35mm camera and Kodak HIE 35mm infrared film. I printed the image on Kodak Ektalure G paper, then painted on the print with oil paints, colored pencils, and pastel chalks. I put the blue on the entire sky to get an even coat and then removed the color from the clouds.*

Christine, 1998. *I shot this image with a 2¼ x 2¼-inch Hasselblad camera using Kodak T400CN film, then painted the print with oil paints and pencils.*

SETTING UP YOUR DARKROOM

With the exception of image transfers and emulsion lifts, all of the processes mentioned in this book require a basic darkroom. Luckily, as many amateur and professional photographers will attest, creating a makeshift darkroom is not very difficult. For years I used a corner of a room as my darkroom. The key to being able to transform a room (or part of a room) into an effective darkroom is being able to block out the light. Remarkably, blackout curtain material and Velcro (or even heavy-duty black garbage bags and duct tape), if handled properly, can turn even a bright room into a workable darkroom.

In addition to sealing off your work area from light, you will need access to a water source and adequate ventilation. (*See Ventilating Your Workspace*, page 8.) If you have never had a darkroom of your own and want to build one, I suggest that you look through several of the how-to-build-a-darkroom books that are available through your local bookstore. Once you have created a basic darkroom area, it is time to equip it for the alternative processes featured in this book. This involves obtaining basic darkroom equipment and materials, a suitable light source, and an ample supply of interesting base supports, including paper.

BASIC DARKROOM EQUIPMENT AND MATERIALS

Many of the materials needed to outfit your darkroom for alternative processes are similar to those needed in a regular darkroom. So you will undoubtedly find that you already have a lot of the equipment and materials listed below. The major difference between setting up a "normal" darkroom and one that will be used for alternative processes is that the latter should be devoid of any equipment that has metal on it, as the metal will react with your chemicals and cause oxidation and staining. Items that typically have metal on them include sinks, brushes, bottles (in particular bottle caps), and trays. So pay particular attention when procuring these items.

Before you get started with the techniques described in this book, make sure that your darkroom is equipped with the following:

Apron Most of the processes discussed in this book involve chemicals that stain clothes, so it is important to wear an apron, smock, or old shirt while you're working.

Archival Storage Box This acid-free box is used to store your final prints.

Black Garbage Bags Heavy-duty black garbage bags (the kind used by janitors that are found in most hardware stores) are stronger, and therefore more opaque, than regular kitchen garbage bags. These can be used to seal off light from your work-

ing area. They can also be used to create an alternative paper safe if your support is very large.

Blotter Book This can be used (instead of a drying screen) to dry your finished prints.

Brushes While several techniques are possible, some people like to use either sponge or bristle brushes to apply both their sizing and their sensitizer. If you decide to use the brush methods, you will need a brush for each process; to avoid confusion, I write the process directly on each brush with a waterproof marker. If your brushes have metal on them, you can coat the metal with nail polish so that no contamination occurs. (*See* Brush Method, page 25 and 27.) With sponge brushes, I prefer the kind with *wooden* handles, as those with plastic handles tend not to have as much foam and can scratch your support.

Bucket This comes in handy when mixing large quantities of chemicals—particularly developer.

Canned Air This helps remove dust from the surface of your negatives or support. You can buy it at photography stores and can usually find the kind that is ozone safe.

Here are some of the different instruments used to apply both sizing and sensitizer (from left to right): bristle brush, glass rod, Japanese Hake brush, and foam brush. Note that the bristle brush has plastic (instead of metal) holding the bristles.

Cheesecloth This is used to filter precipitates or mold from your stock solutions, particularly if it is old or is stored in humid conditions.

Cleansers If you are using glass, Plexiglas, metal, or eggs as a support, you will need to clean the surface before it will accept a sizing solution. Vinegar, isopropyl rubbing alcohol, stop bath, or lighter fluid can be used for this purpose. Then the material should be washed with washing soda to remove the protective wax or oily surface.

Clothesline Hanging a clothesline in your darkroom provides a place to hang paper or fabrics to dry.

Clothespins These can be used to attach your wet support to the clothesline.

Coffee Filters These can be used (as an alternative to wax paper) to protect your darkroom scale from contamination when you are measuring your dry chemicals. They are also useful for filtering your liquefied chemicals if there is unwanted sediment.

Contact Print Frame Make sure your contact print frame has a hinged back, so that you can check your exposures without disturbing your registration. (*See* image on page 18.)

Cups and Bowls You'll need to have plenty of paper or plastic cups and ceramic bowls on hand. I use them to hold the correct amount of sensitizer for each process. The size of the container will depend on how much sensitizer you will need for your work session and how big a brush you are using. I throw the paper cups away after each use and wash the ceramic bowls out with hot water.

Darkroom Thermometers Purchased at a photography store, darkroom thermometers are used to make sure that your chemicals are the proper temperatures—when you are mixing as well as using them. All temperature requirements are listed with the chemicals in their respective chapters. Darkroom thermometers usually measure in both Celsius and Fahrenheit.

Distilled Water It is better to use distilled water (instead of tap water) when mixing your chemicals. Tap water often has too much iron, which can cause stains that may not show up until years later. Also, the chlorine in tap water can cause the chemicals to lose their potency.

Drafting Tape This is wonderful to have in your darkroom, as it will not stick to your support and rip off the sensitizers. Some people use it to mark off the size of their negative and put the sensitizer inside the tape area for a very clean look without brush marks outside the image area. This tape looks just like masking tape and can usually only be found in good art-supply stores.

Drying Screens These are used to dry photographs. You can buy them from most photography stores or make them yourself by securing fiberglass screening to a wood frame.

Easel An easel is placed under the enlarger to hold your film or support flat and in the proper place during exposure. Depending on the price you want to pay, there are several types from which to choose. The best ones have four blades that can be moved to fit to the correct size of your final image.

Enlarger An enlarger uses a lens and bellows to project white light through a negative onto film or paper to make an enlargement. You will need an enlarger and safelights while making enlarged negatives and liquid emulsion prints. You can also use an enlarger while making Polaroid transfers and emulsion lifts, although it is not necessary. (*See* Chapter 11.) An enlarger will not be used for any of the other techniques discussed in this book, because the sensitizers all need to be exposed using sunlight or special bulbs that emit ultraviolet lightwaves. (*See* Light Sources, page 18.)

Eyedroppers These are required for precise measuring when doing kallitypes and platinum or palladium printing. They are also used when using the glass rod method for applying sensitizer to your paper support. There are two things to remember when purchasing eyedroppers. First, it is important that all of your eyedroppers are the same size, so that the proportions of your stock solutions are the same when you are mixing. And second, it is important to label your eyedroppers and only use one per solution. You may find it useful to purchase eyedroppers that come with small, brown, glass bottles.

Fan You can use a small fan (in lieu of a hair dryer) to help dry your sensitized support.

Glass A piece of glass can serve as a flat, clean surface on which to place your paper while coating it with the various sensitizers. (You can also use a board or piece of Plexiglas as a flat surface as long as it is strong and smooth.) Your support surface should be a few inches larger than the size of your largest image and should be about 3/4 inch thick, so that it will be strong. You only need one piece of glass, but make sure that you keep it clean and chemical-free. A second piece of plate glass can also be used instead of a contact print frame for contact printing.

Glass Rod This is used for coating your paper or other materials with the sensitizer. You can wash the rod with hot water and reuse it for a number of processes. Some people prefer rods to brushes because they allow you to use less sensitizer. (*See* Glass Rod Method, page 25.)

Gloves Both household latex gloves and surgical gloves are suitable for darkroom use. I prefer surgical gloves largely because they are not as clumsy as latex gloves and they can be thrown away after a few uses, which cuts down on contamination. If you use latex gloves (which are reusable), make sure to allocate one pair of gloves for each process; these should be clearly marked so as to avoid confusion and possible contamination. (*See* Wearing Gloves, page 8.)

Goggles Goggles should be worn whenever you are mixing chemicals to protect your eyes from splashes. They can be purchased at any hardware or art-supply store. (*See* Using a Mask and Goggles, page 8.)

Graduates Different size graduates can be bought at any darkroom or chemical-supply store. You should have a different graduate for each chemical. I mark the graduates with a waterproof pen so that I do not mix them up.

Grain Focuser A grain focuser is used to help focus a negative before you enlarge it either onto a piece of paper or (for enlarged negatives) onto another piece of film. The focuser magnifies the grain of the film for easier focusing.

Hair Dryer Most of the processes listed in this book are done by coating a sensitizer onto a surface, exposing it, and developing it. The sensitizer must be dry before you lay your negative on top of your support and expose it to the ultraviolet light. A hair dryer will help dry the sensitizer quickly, but it needs to have a "cool" setting because the warmer settings can burn the sensitizer. Make sure that your hair dryer does not emit light when turned on, as this can cause your sensitizer to fog.

Hot Plate This is a useful item in general, but it is crucial if you are going to be creating liquid emulsions, tintypes, and/or emulsion lifts.

Isopropyl Rubbing Alcohol This is available at pharmacies and grocery stores and is used to clean your glass or Plexiglas surface before applying your sensitizer as well as (in the case of liquid emulsion) diluting your sensitizer or (in the case of tintypes) making your varnish.

Light-tight Containers These can be used to liquefy small amounts of emulsion. Some people use opaque film canisters for this purpose.

Mask A mask for organic chemicals is needed to ensure your safety when mixing your solutions. You can buy one at most hardware or art-supply stores. (*See* Using a Mask and Goggles, page 8.)

Mixing Rod A glass or Plexiglas rod is used for transforming all of the chemicals from the stock solutions into the working solutions. If it is washed off well with hot water after each use, one rod should be sufficient for all mixing, although some people prefer to have a separate mixing rod for each chemical. Personally, since I do not mix large quantities of sensitizer, I tend to use plastic spoons instead (and then throw them out when I'm finished).

Negative Sleeves In addition to sleeves that are designed to hold your original negatives, you will need larger plastic sleeves to store and protect your internegatives and interpositives. Some people prefer the sleeves that are designed so that you can slide your film in and out. Others feel that, if you are not careful, the film will scratch just by removing it from the sleeve; they buy sleeves that are open on three sides so that you can remove the film without sliding it.

Newspaper This will help cover your work area so that the chemicals will not stain the table, appear on unwanted paper, or get onto your skin.

Painter's Masking Tape This blue tape is made to remove easily from any surface and will not leave a sticky mess. I find it especially useful in marking my baseboard before I expose a print, so that I know where my support will be placed.

Paper Safe A paper safe is a large, light-tight black box that is great for protecting coated support or film in a darkroom. I tend to coat a lot of support when I am working with liquid emulsion and use a paper safe to store the paper for several days at a time. Most camera stores stock paper safes in different sizes. Larger supports can be stored in heavy-duty black garbage bags. (*See* image on page 54.)

Paper Towels It is always a good idea to keep paper towels in your darkroom for quick cleanups.

Pencils Stock your darkroom with plenty of #2 pencils. These are essential for marking the back of your support. For instance, when you cut watercolor paper down to a usable size, you may also cut off the original watermarks. The watermarks tell you which side is the correct side and which is the back side. Marking the back of the paper is an easy way for you to know which is the front for coating. It is also good to get into the habit of writing down details about the exposure, toner, or any other information you find necessary to allow you to repeat what you have done on another day.

Plastic Spoons These are good to have on hand when measuring your chemicals. I use them to move chemicals on and off the scales. They contain no metal and are disposable, so you do not need to worry about contamination.

Pot This is necessary if you plan to make liquid emulsions, tintypes, and/or emulsion lifts. I place the water-filled pot on top of a hot plate and then place a Pyrex measuring cup inside the pot. This contraption acts like a double boiler and heats the emulsion evenly.

Pyrex Measuring Cup This is useful for making the "double boiler" described above as well as for measuring darkroom liquids such as distilled water.

Ruler I rarely make a print that is as large as a full sheet of watercolor paper (i.e., about 22 x 30 inches), so a ruler is necessary to measure the paper to the desired size.

Safelights The size of your darkroom will determine how many safelights you will need. Safelights allow you to see in the darkroom without exposing your silver photographic paper to white light (regular room light), which will cause it to fog. For most alter-

native processes, you can use a safelight that has been equipped with a red or amber filter or you can use a low-watt normal household bulb, such as a 40-watt bulb, in a lamp or ceiling fixture. Both will illuminate the room without fogging your materials.

Scale As you will be using this to measure your chemicals, make sure that you select a scale that goes as low as a few grams. Food scales work well, as do scales from chemical suppliers.

Scissors Good, quality scissors are essential in any darkroom.

Scotch Magic 811 Removable Tape This is a transparent tape that is great for holding negatives down for all the contact processes featured in this book. The tape will not show on the final print and it will not rip up the sensitizers or ruin your negatives. It has a low adhesive as well as a low acid count, so that it will not yellow over the years. It also can be written on with pen, pencil, or markers, and is more readily available than drafting tape.

Spot Tone This is helpful for spotting your black-and-white prints, particularly if you are going to hand paint them. Many of the alternative processes require different spotting materials. For instance, platinum and palladium prints can be spotted with a soft pencil, black India ink, or a watercolor pencil.

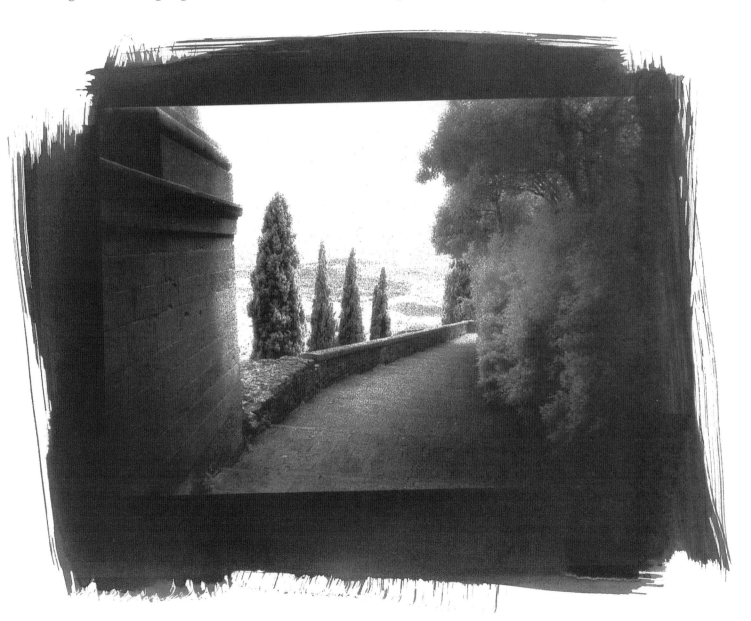

Pienza Walkway, 2000. *This Selenium-toned Van Dyke brown print is on Fabriano Uno 140-lb cold-pressed watercolor paper.*

Three Girls, Puerto Rico, 1999.
This Polaroid transfer involved slight manipulation. I added more magenta (to enhance the skin tone) plus let the image process a bit longer than usual (to get a darker transfer).

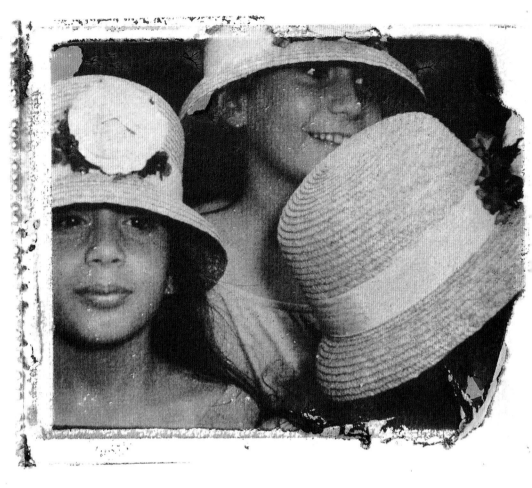

Squeegee A *clean* darkroom squeegee (or windshield wiper) will help you remove excess water or sizing from your support material. Your squeegee should be larger than the support you are using.

Storage Bottles Three of the processes discussed in this book use the same chemicals that you would use for normal silver printing. (These include black-and-white infrared film, liquid emulsion, and enlarged negatives.) Therefore, special bottles are not needed for these processes. However, the chemicals used for most of the techniques discussed in this book react adversely to metal, so for the chemicals in these processes it is important to use dark brown plastic or glass storage bottles with plastic (*not* metal) caps. You will need a separate bottle for each chemical. All of the necessary chemicals are listed within each chapter, as are the particulars for how many (and what size) storage bottles are needed.

Straight Edge These are twice as strong as rulers and are used to tear your paper. There are two different kinds of straight edges: one gives you a slightly torn edge, the other creates an effect (called a deckled edge) that simulates a factory-made edge.

Syringes Small syringes (i.e., ones that hold 2ml of liquid) work well when using the rod method for applying your sensitizer onto your support. The syringes hold the sensitizer and allow you to gently release it onto the rod before coating.

Timers You will need at least two timers—one either for the enlarger or for the ultraviolet light source to time the exposure, and one for the chemicals to time how long the image is in each tray. The timers need either to have a second hand or (if it is a digital timer) to read in seconds. They also need to be visible in the subdued light of a darkroom. You can buy a timer, such as a Graylab timer, at any photography store.

Tongs These come in packs of three at photography stores and should be used to move your paper in and out of the trays. You will need one tong per tray. Specific tray requirements are listed within each chapter. Bamboo tongs do not scratch the emulsion as much as plastic tongs.

Towels Keep a few darkroom towels handy at all times. These help to keep your hands clean and dry, especially when you're working with liquids. If you opt for paper towels, make sure to spend the extra money and buy *soft* ones, as the cheap ones can scratch delicate surfaces.

Trays Stainless steel trays can be used for liquid emulsions, tintypes, image transfers, and emulsion lifts. All other processes in

this book require *plastic* trays. You will need to designate trays for each photographic process that you use, noting that you need a separate tray for each chemical within each process. Each chapter notes how many trays are needed for that particular technique. I label all of my trays—with both the name of the technique and the name of the chemical—so that I do not mix them up, which could contaminate them.

Watercolor Pencils or Paints To spot your black-and-white and color prints, you can use watercolor pencils or paints. Test the pencil or paint with both the color of the support and the color of your emulsion to make sure that they match before you work on a finished print.

Wax Paper Sometimes it is necessary to measure your chemicals—especially if you have bought them in large amounts and need to make a smaller volume. Because you will have only one darkroom scale (instead of a scale for each process), you need to use wax paper to protect the scale from contamination. The wax paper can then be thrown out after use. Wax paper can also be used (instead of palette paper) to mix paints for hand painting black-and-white photographs.

Miami Beach, 1997. *I took this image with a Diana camera using Tri-X film. I then made an enlarged negative using 11 x 14-inch Arista orthochromatic film and made this platinum print by exposing the negative and support (Arches Platine paper) for 4 minutes.*

LIGHT SOURCES

Because most of the processes discussed in this book involve using sensitizers that are activated by ultraviolet lightwaves, choosing the proper light source is an important factor when setting up your work area. If you live in a sunny location, you may choose to use sunlight (i.e., natural ultraviolet light) and not have an artificial light source in your studio. However, sunlight is not dependable. Rain or snow can stop even your best intentions for a full day of printing. It is also nearly impossible to repeat printing conditions exactly, since the time of day, time of year, and weather conditions affect the strength and quantity of the ultraviolet rays emitted.

You can make your own ultraviolet exposure unit (also called a UV light box) using ballasts, fans, and wood. Or, if you are like me, you can buy one ready-made, like the one shown below. When I first started doing alternative processes, I tried all kinds of bulbs. I have listed them below, in order of preference. Black-light bulbs and aqua bulbs are both excellent options. They both emit the same amount of ultraviolet light and both work fine for alternative photographic processes. The difference lies in the price. So for me, the black-light bulbs won out. Nevertheless, in the spirit of experimentation, I have listed all of the various options below. Keep in mind that you should *never* look directly into any ultraviolet light source, as it can damage your eyes.

Black-light Bulbs These are often used to illuminate psychedelic posters or bug zappers. Many alternative-process photographers use these bulbs, which are referred to as either "ultraviolet BL fluorescent bulbs" or simply "UV bulbs." They can be bought at most bulb-supply stores, but make sure you buy "BL" (black-light) and not "BLB" (black-light blue) bulbs. BL bulbs emit enough ultraviolet light to require relatively short exposures, whereas BLB bulbs emit less ultraviolet light and are also more expensive.

Aqua Bulbs Used in fish aquariums and reptile tanks, these also emit adequate ultraviolet light. A lot of alternative process photographers favor these bulbs.

Mercury Vapor Lamps While these bulbs do not get hot, they emit a high amount of ultraviolet light as well as having a high wattage. Consequently, they can expose your images very quickly. However, they are also considerably more expensive than the alternatives. They are found in vacuum frames used by printers.

Sunlamps While some people use sunlamps for alternative processes, I have found that they overheat and can be dangerous. I don't recommend them.

PAPER

Because there are so many kinds available, choosing paper can be daunting. However, this decision is critical because paper not only plays an important role in the appearance of your final image but also affects its permanence. The three major qualities to consider when selecting paper are its color, weight, and surface.

The color of the paper will show through the highlight areas of your image. So the difference between a bright white or a warm white paper will affect the final product. Some papers come marbleized or in colors. The type of dye that has been used will determine how archival the paper is. This information is available from the manufacturer and is important to know if you are concerned with the life of your images.

A paper that is said to be 140-lb paper is lighter than a 300-lb paper and therefore not as thick. Both will do well in all of the

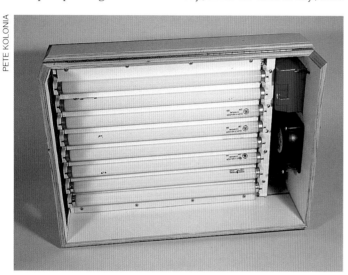

This ultraviolet exposure unit can be used to expose prints of up to 11 x 14 inches. This model uses eight ultraviolet bulbs and a fan to keep the bulbs and emulsions from overheating. If you want to expose larger surfaces, you can either buy longer bulbs or put more bulbs together within a larger exposure unit.

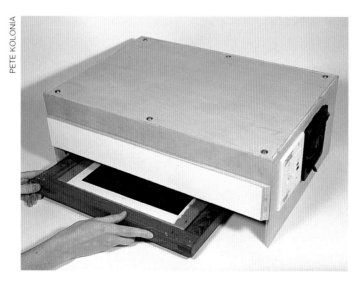

A contact print frame can be placed underneath the lights in the ultraviolet exposure unit to expose your base support.

wet-tray processing used for the photographic techniques in this book. It is worth noting that thinner papers sometimes curl, though this can be prevented. Some mills use the measurement Gr/M², which means weight in grams of one square meter of paper (e.g., a 250 Gr/M² paper is equal to about a 140-lb paper).

After paper is made it is either left alone or pressed using a cold-pressed method or a hot-pressed method. Cold-pressed papers have been put through rollers with no heat and, therefore, have texture. Hot-pressed papers have been pressed with heat and, therefore, are generally smooth. Rough-textured papers have not been pressed at all. The finer your texture is, the sharper your image will be.

Papers have a "right" side and a "wrong" side. If you are trying to make editions of a particular image, you will need to pay attention to this fact or your prints will be inconsistent. Most papers have a watermark that will read correctly on the "right" side. Since most papers come in large sheets, you will likely want to cut them down to smaller pieces before you start printing. Before you start cutting, take note of the watermark. Then, using a pencil, make a small mark on the "wrong" side of each piece as you cut the paper down to your required size. This way, when you are ready to print, you will be able to consistently expose the "right" side of the paper.

Papers are named for the mill in which they are made. Some of the mills have been around for hundreds of years. During a quick look through the New York Central art supply catalog I noticed a mill in Japan that had been around since about 702 and another in France since 1326. The papers are listed by the mill name and then the mill gives each type of paper another name and a weight (either in pounds or grams). Your art-supply store will list which weights they carry and what colors of the papers are available.

The choice of papers for these processes is endless. I personally found my favorites by spending time at art-supply stores and touching everything to see which papers felt good to me. During each trip I would buy a few different kinds, making sure that I could either read the watermark put on the paper by the manufacturer or that I marked on the back of the paper with a pencil before having the paper packed up for me. Once I got home I would cut the paper down and try it out with different processes. Choosing paper is a fun—and individual—art.

Carp, 1999. *Paper isn't the only support that can be used with alternative processes. For instance, I chose this negative, which I made using Kodak HIE 35mm infrared film, to make a liquid emulsion tile installation. I coated the tiles first with gelatin sizing and then with Silverprint. After exposing, developing, and fixing the tiles, I toned them with selenium toner.*

LEARNING THE BASIC TECHNIQUES

As a photographer, you make choices all the time. Deciding what kind of camera to use, whether to employ traditional film or digital, whether you want to produce your image in a dark-room or generate digital printouts, even the details of how to exhibit your work—these choices all constitute facets of your own unique technique. The choices involved with alternative processes are similar to those involved with regular black-and-white and color processes, but they are even more extreme. This is because for each alternative process you choose the base support (whether it should be paper, glass, or something entirely different), plus the type of sizing, sensitizer, coloring method, etc. This list goes on—and the options are seemingly infinite.

Each choice not only has a specific visual consequence, it also affects the other choices that you make. How do you want the sensitizer to look? Well, the effect you get will depend on the support you have chosen, the technique you used to apply the sizing (or whether you chose to use sizing at all), and how you applied the sensitizer to your support. So when you're thinking about coating techniques—and wondering whether you should use a Hake brush or a glass rod to apply your sensitizer—you should also be thinking about the other decisions that you have made (and are about to make) to create your image.

As always, I suggest that you experiment with all of the different techniques—so that you not only perfect your favorites, you also know what possibilities await you the next time you are faced with a creative decision.

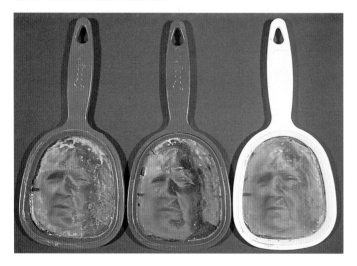

Looking Back at You, 1998. *Liquid emulsion will slide or bubble off mirrors if you do not clean and size them first.*

IMPORTANT POINTS TO REMEMBER

Many of the processes described in this book can be combined to create different new and unusual visual affects and color combinations. (*See* Mixing Your Techniques, page 31.) As always, my advice is to experiment and have fun. Though my general tendency is not to enforce too many "rules" on the process, here are a few tips that will be helpful as you start to become familiar with the working methods of alternative photographic techniques.

* When washing prints or negatives, never put too many items in a tray at one time, as they both scratch easily when wet.

* Never let water run directly onto a print or negative, as they are easily damaged.

* When transferring your print from one chemical bath to another, always allow it to drain fully before submerging it in the next bath. This will reduce the amount of contamination.

* Always make extra prints and save your mistakes (light or dark prints) so that you will have plenty with which to experiment.

* If you are making multiple exposures on the same print, size or preshrink your paper before you start to work or you will have trouble aligning your negatives as you put one exposure on top of the other. I only size and preshrink my paper when I make multiple exposures; however, some people do it as a matter of habit with each print. Again, it is a matter of preference.

* Always expose your paper soon after you have coated it with sensitizer and dried it. Most of the sensitizers in these processes lose their intensity as they sit around. However, paper that has been preshrunk and/or sized, but not sensitized, can be stored indefinitely.

* You can cut masks for your negatives with rubylith to control your exposures by process. Rubylith is a red acetate that you can use to cut out different areas for each exposure. The ultraviolet light will not penetrate through the red areas because they act like a mask.

* You can expose areas of your images selectively by using fine brushes. Dip a small brush into an emulsion to control exactly where you want to expose an area.

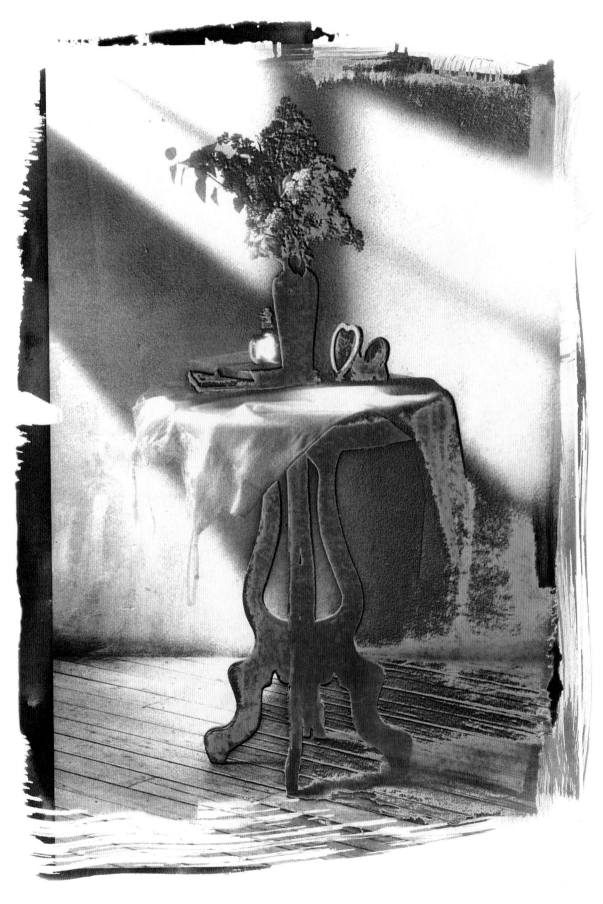

Vassarette, 1992.
I created this image by mixing different alternative techniques. First I exposed the cyanotype sensitizer for 20 minutes to make a contrasty and dark cyanotype. Then I coated Van Dyke brown sensitizer on top and exposed the image again for 4 minutes. The dark areas stayed blue while the light areas turned brown. A kallitype of this image can be seen on page 100.

SIZING FORMULAS

The terms "sizing" and "subbing" are interchangeable and mean the same thing. However, when paper or canvas is the base support, "sizing" is the term most often used, and when glass or ceramics is the base, "subbing" (which is short for "substratum") is most often used. To be less confusing during this book, I use the word "sizing" regardless of the material at hand.

Sizing is a solution of animal glue, gelatin, or synthetic material that is added to the base support to control the level of absorption of the sensitizer and to make the base support moisture resistant. Some papers come with an internal sizing, which means that the sizing solution is added to the wet pulp before forming the finished sheet of paper. Other papers are tub sized, which means that the paper is passed through a vat of sizing solution, usually gelatin, after the papermaking process is completed. Still other papers are sized using both methods.

Despite being commercially sized, a lot of watercolor papers are still too absorbent, so home sizing might be necessary. Sizing is also necessary when using other types of materials, such as glass, plastic, metal, or wood. (For the sake of consistency I use the term "base support" to refer to the material on which you put the sizing and sensitizers, unless the technique differs.)

Whether or not you size your paper or fabric is a matter of choice. Some sources say that you *must* size before printing, others recommend it for certain papers and fabrics only. Different sizings can affect not only the color of a final print but also how smooth or sharp the image looks. If you are printing on fabric or canvas, always wash out the manufacturer's sizing (this may take washing the material two or three times) or you will get uneven absorption.

On these two pages you will find several different types of sizing solutions. These are basic, all-purpose recipes. A word of caution: Gelatin tends to form air bubbles if you overmix the solution. If this happens, try adding some defoamer. It is used to keep air bubbles to a minimum in machines but you can buy it in small quantities at most photography stores. Use one drop per 4 ounces of gelatin sizing before applying the sizing to your base support. As with the other aspects of these processes, I suggest that you experiment—not just with the different recipes, but also with whether or not you want to size your support for the various photo processes.

EGG WHITE SIZE

Photographic historian Mark Osterman suggests this sizing solution. It is similar to the recipes that were used by photographers in the late nineteenth century.

1 egg

16 ounces distilled water

1. Separate the egg white and discard the yolk.

2. In a large bowl beat the white until well mixed (but not stiff). Add the water and stir the mixture well.

3. Filtering the mixture through a cheesecloth, pour it into a clean jar. It is now ready for use.

KNOX GELATIN SIZE (FORMULA 1)

This size is easy to make, particularly because Knox gelatin is readily found in most grocery stores.

½ teaspoon unflavored Knox gelatin

1 cup cool distilled water

1. Place gelatin in a pot, add the water, and transfer the pot to a hot plate.

2. Stirring constantly, heat the mixture (at 140° to 160°F) until the gelatin is dissolved (approximately 1 or 2 minutes).

3. Cool the solution to lukewarm; it is then ready for use.

KNOX GELATIN SIZE (FORMULA 2)

This version of the Knox gelatin size recipe works for any base support, although it works *especially* well to prepare paper for image transfers, as it brings out more intense colors and blacks. The gelatin thickens as it cools. Try to keep the mixture warm while using and only coat one piece of paper at a time as needed.

2 cups boiling distilled water

1 (¼-ounce) envelope unflavored Knox gelatin

3 drops Kodak Photo-Flo

1. Place water in a paper cup or glass and add gelatin. Mix well.

2. Add Photo-Flo.

3. Allow mixture to cool to 100° to 130°F; it is then ready for use.

GELATIN AND HARDENER SIZE

This recipe is adapted from the book *Silver Gelatin* by Martin Reed and Sarah Jones. Reed and Jones recommend using this particular sizing when making liquid emulsions. I have found that when using glass, metal, or any other slippery surface, this recipe works well because of the added hardener (chrome alum).

125ml distilled water

½g chrome alum

½g Photographers' Formulary gelatin, hard

1. Pour 100ml of the distilled water into a pot and heat it on a hot plate to 100°F.

2. Transfer 25ml of the hot water to a small glass container. Add the chrome alum and stir the 2% chrome alum solution until it is well dissolved. Set aside.

3. In a second glass container mix your gelatin solution by adding the remaining 75ml of hot water to the gelatin.

4. In a third glass container, mix 2ml of your 2% chrome alum solution into the gelatin. (The 2% chrome alum solution has a shelf life of only a few days, so unless you are going to make another batch of size immediately, the remaining solution should be discarded.)

5. Add enough room-temperature distilled water to the gelatin/chrome alum container to equal 100ml.

ARROWROOT STARCH SIZE

Photographers' Formulary usually includes a package of arrowroot starch as the sizing medium when you purchase one of their kits. Arrowroot starch size generates a slightly unpleasant odor as it is being made, but it goes away as it dries on the base support.

1 liter distilled water

1 (20-gram) package arrowroot starch

1. Pour the distilled water into a pot and heat it on a hot plate to 100°F.

2. Place the starch in a 1-liter saucepan.

3. Add about 20ml of the distilled water, transfer the saucepan to the hot plate, and keep it on low heat, stirring until the mixture is a thick cream. Mix until no lumps remain.

4. Add the remaining water, raise the heat, and stir constantly until the mixture boils.

5. Boil the mixture for 5 minutes, then remove it from the heat and allow it to cool to room temperature.

6. Skim off any scum. Pour only the clear solution into a storage container.

Viviane's View, 2001. *I captured the original image in 1986 with Kodak HIE 35mm infrared film. I made this tintype by printing the negative onto Kodak Ektalure G paper, hand painting it with oil paints and colored pencils, then copying this image using 4 x 5-inch color transparency film. I then prepared a 4 x 5-inch piece of metal by spraying it with matte black spray paint (which acts as a sizing), coating it with emulsion, and exposing it for 3 minutes using an enlarger light.*

Sizing Techniques

Deciding whether or not to size your base support is an important part of the photographic process. If sizing is required and is done properly, any unexposed sensitizer will lift easily out of the paper fibers and the image will sit on the surface and have good contrast and sharpness. Some base supports *must* be sized before they can be sensitized, but others shouldn't be sensitized at all. Sometimes you can only know by testing. For example, one of my students had a great-looking piece of rubber that was very smooth, so of course, we thought it would need to be sized. But after sizing the rubber, the liquid emulsion would not stick—instead it cracked, the image did not look sharp . . . everything that could go wrong went wrong. Instead of giving up, we decided to sensitize the rubber without sizing it. And it worked beautifully! But the reverse can also be true. I once brought home some beautiful papers from Guatemala. Some of the papers made wonderful images and others sucked the sensitizers right into the fibers. After sizing, the previously unsuccessful papers worked, but there was no way to know beforehand because they were all handmade papers and felt pretty similar. The moral of the story is that if you like a material, try everything. Eventually you'll find a way to make it work for you.

If you are using glass, Plexiglas, or metal as support, you will need to clean off the oily or waxy protective surface that is on these materials before it will accept a sizing solution. A number of cleansers can be used, including vinegar, rubbing alcohol, stop bath, or lighter fluid. After one of these solutions is used, the surface must then be washed with hot water and washing soda, as outlined in the pour method below.

Regardless of which method you use, you should allow the sizing to dry for at least 4 hours. The best-case scenario is to let the supports dry overnight. If done correctly, once a support is sized, you should be able to store it indefinitely and use it as needed.

POUR METHOD

This method is primarily used for eggs, glass, and Plexiglas, which are virtually the only materials that—without exception—need to be sized. It is important to adequately prepare your support before you apply the sizing. If it is not prepared properly, then the emulsion will have nothing to adhere to and will slide right off. Below are instructions for preparing and sizing your support.

1. Using washing soda, make a strong solution with hot water.

2. Scrub the support with the solution and then rinse it with warm tap water until the water no longer beads up on the support.

3. Pour the sizing over the support. Drain off the excess sizing and allow the support to dry for *at least 4 hours.* It will then be ready to be coated with sensitizer.

TRAY METHOD

In general, the tray method is favored for paper, as it creates a more even coating and less air bubbles than the brush method. Paper is much less predictable than glass—sometimes it needs to be sized, but not always. Again, experimentation is the key. There are many ways to apply sizing to paper and other base supports. Problems can occur if the sizing is not put onto your support in the correct way, so it is important to pay close attention as you are coating. If too much sizing is used, the sensitizer will not adhere properly; if too little sizing is applied, the sensitizer can sink too far into the fibers and will not wash out properly, making your image appear flat and soft (out of focus).

Whether you are using arrowroot starch or gelatin with or without chrome alum (hardener), the idea is the same. The sizing should be warm when you apply it and you want a thin, even coat. While many people have their favorite way of applying sizing, there is no perfect method. Try one and if it works for you, stick to it. If you are not happy with the results, try another technique.

Gelatin or arrowroot starch can be covered and stored in the refrigerator for a few days and can be liquefied by reheating. Repeated heating (or prolonged heating) will weaken the sizing solution, so keep this procedure down to one or two times and then discard the remaining sizing.

As with all of the chemical stages of alternative photographic processes, it is important to use a plastic tray that will be dedicated for sizing only.

1. Warm the tray by rinsing it with warm water for a few minutes, then wiping the water off with a paper towel. Placing the tray in a larger tray filled with hot water (which creates a double boiler) is also a good way to keep the gelatin warm.

2. Pour the warm sizing into the warmed tray, then place each sheet of paper (or other base support) into the solution, one at a time. (I have sized as many as 20 sheets of paper at a time.)

3. Leaf through the supports, turning each piece over at least once to be sure that both sides are covered and there are no air bubbles sticking to the surface. You can wipe off any air bubbles you may see.

4. After about 10 minutes, and starting with the first sheet that was placed in the gelatin, carefully draw the *front* side of each sheet over the edge of the tray to remove excess gelatin and air bubbles. (Judy Seigel, the editor and publisher of *The World Journal of Post-Factory Photography,* suggests getting someone to help you at this stage and having them hold a plastic rod over the edge of the tray while you pull the paper in between the tray and the rod. This method allows the paper to be squeegeed on both surfaces.)

5. Place the *back* side of the support on a flat surface (such as plate glass) and squeegee the front side with a plastic rod (a Plexiglas shower curtain rod works well). It is important only to

squeegee the front side because as you lift the support up from the flat surface, some gelatin will lift off unevenly and you want the front to be as even as possible.

6. If you are sizing paper or something that can hang, hang the sheets by two corners to dry, using clothespins, so the support hangs straight down. Do not stack the supports together, as they will lift off the sizing unevenly from each other. Be careful when handling damp sheets because a buckle will cause a permanent wrinkle in the paper.

BRUSH METHOD

In general, the brush method is preferred if you're working with glass, Plexiglas, wood, tile, and rubber, though it can generate interesting effects with paper, too. The basic factors that were discussed in the introduction to the tray method apply to the brush method. The major differences between these two techniques are the effects that are created—the tray method creates a more even surface, while the brush method creates a more textured surface.

Prepare and store your size as described above, then apply it using the following process.

1. If possible, tape the base support to a piece of plate glass so that you have a smooth surface on which to work.

2. Lightly dampen a foam brush with distilled water.

3. Apply the sizing to the surface by brushing first across, then up and down, until the base support is completely wet.

4. Using another brush, work at the surface until it loses its gloss.

5. Allow the support to dry by hanging it (as described above in the tray method section) or by keeping it taped to the glass.

6. If you are sizing a heavy piece of wood or tile, allow it to sit until it is completely dry. Do not stack it.

SENSITIZING TECHNIQUES

Hand-coating your paper with sensitizers is a fundamental part of alternative photo processes. There are many different coating techniques. The three most common involve using a tray, a brush, or a glass rod. Everyone has his or her favorite way of coating. Your coating technique will become a trademark of sorts, as each technique has a different look. For instance, if you use a glass rod and tape your edges, the image area will be very neat; however, if you use a brush and don't tape your edges, brush strokes may be visible throughout your image area. Sometimes it is advisable to coat the support with two applications of sensitizer—though if that is desired, the support should be allowed to dry fully in between coatings.

TRAY METHOD

This method can be used for a range of (flat) support materials, including paper, fabric, glass, and Plexiglas. Using a tray to coat

your support requires the most sensitizer of the three techniques. The support material will be covered with sensitizer and the look will be very even. For example, if you were doing this technique when making a cyanotype on a white sheet of paper, the paper would look blue (where there was no negative) instead of white. This plays an important role in choosing what size your support should be. You will not have a border, as you would with the other coating techniques, but you might want to leave extra room around the edges of your negative area in case you contaminate them with your fingers or get marks when the paper is hanging to dry.

These are the basic steps for applying your sensitizer with a tray:

1. Pour your sensitizer into a plastic tray.

2. Carefully place your support into the sensitizer and slowly rock the tray back and forth, making sure that the support is totally submerged.

3. Agitate the tray continuously for about 2 minutes.

4. Lift the support out of the tray and drain the excess off each of the four corners. Remember, no matter what technique you are using, you should always wear gloves when you are handling your support.

Before exposing your support, allow it to fully dry. (*See* Drying Techniques, page 29.) If you are working with fabric, submerge the material into a tray (or a bucket, if your support is large) that is filled with the working solution. While this uses up a lot more sensitizer, it will evenly coat the fabric on both sides.

GLASS ROD METHOD

This method is best suited for paper. Working with a rod uses the least amount of sensitizer of the three processes described here. You can use about 5% less sensitizer on your image area than you would use with a brush. Also, the glass rod method ensures an even, uniform coating, while the brush method occasionally produces thinner areas (where the sensitizer wasn't adequately applied). If you like the brush strokes at the edges of your image area, you can add them when you are finished coating, by taking a brush and coating out from the edge a few inches.

You can purchase glass rods at any of the alternative chemical stores listed in the source list. There is no absolute correct design—as long as the rod is straight, with no flaws (no bumps in the glass). It also does not matter how you hold onto it as long as it is comfortable in your hands. The rod shown on page 12 (from Jon Edwards) looks like a squeegee, but there are others that have handles on both ends of the rod. I personally like the squeegee-type rod, as I feel like I have a good grip and more control than I do with rods with handles. While it takes practice to learn to coat well with a rod, once you learn, you will not forget how to do it. The length of the rod determines the width of the coated area.

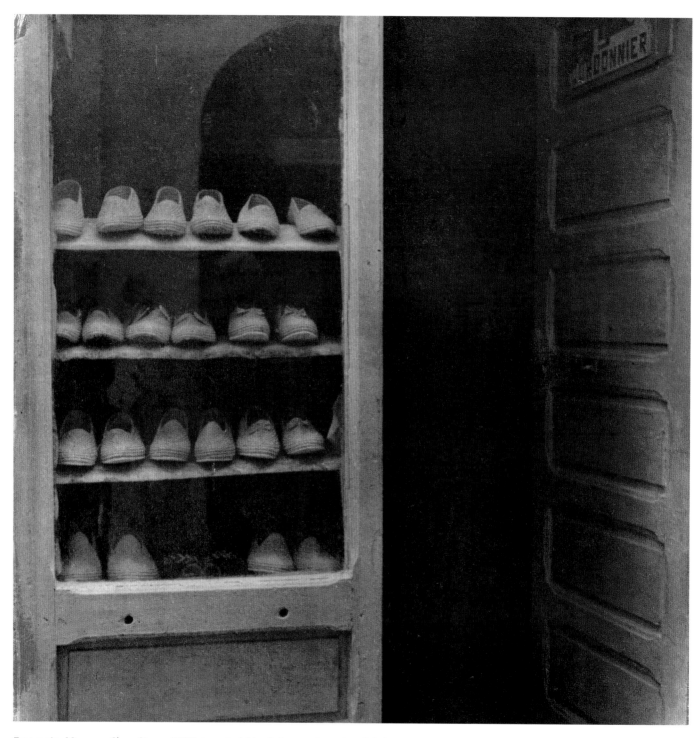

Essaouria, Morocco Shoe Store, 1999. *I wanted this platinum print to be slightly warmer than could be achieved by using pure platinum sensitizer, so I used a combination of 16 drops platinum and 8 drops palladium. I applied the sensitizer using the glass rod method, which created the clean edges. This was a slightly flat negative, and I exposed it for 5 minutes. A cyanotype of this image, which was sensitized using the brush method, can be seen on page 83.*

These are the basic steps for applying your sensitizer with a glass rod:

1. Your support should be larger than your image area. The margin serves both as a border and as a place to handle the paper without contaminating the image area.

2. Using drafting tape, adhere your support to a piece of glass or other flat surface.

3. With pencil, mark your support where you will place your negative. This will be considered your "image area."

4. Always clean the rod with a cotton rag or lintless tissue before starting the coating process.

5. Holding the rod with one hand, place it just above the image area. Fill a syringe with sensitizer; then, gently squeezing it, allow the liquid to flow out onto the support at the top of the image area.

6. With light pressure draw the rod down into the solution, allowing the sensitizer to adhere to the rod (this might take a few seconds). Then, using very light pressure, steadily draw the wetted rod down to the end of your image area. (*See* image on page 96.)

7. When you get to the bottom, quickly run the rod back up to the top of the image area.

8. Repeat the down-and-up motion four or five times to make sure that you have an even coating and that all the sensitizer that you first put down on your support is absorbed. The first two passes should be made quickly to ensure complete coverage, and the last two or three should be made as slowly as possible (about 10 seconds each) to allow maximum absorption.

9. During the final pass lift the rod slowly off the paper and wipe off any excess sensitizer from the support with a lintless paper towel or blotting paper.

Before exposing your support, allow it to dry fully. (*See* Drying Techniques, page 29.)

BRUSH METHOD
This method is frequently used for paper and fabric; however, it can also be used for most other possible supports, including rubber, tile, wood, metal, and glass/Plexiglas. Using the brush technique to coat your paper wastes a bit of sensitizer, but it creates a distinctive "painterly" look. Photographers who use this technique are generally very fussy about their brushes; many find that each process warrants its own type of brush. Even if you don't use a different *kind* of brush for each process, you should use different brushes to avoid contamination. Make sure to label your brushes well so that you do not mix them up, as this can cause problems. (For example, using your platinum brush to make a cyanotype and then using it again to make a platinum print will contaminate the brush, the support, and the sensitizers.) Also, be sure not to take your brush out of the dark-

room while you're working, as this can expose the sensitizer on the brush, which will cause streaking to appear on your support. Always wash your brush out thoroughly with hot water between uses.

Here are some of the most common kinds of brushes that are used:

Foam Brushes Foam brushes come in a range of sizes—from 1/4 inch to 2 inches wide. They work well, are cheap, and are readily available at house paint and hardware stores. Make sure to use foam brushes with *wooden* handles, as the plastic-handled ones do not have as much foam and can easily scratch your support.

Bristle Brushes Never use a brush with a metal rim for alternative processes unless you have prepared it first by blocking the metal. Otherwise the brush will become contaminated as the metal starts to oxidize and leak down the bristles. To block the metal, coat it two or three times with clear nail polish. Let the polish dry completely before using the brush. It is not worth buying cheap bristle brushes from a paint store because the bristles tend to fall off and stick to the sensitizers. Good brushes are worth the extra money. Go to an art-supply store and spend time feeling the different textures of the brushes. Some are softer, harder, larger, smaller, etc. It really is a subjective choice. Buy two or three different kinds and try them out.

Japanese Hake Brushes These are especially popular for making platinum prints because they are soft and do not soak up a lot of the expensive sensitizer.

Below are the basic steps for applying your sensitizer with a brush:

1. Your support should be larger than your image area. The margin serves both as a border and as a place to handle the support without contaminating the image area.

2. If possible, adhere your support to a piece of glass or other flat surface with drafting tape.

3. Mark the four edges of the area you want to coat with a light, small pencil mark. Sometimes I like to overcoat the image area by about 1 inch to show the negative edge, so I will make my pencil marks accordingly. Other times I like to coat inside the negative edge so that the image ends before the brush strokes, making the brush strokes an important part of the end product. If you want your edges to be very neat, you can use drafting tape to mark off the area you are going to coat. The drafting tape will not rip the base support as long as you take the tape off *after* the sensitizer has dried. However, to make sure it will come off the support easily, remove the tape before exposing it to the ultraviolet light.

4. Dip your brush into distilled water and almost completely dry it off again. This not only ensures that your brush is clean, but being slightly damp stops it from soaking up excess sensitizer.

San Pedro La Laguna, Guatemala, Saint Day Festival, 1998. *I used an old bottle of Silverprint liquid emulsion on Fabriano Artistico 140-lb cold-pressed watercolor paper. It turned colors in unpredictable ways that I liked and so I kept using it. I used a bristle brush to coat this paper. I wanted the brush strokes to show throughout the image and along the borders. If I had used a foam brush, the coating would have been much smoother than I would have liked.*

5. Dip your brush in the bowl or glass that is holding the sensitizer, then push it against the side to allow the excess to drain off.

6. Begin coating your support by placing your brush at the top of your image area and working downward. Brush first horizontally and then vertically to cover your image area evenly with the sensitizer. You might have to redip your brush into the sensitizer at some point as you are coating. As you practice, you will sense when your brush is too dry, but this is really a matter of choice. Some people like putting very little sensitizer down (using a dry brush) on the supports so that more brush strokes show and their image is more abstract, while others like to have a large amount of sensitizer on their brush to get an even coating of the sensitizer. There are no rules. It is a matter of choice and discretion as to how you want your end image to look. However, brushing more than necessary may cause streaks and will abrade the surface of the support.

The steps are slightly different if you are working with fabric:

1. Lay your pieces of fabric on top of each other.

2. Using a brush, coat the top piece of fabric. As you coat, the sensitizer will soak through onto the next piece.

3. Remove the top piece and recoat the next one to make sure that it is coated evenly.

4. Continue until all of your pieces are coated.

Before exposing your support, allow it to dry fully.

DRYING TECHNIQUES

Drying techniques come into play at two stages—first, after you have sensitized your support and second, after you have exposed, developed, and washed your finished print. Drying your sensitized support is almost as important as applying the sensitizer. If the support is not dried correctly, you can get burn marks (which show up as discolored areas) on your final image or the sensitizer can puddle in different places on a support and crack off once developed. It is also important to be aware of the light sensitivity of the particular sensitizer that you are using and adjust your light source accordingly.

One way to dry your sensitized support is to use a hair dryer. It is best to let the support air dry in total darkness for up to 10 minutes before accelerating the drying process with the hair dryer. (If you have used the tray method to apply your sensitizer, you should allow your support to air dry for 1 hour.) When you do use the dryer, always use the "cool" setting and move the dryer back and forth over the support so that you do not burn it. If you want to check to see if the sensitizer is fully dry, try not to touch the coating with your fingers. Instead, if you are using paper, feel the back of it; if it is cool, the paper is dry. If you are using another material, then you will have to touch the edges (with gloves on) to double-check for dryness.

If you do not want to use a hair dryer, place your support, sensitizer up, in a dark closet for a few hours. Do not stack your supports if the sensitizer is still wet, as they will stick together and lift off sensitizer from one support to another. Supports with moist sensitizer will ruin your negative, so make certain that the sensitizer is fully dry before exposing your negative.

If you are using fabric as your base support, you might want to use a combination of these methods. First, lay your fabric onto a piece of Plexiglas, keeping it flat and in place with clothespins or drafting tape. Let your fabric air dry (or use a fan) for about 1 hour, preferably in total darkness, then use the hair dryer. Not using the hair dryer immediately will help stop streaking.

Whichever materials and drying method you choose, try not to sensitize your support during very hot or humid weather, as fogging can take place during the drying process. It is also worth noting that thinner papers sometimes curl. To prevent the images from curling, tape the paper down with drafting tape to a piece of glass, Plexiglas, or screen. Apply the sensitizer and allow the paper to dry naturally on the stiff surface. Once the paper is dry, you can remove it from the backing and it will stay pretty flat.

After exposing, developing, and washing, your finished prints can be dried in a number of ways. If you have used paper (or smaller pieces or fabric) as your support, the images can either be hung to dry, pressed in a blotter book, or placed on screens. However, if you use screens, *do not* put your prints face down or they will develop screen marks (as all of these sensitizers are very soft until they are fully dry). Larger pieces of fabric can be laid flat on a table and left to air dry.

Italy Doorway with Olive Jug, 1999. *I made this cyanotype print by exposing it for 20 minutes. I then used the wrong tray to wash the print, putting it into a tray that had been used to print Van Dyke brown prints. This is a great example of why you should separate your trays and mark them with the name of each chemical that they should be used for. This cyanotype was contaminated so it looks as if I toned it.*

Maine Beach, 1996. *I took this image with a pinhole camera using Polaroid type 55 positive/negative film. I found that the best result came from using an overexposed cyanotype (exposed about 20 minutes). I washed the print well, then dried it, coated it with a diluted Van Dyke brown sensitizer (1:1, using distilled water), and underexposed it (about 2 minutes). The paper is Arches Platine 310-g hot-pressed paper, which is specifically made for platinum and other printing techniques. A straight cyanotype version of this image can be seen on page 78.*

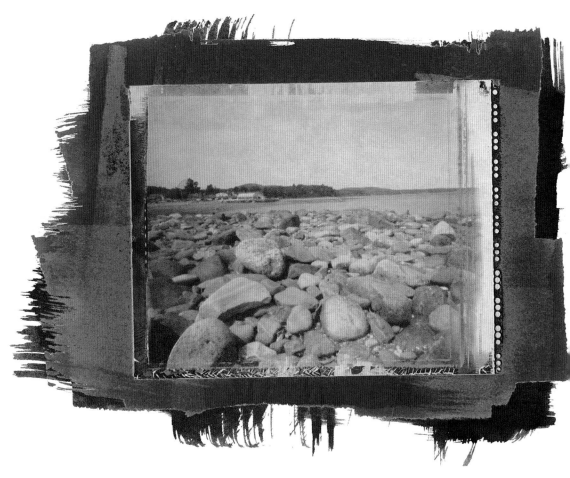

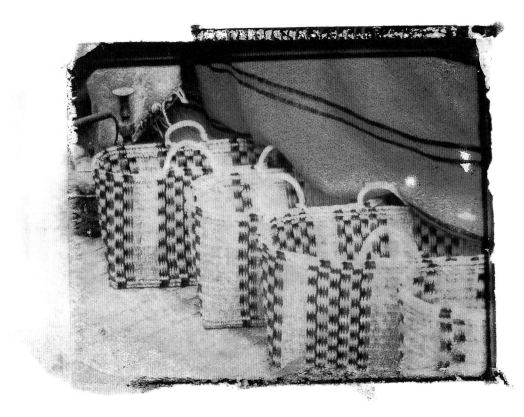

Moroccan Bags, 1999. *I hand painted this Polaroid transfer image to create more color saturation in certain areas throughout the image. By using a cold-pressed paper (Fabriano Artistico), I was able to adapt the texture of the paper to enhance the image.*

MIXING YOUR TECHNIQUES

I always tell my students that they should never throw anything away because there is always experimenting to be done. Though you sometimes get mixed results, it is really fun to combine processes to complete an image. Technique mixing is generally achieved by either reregistering the same negative or using a different negative to create a second (or third or fourth) exposure with a different process. However, if you are working with paper that you intended to use just one time and are now deciding to use for a second process, the exact registration of the negative for the second exposure may not be possible; since the paper has gone through water and has probably shrunk, the registration may be off slightly. Rather than viewing this as a hindrance, you can use this to your benefit to make interesting images.

If you know beforehand that you want to experiment with using different processes, I recommend two things. First, size the paper before you get started. Second, keep notes as you work. I tend to start playing around in the darkroom and forget what I have done and then cannot always repeat it. It was a big help during the making of this book to have an assistant with me to write down what I was doing, but that is not always an option, so keep a pencil and paper handy. Some people find it easier to use a miniature tape recorder to keep track of what they are doing.

Van Dyke brown and cyanotype sensitizer can be combined to create beautiful tones (as can be seen on the facing page). You will get a different effect depending on which process you expose first. We found that starting with an underexposed cyanotype and then using Van Dyke brown sensitizer creates a look that is very similar to a cyanotype that has been toned with tannic acid/sodium carbonate. However, if you dilute the Van Dyke brown solution 1:1 with distilled water, you might get some unique results. A few of the prints we experimented with had a deeper brown than you would normally get from just one exposure of a Van Dyke brown print, similar to what you get when doing two exposures in the ultraviolet box using the same process.

It is also possible to start with Van Dyke brown prints and then apply cyanotype chemistry. We found that the potassium ferricyanide in the cyanotype bleaches out the silver in the Van Dyke brown. However, if you use a small brush and selectively apply cyanotype sensitizer on top of an overexposed Van Dyke brown, the prints can really be beautiful.

Mixing cyanotype and palladium or platinum sensitizers can also be interesting. Again, the strength of the sensitizer and the length of the exposures play an important role in the final look of the image. Putting palladium sensitizer on top of a normal cyanotype print takes most of the cyanotype off. However, putting palladium sensitizer on top of an *overexposed* cyanotype leaves a little bit of blue (much like the Van Dyke brown/cyanotype print) and can be very beautiful. Using diluted cyanotype sensitizer on top of a slightly dark palladium print can leave just enough blue in the shadows to be worth the experimenting time.

It is also possible to create layered effects with liquid emulsion prints, though getting a satisfactory result can require a lot of experimenting, as the chemicals for the nonsilver techniques bleach liquid emulsion prints. This bleaching effect can be interesting, if you learn to control it by coating selectively. Alternatively, you can try applying liquid emulsion on top of the nonsilver processes.

You can also experiment with interpositives and internegatives, for instance, using both pieces of film to make one image. Try using the negative first with Van Dyke brown sensitizer and then, for the second exposure, using the positive with slightly diluted cyanotype sensitizer. Then try another print using the positive first and the negative second. You can also use different negatives on top of each other or next to each other.

When you're experimenting, don't forget about the computer. If you are using multiple images, think about putting your prints through an Epson ink jet printer. A student of mine just showed me a beautiful book he did by painting white paint onto black paper and putting an ink jet image on top of the painted area. There is no reason why you cannot do this with any of the processes that we are talking about. Do a test first to see where the image lines up and start combining techniques that span two centuries of art.

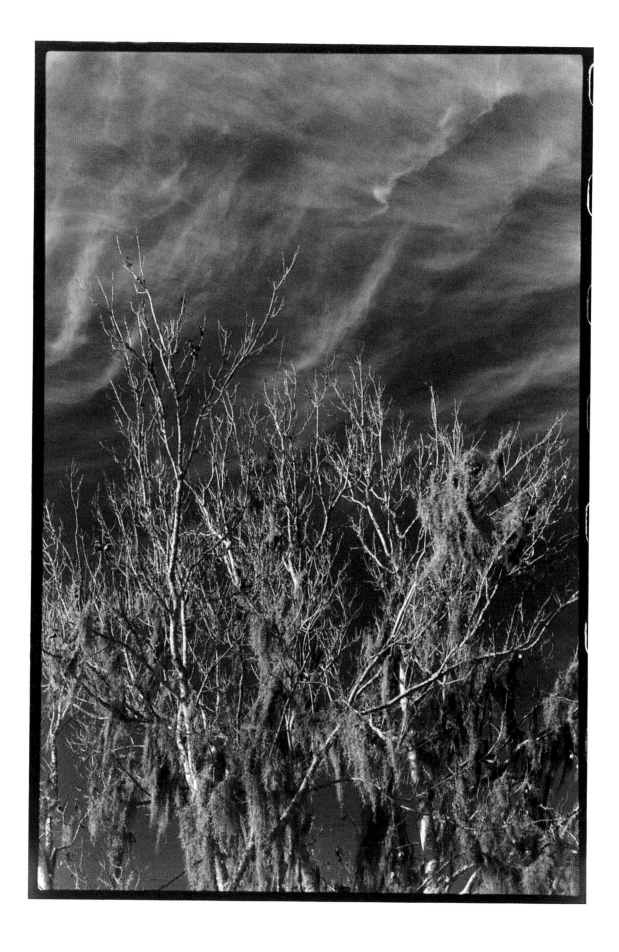

CHAPTER THREE

BLACK-AND-WHITE INFRARED FILM

SOME PEOPLE SHY AWAY from using infrared film because they think it is too finicky, but working successfully with infrared film is really just a matter of practice and planning. After you learn a few tricks, it is as easy to use as any other film. The first two tricks relate to handling the film; some infrared films need to be kept cool and must be loaded and unloaded in total darkness. However, the main trick involves exposing the film; when most photographers are putting their cameras down during the midday sun, infrared photographers are just getting started.

Infrared radiation is not visible to our eyes, and this in itself can be very exciting. I have been shooting infrared film since 1974 and I still get at least one surprise with each roll. Make sure to keep notes so that you will be able to repeat any results that you find appealing. A small amount of scientific explanation is needed—but do not let this scare you off. This may sound complicated, but the film is really easy to use.

The term infrared means "beyond the red" and refers to the position of infrared on a chart called the electromagnetic spectrum. Wavelengths in the *visible* portion of the electromagnetic spectrum range from about 400 nanometers (nm) at the violet end to about 700nm at the red end. Infrared extends from the limit of visible light. The longest wavelength of radiation recorded by photography is about 1350nm, but the most common applications of infrared photography deal with the region between 700nm and 900nm.

According to John Edward Wilcox's 1938 article in *Popular Photography*, Sir John Herschel, a British astronomer and physical scientist, first noticed the effects of infrared rays on sensitized plates in 1839. Herschel noticed that an exposed but undeveloped negative was weakened by exposure to infrared rays. It would be another 80 years before film companies would incorporate cyanine dyes into the emulsion of black-and-white and color slide films to record infrared rays. Even then, infrared film was mainly used for scientific purposes; however, a few photographers used it because they liked the ethereal affects. The film seemed to gain popularity in the 1970s and is widely used today in both the art and commercial realms of photography. Most recently, photographers have been experimenting with digital cameras to mimic the look of infrared film.

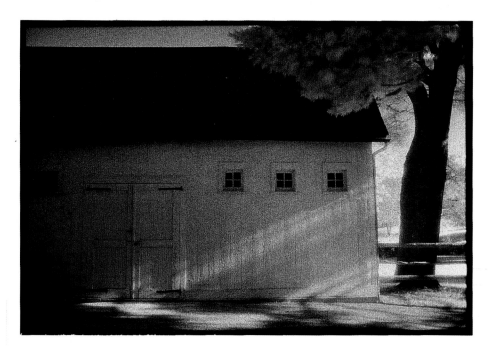

Connecticut Barn, 1986. *I created this image using Kodak film and a #25 red filter. While the tree did not record white, its leaves are very soft and the area behind it (where the sun was shining) did stay white. The shadow on the barn is more enhanced than it would be on normal film and the barn roof is blacker. All of these points are what attracted me to the combination of the film and scene.*

Opposite page:
Louisiana Bayou, 1999. *I used Cachet film and a #25 red filter to capture this image. I was on a boat. The light was beautiful. It was late in the day, but I noticed the sky and decided to take a chance—both with infrared film and with the very low shutter speed that the shot required. Cachet tends to be slightly grainier than Ilford and Konica, but less so than Kodak.*

CAPTURING YOUR IMAGE

Tonal gradations that are recorded on infrared film differ from what is recorded on panchromatic film, which is more sensitive to the short wavelengths (bluish colors) than to long wavelengths (reddish colors). This is why infrared film is grainier than regular black-and-white film and why it records closer to the white end of the gray scale rather than the darker, blacker end. This is also why people are attracted to the soft, ethereal quality of the film. Infrared film is a black-and-white film with special qualities. The latitude of regular black-and-white film is more forgiving than infrared film. A slight change of metering or focus can create a final print that is very different from what you originally intended. When using infrared film you are opening yourself up to experimenting more and more and surprising yourself with every click of the shutter. This next section covers a number of suggestions, providing a jumping-off point from which you can feel free to explore.

GETTING STARTED

If you already have the standard equipment to shoot black-and-white or color film, then you'll need very little extra equipment to start using infrared film. A black bag is needed to prevent fog-ging and many different filters can be used for different effects, but your regular camera and lens will work for infrared and any environment will lend itself to infrared interpretation. The best thing about infrared film is that you can never be sure of what you will get. A soft, ethereal, dreamlike image can be obtained by slightly overexposing your negative; water will appear either light or dark, depending on the objects that reflect off the water's surface; the sky on a sunny day can photograph almost black, because there is very little radiation present in the sky. If you follow the advice in this chapter, you will see great results with your first roll of film.

CHANGING BAG

While Konica, Ilford, and color infrared films can be loaded and unloaded in subdued light, both Kodak and Cachet black-and-white infrared films need to be loaded and unloaded from your camera in total darkness. A black changing bag can be bought at any camera store and used as a portable darkroom. A good-quality changing bag consists of two layers of black bags, one of which zips inside the other. These bags are opaque and should be safe for infrared film. Do a test with your new bag: If the armholes are too big for you, there may be a slight light leak, which will

TRAVELING WITH INFRARED FILM

With X-ray machines getting stronger, it has been recommended that you not put any kind of film into your suitcases but carry everything on the plane with you. Infrared film seems to be much less sensitive than panchromatic film to X-rays, but I still try to get my infrared film hand-checked. Of course, this isn't always possible (especially with the new changes in airport security). I have had my film taken from me many times and thrown through the X-ray machines, as the security person smiles. Try not to let anyone take your film into another room, however. On one occasion a security person took my film into a back room and began to open the canisters. This would be fine with a panchromatic film, but he fogged a few rolls of my infrared film before I could stop him.

While certain things are out of your control when you travel, there are some precautions that you can take to preserve your film. For instance, I mark my infrared film so that I know how many X-ray machines it has gone through and try not to exceed eight passings. Sometimes simply navigating through an airport in an aware manner can make a difference. For example, if you travel through Rome and have to switch planes in the Fiumicino airport, go outside the terminal or you will pass through what seems to be hundreds of X-ray checkpoints!

Once I arrive at my destination, I check out the hotel restaurant situation. I ask if my film can be left in their freezer every night and explain that I need to have access to the film in the mornings. Each morning I try to estimate how many rolls I need for the day's shooting and then grab a few extra (just in case), putting the rest back in their freezer. I make sure that my bag is marked well with my name and room number so that if I do not know the person working at the time I come in or there is a language barrier, I can show them my name on the bag and prove that it is mine.

I always travel with a climate-controlled container and use this to carry my film with me for my day trips. If I am in a particularly hot climate, I put cold packs in with my film during the day. I also use zip-lock bags to separate exposed film by area or date. This is really a filing system—you need to come up with what works for you. I mark each container as to when I shot it and the date and tape it up so the lids do not come off from handling or change in temperature.

Don't worry if you are not able to follow each one of these guidelines precisely. Over the years I have realized that infrared film is much sturdier than anyone gives it credit!

Gainesville, Florida Porch, 1979. *I shot the above image (using Kodak film and a #25 red filter) near high noon, which to me is the best time to photograph with infrared film, and processed it with D-19 developer. I particularly love old houses that look as if they are about to fall apart. Capturing them on film is my way of preserving them. The infrared glow (white foliage) surrounds the house, giving it a much grander feel than if it was on color film.*

Antique Store Chairs, 1979. *I stepped into this antique store in rural Florida on an extremely hot summer afternoon thinking that I could cool off. It was just as hot inside as it was outside, but the place was dark and dusty. The translucent plastic over the dark table and chairs defined the feeling that I had being in the store. As with the image above, I made this image using Kodak film and a #25 red filter and then processed it with D-19 developer for a contrasty look.*

cause your film to fog. Your film might also fog if you take your arms in and out of the bag as you are loading and unloading the film.

CHEMICALS

The chemicals required to process infrared film are identical to those required for ordinary black-and-white prints.

FILM

A number of companies manufacture black-and-white infrared film. As each of these films will give you a different result, you might want to spend a few days (under various weather conditions) trying them all and deciding which type of film is best for your way of seeing. Films that are more sensitive to infrared radiation (such as Kodak) will generate a more pronounced infrared effect in your image. For example, the foliage will record whiter and the skies will be darker; the glow around a person's body or around shiny objects will also be more pronounced. Kodak and Cachet films also have to be handled a little differently than other films; to avoid fogging it is important to use a black changing bag when loading and unloading these films.

Cachet Cachet Macophot IR 820c film captures images at 820nm and is available in 35mm, 2¼-inch, and 4 x 5-inch formats.

Ilford SFX 200 film captures images at 720nm and is available in 35mm and 2¼-inch formats.

Kodak HIE high-speed infrared film captures images at 900nm and is readily available in 35mm and 70mm formats; 4 x 5-inch film has been discontinued but can be found through some suppliers.

Konica Infrared IR 750 film captures images at 750nm and is available in 35mm and 2¼-inch formats.

Kodak, Konica, Ilford, and Cachet (not shown) all make infrared films that can be used with red, orange, yellow, or polarizing filters. Only the Kodak and Cachet films need to be changed in the light-tight black changing bag.

FILTERS

Because infrared film records both visual light (green, blue, violet, and ultraviolet) and infrared, some filtering is needed to get true infrared results. There are a lot of options depending on what you want your end result to look like—from polarizing to deep yellow to dark red filters. The standard range of filters includes #12 (deep yellow), #15 (yellow), #16 (yellow-orange), #21 (orange), #22 (deep orange), #25 (red), and #87 and #89 (dark red).

FOCUSING

Some people use infrared film and wonder why their images are out of focus. It is true that infrared film generates images with less definition than normal film does. However, the real problem is usually that the photographer has not taken into account that we cannot *see* infrared radiation and therefore he or she may not have accurately focused. Some photographers suggest that you adjust your focusing length when shooting with infrared film because the general rule for visible light is that red focuses behind the film plane and blue focuses in front of the film plane. In other words, for red you need to focus closer and for blue you need to focus further away.

I personally do not adjust my focus no matter what lens I use. I try to shoot using an aperture between f/8 and f/22 and adjust my shutter speed accordingly. Some people suggest not having your lens opened up all the way or closed down all the way. I have never had a problem when closing down, but have had out-of-focus pictures when opened up more than f/8.

If you are new to infrared film, experiment with focusing before you start. Pick a subject. Take your first picture without adjusting your focus. Then shoot the same scene again following the instructions below. Most lenses have a red dot or "R" on the depth-of-field ring (which is between your focus and f-stop rings). This is the infrared adjustment mark. It works like this:

1. Focus your camera.

2. Look to see how many feet away from your subject you are.

3. Rotate the focusing ring until the distance noted at the normal focusing point aligns with the red dot. (The image may look out of focus in the viewfinder, but it will look sharp on the infrared film.)

4. Take your picture.

Wide-angle lenses have greater depth of field than standard lenses, so you may not need to correct your focusing. However, if you are using a longer lens, this system might improve your focus. Many zoom lenses do not have the red dot. In this case, test your lens by taking several frames of one scene, focusing on different areas. Take notes as to how many feet away you are focusing and study the developed film. This will enable you to know the best focusing distance for your focal length.

METERING

Most literature states that you cannot use your through-the-lens meter because, by design, the meter reads only the visible spectrum of light. Some suggest that in bright sunlight you can use a shutter speed of 1/125 second at f/16 and then bracket your exposures over and under by two stops. Once again, I do not follow the rules. I meter through the lens and filter, bracketing when photographing in a new environment. (The amount of infrared in a given place is affected by time of day, cloud cover, temperature, and geography, so I never take chances on missing a shot.)

If you are using a hand-held meter, remember to open up your lens to compensate for your filter. For example, the #25 filter has a two- to three-stop increase, depending on the manufacturer of the filter. So if your hand-held meter tells you to shoot at f/16 at 1/125 second, adjust your exposure and shoot at f/8 at 1/125 second. Each filter has its own filter factor, so make sure you check the information sheets for your filters.

The newer cameras have excellent meters. However, if you have an older model, try to think of some tricks used in Photo 101. I have a relaxed method for the zone system. Meter from the highlight area and check your exposure, then meter in the shadow area. Decide which part of the scene you are more interested in, go closer to that as your exposure, and then bracket. For example, take a subject whose highlight reads f/22 at 1/125 second and whose shadow reads f/5.6 at 1/125 second. Since I want the highlight area to have the most detail and do not really care if the shadow area goes a little dark, my final exposure would be f/16 at 1/125 second. This way I have brought the two areas closer by one stop and will usually be able to get a little detail into the darker areas. I then bracket one stop over and one stop under from that point.

EXPOSING

Every article will suggest a new starting point ISO for infrared film. For Kodak film, I have read recommendations that range from ISO 50 to ISO 500. However, I suggest starting with ISO 200 and a #25 filter. Konica film is slower, so you might want to start with ISO 50. Cachet film is rated at ISO 100. Ilford film is ISO 200, but can be pushed to 800. Simply pick an ISO and bracket. The more you shoot, the more you will realize what is best for you and your equipment. But remember, the higher your ISO, the more grain your image will have.

Studio light is different from daylight. Again, the key is to do tests. Try Kodak at ISO 50 with strobes; try Konica at ISO 32. Tungsten light should create the same effects as daylight. One of my students uses ISO 400, no filters, studio lights, and develops normally with D-76 straight; another exposes the same (ISO 400, no filters) but prefers to use Xtol developer and loves it. This is a subjective art.

USING FILTERS

The filter favored by many photographers who shoot with infrared film is the red #25 filter, which blocks out most of the blue light. If you go lighter (i.e., toward yellow), more colors will be recorded on the film and a less pronounced infrared look will be achieved. A dark red filter (such as a #87) will be visually opaque and does not allow anything to be recorded except for infrared radiation. Because you cannot see through an opaque filter, it is best to use the square gelatin filters instead of the screw-on type. This will enable you to remove the filters to adjust your focus and take a meter reading. Then you can put the filter back in front of your lens and remember to adjust your meter reading for the filter factor (check the paper that came with your filter to know what the filter factor is).

Another suggestion is to use a polarizing filter along with the colored filters. Infrared film can penetrate through haze and the polarizer helps make this be an even more prominent feature. Ultimately, however, the choice as to what to use is up to you. I suggest taking one roll of film and using several filters. Look at the results to see which you prefer. There is no right answer. It is all personal taste. Remember that the fun is in the surprise.

USING A FLASH

Using infrared film to photograph at night can be a lot of fun. If you use a #87 filter on your flash, there will be a slight glow when you take a picture but no real "flash." People really cannot tell when the picture is taken. You do not need to have a filter over both the lens and the flash; only one light source needs to be filtered. Most people filter the flash so that they can take pictures without being noticed and so that they can more easily focus in low-light situations.

You need to do a test for each flash, filter, lens, and camera. A good starting point can be ISO 50 (remember, the filter is slowing the film speed) at f/8 to f/11 for medium distance. Some flash units come with a separate head specifically made for infrared film, but you can also buy a #87 4 x 5-inch gel, cut it down, and use black tape it affix it to your flash.

PROCESSING YOUR FILM

There is no real difference between developing black-and-white film such as Tri-X and developing black-and-white infrared film except that you need to be more careful because infrared is more sensitive and some things show up on it more than on other black-and-white films. For instance, uneven development, which can be seen in highlight areas near the sprocket holes of the film, does not show on Tri-X as readily as it does on infrared film. But in general the process is the same. In addition, a lot of labs now develop infrared film. The cost is generally only slightly higher than for normal black-and-white film. For those of you who like to do it yourself, read on.

GETTING STARTED

To get started developing at home you will need a setup exactly like a regular black-and-white darkroom except for one thing—if you have hollow (instead of solid wood or metal) doors, you will need to hang blackout curtains on them to stop the infrared radiation that can penetrate through nonsolid materials and fog your film while you are rolling it onto a reel. This seems odd, doesn't it? But it is true, and a simple blackout curtain (or a few heavy-duty black garbage bags) hung in front of your door can solve the problem without your having to buy and install a new door.

Once you have settled the door issue, you can use everything you might already have in your black-and-white darkroom. Make sure you have the proper setup. This includes containers (dark brown, plastic bottles) for the liquid chemicals, which include developer, stop, fixer, hypo clearing agent (or perma wash), and Photo-Flo. Decide whether you want to use plastic or metal developing tanks; be sure that your reels are in good shape so that you do not crimp your film. I usually work with a two-reel metal tank and two Hewes reels. (I find these very easy to use, unlike the reels I learned on many years ago.) Some other necessities include a good working thermometer specifically made for the darkroom, a darkroom timer, enough plastic graduates for each chemical, a clothesline, and a few clothespins to hang your film to dry.

DEVELOPER

Regular black-and-white film developer can be used to process infrared film. There are several different kinds from which to choose. Since each will give you slightly different results, you might want to experiment. Stephen Anchell's book *The Darkroom Cookbook* lists fifty-one different developers—all of which you can make from scratch! Do you need to try them all? I suggest picking one or two off-the-shelf developers, developing your film, and making several large prints. Compare the grain structure as well as the detail in your highlights and shadow areas and see which you prefer. Then stick with that developer. The most commonly used developers for infrared film are listed

below, along with a brief description of what you can expect when you use them.

D-19 This is a high-contrast developer primarily used for scientific purposes; it causes the grain of the infrared film to be larger than it is with other developers.

D-76 This has been considered a good general-purpose developer for years. It helps to maintain moderately fine grain and a good development latitude. The combination of this developer and infrared film will give you very white highlights, which I feel enhances the infrared quality.

HC-110 This is similar to D-76 but comes in a concentrated liquid form instead of powder, which some people prefer. It uses shorter developing times than most other developers.

Xtol This is said to produce more shadow detail than some of the other developers, but some say that it causes the film to look a little flat, with the whites not being as white as they can be with D-76.

Agfa Rodinal This is a liquid developer that gives a good tonal range and nice grain. The highlight areas with infrared film will not be quite as bright with this developer as they are with D-76, and some people think this makes it easier to print.

I cannot repeat often enough that choosing your developer is a matter of taste. There is no such thing as one correct developer. All of them will work and give you printable negatives. Below are a number of examples for the estimated developing times, listed according to film category. However, these examples are just that—examples. You can use whatever you want. The key things to keep in mind are that developing times with infrared film are determined by the same three components as with other black-and-white films: type of developer, dilution of developer, and ISO of the film.

If you're processing Ilford film, start by using D-76 straight. Start with the recommended times on the packages, do a test, see your results, and go from there. In general, for ISO 200, develop your film at 68°F for 10 minutes; for ISO 400, develop your film at 68°F for 12½ minutes; for ISO 800, develop your film at 68°F for 16½ minutes.

If you're processing Kodak film and used ISO 200, try using D-76 straight either at 70°F for 10 minutes or at 68°F at 11 minutes. (This is my favorite method.) If you want a contrastier negative with bigger grain, use D-19 straight either at 68°F for 6 minutes or at 70°F for 5½ minutes. Rodinal does not blow out the highlights as much as D-76. Because there will be more detail in the highlights, when you use Rodinal you may not have to burn in detail when you are printing. However, the grain will be bigger. Try using Rodinal 1:50 with distilled water either at 68°F for 12 minutes or at 70°F for 11½ minutes.

Gazebo, 1978. *I took this image with Kodak film and a #25 red filter. This scene is about texture—the old, worn gazebo in the middle of a field with tall grass and overgrown trees behind it. To give the image a timeless quality, I enhanced the grain of the film by using Kodak D-19 developer.*

If you're processing Konica film and used ISO 50, try using D-76 straight either at 70°F for 8½ minutes or at 68°F for 9 minutes. You can also try using Rodinal (diluted 1:50) at 70°F for 9½ minutes.

DEVELOPING YOUR FILM

While the process of developing your infrared film is very similar to developing standard panchromatic film, there are a few additional precautions that you need to take. First, take your film out of the refrigerator an hour before you will be ready to process it so that it reaches room temperature. Second, be extra careful with light when developing infrared film. If you have plastic tanks, you may need to wrap them in aluminum foil. Infrared radiation can penetrate some plastics and fog your film; however, remember that the film does come in a plastic con-

tainer. I use a steel tank that has a plastic top and I have never had a problem, but all the film manufacturers mention it.

Prepare all your chemicals and have everything set up in the darkroom before you turn off the lights. All your chemicals should be +/- 2 degrees of the temperature of the developer. The stop bath can cause pinholes, so be sure to dilute the stop bath according to the directions on the bottle. Hypo clearing agent will also need to be diluted to make a working solution.

Infrared radiation can penetrate through hollow doors, so if your door is not solid, cover it with a blackout curtain, aluminum foil, or a few heavy-duty garbage bags. Cover the door frame, too, so that light does not leak around the edges, and check around the floor. Most darkroom timers have glow lights, so make sure to turn their faces away from you or, better still, take them out of the room until you are done rolling your film into the can. Your watch probably has a little glow to it, so take

that off, too. You can turn the lights back on after you have rolled your film, put it in the tank, and put on the lid.

Everyone has his or her own way of developing film, with agitation being the most important factor. Infrared film attracts air bubbles (which, according to Kodak, occur in the first 5 seconds of development), so you must agitate very evenly and *bang* the film hard before and after each agitation cycle. The most common way to develop film is to agitate it for the first 30 seconds and then for 5 seconds every 30 seconds. I have found that this not only overdevelops infrared film, it can cause too many air bubbles. I have also seen problems in people's film that have been caused by uneven agitation as a result of rushing through the 5-second/30-second drill. With that said, I have helped people get through a lot of developing problems by changing the agitation process slightly. I recommend the following:

1. Presoak your film with distilled 68°F water for 2 minutes and agitate it constantly. This will help ward off pinholes and get the film and the tank to an even temperature. Discard the water after 2 minutes.

2. Pour the developer into the tank very evenly and slowly.

3. Bang the tank.

4. Holding the tank with two hands (one on the bottom and one on the top), agitate it slowly for 30 seconds, making sure that you are turning the tank totally upside down and then totally right side up again.

5. Bang the tank.

6. Let the tank sit for a full 60 seconds without touching it.

7. Bang the tank, agitate it for 10 seconds, then bang it again.

8. Repeat steps 6 and 7 throughout the remaining developing time. Discard the developer.

9. Pour in the stop. Agitate the tank for 30 seconds, banging periodically. Discard the used solution.

10. Pour in the fixer. Depending on how fresh your chemicals are, fix your film for 2 to 4 minutes, agitating the same way that you agitate the developer. If the chemicals contain hardener, do not fix for longer than 4 minutes. Discard or save the fixer in a bottle marked "Used Fixer."

11. Rinse your film for 2 minutes under running water. (You can take the top off the tank at this point.)

12. Add the hypo clearing agent or perma wash. Agitate your film constantly for 2 minutes. Discard the used solution.

13. Rinse your film for 20 minutes under running water.

14. Add one drop of Photo-Flo to 32 ounces of water. Pour this mixture over your film, letting the overflow run into the sink. Within 30 seconds discard the chemicals.

Infrared film curls a lot as it is drying, so use double weights on the bottom and let it air dry. Store your negatives in a notebook with a weight on top for a few days until it is flat. Infrared film is printed just like regular panchromatic film.

Louisiana Trees, 1981. *I shot this image with Kodak film and a #25 red filter. Infrared records leaves as white more than normal panchromatic films do. By printing the image a little lighter and flatter than I might normally, I was able to keep the soft look.*

Important Points to Remember

What may work for one person may not work for another; the "trick" to infrared film is to experiment. That said, however, there are a few general guidelines that are worth keeping in mind.

- Like all films, you should shoot infrared film as quickly as possible. If you leave the film in the camera too long, it will fog. The whites will be gray and the blacks will be flat. "Too long" depends on the conditions. If the camera is in an overheated room, the film will fog much faster than if it is in a very cold room.

- Never buy infrared film from a store that has kept it on a shelf instead of in a refrigerator.

- Test your camera and changing bag for light leaks before going off to photograph a lot of film.

- When you rewind your film make sure the entire "lead" is wound back into the cassette. Otherwise some fogging may occur.

- Infrared film must be refrigerated until it is used, and then again (in its original plastic film canister) after it is used until it is developed.

- Like all films, it is best to develop infrared film as soon as possible. However, this is especially important with infrared film, because the longer it sits around the more it loses its tonal range.

Fire Island Chairs, 1981. *I also used Kodak film and a #25 red filter to take this image. To keep the original contrast of the scene (the dark interior with the bright sunlight in the windows) I exposed for the chairs and let the window light get very bright. I knew that if I used D-76 developer, I could achieve detail in the windows once I was printing. In the end, I burned in the window areas for several minutes to bring out just enough detail to show the window frame.*

EVALUATING YOUR IMAGE

Infrared film is thinner than most other emulsions. Therefore the film is not only very curly, it also scratches very easily. Consequently, you want to handle infrared film as little as possible. Because of this I leave my negatives in the sleeves when making my contact sheet. While the contact sheet may not be as sharp as it would be if printed without the sleeve, this method keeps the negatives safe.

Picking out the best negative with infrared film takes a little getting used to, but, as always, there are a few tips. Use contact sheets to view the images only. I usually don't evaluate the exposure from the contact sheets, but rather look at my negatives. In particular, I look for the negative that will give me the detail that I want in a particular image. When you are first starting out, choose a scene that you have bracketed well and that you will enjoy printing. Make a print from each negative—"normal," underexposed, and overexposed. You can probably make a good print from all of these exposures. It is really a matter of taste and what effect you like the best.

GETTING THE RESULTS YOU WANT

Infrared film has a wonderful latitude, so even if you under- or overexpose your film, it may be usable. Below I have mentioned a few possibilities of what you may expect when you print different exposures.

- Overexposing the negative will produce a soft, ethereal, and dreamlike image.

- A "proper" exposure will render an average scene with an excellent contrast range.

- Underexposing the negative by as much as 2 stops will create a printable negative, but the shadows will be blocked in and the image will have an overall flatness.

- A sunlit outdoor scene with green foliage and grass will have a snowy appearance because the chlorophyll in most healthy plants reflects infrared radiation. However, the chlorophyll in each species of plant will record slightly different tones.

- Sand, clouds, and people will be recorded in very light tones because they also reflect infrared radiation.

- Water will appear either light or dark, depending on the objects that reflect off the water's surface.

- Because there is very little infrared radiation present in the sky, on a sunny day it can photograph dark (and any clouds will photograph very light).

- Infrared radiation penetrates through haze, so you can use infrared film to take a picture on a hazy day and the film will record it as a clear day.

Arboretum Benches, 1986. *I captured this image with Kodak film and a #25 red filter. When I was reviewing the negative, I liked the solitude that this image conveyed because it was devoid of people. So when I blew it up and saw two people in the background, I decided to paint them out with a spotting solution.*

White Room, 1979. *I captured this image using Kodak film and a #25 red filter, but then misplaced the roll of film in a warm Florida house for several months. Once I found the roll I decided to develop it anyway. The rest of the roll was totally unusable, but when I saw this image I was happy that I never throw anything out. I do not think the image would have been as ethereal without the softness of the "bad" film. Mistakes in art are wonderful and should always be explored. A cyanotype print of this image can be seen on page 77.*

- Konica film records slightly differently than Kodak. Most vegetation records white with both films; however, Konica film will record closer to a light gray than white in some instances.

TROUBLESHOOTING

Problems exist for everyone. The most common problems are due to mishandling the infrared film because it is more fragile than regular black-and-white film—even after development.

- If you are getting splotchy-looking areas near the sprocket holes on the film, the film probably hasn't been developed evenly. These irregularities tend to be most visible in skies or grassy points. If you do not agitate evenly during development, the film overdevelops around the sprocket holes because the developer flows more freely in the areas around the openings than it does elsewhere. Smooth, even agitation fixes this problem.

- If your infrared film is marred with black streaks, scratch lines, and pinholes, it probably came into contact with static electricity. Rewinding the film very slowly may solve the problem. You can also try coating the pressure plate of your camera with Photo-Flo every few months to help cut down on the friction that causes static electricity. Use a high-quality brush or the tip of your finger to coat the plate and allow it to dry completely before loading the camera.

- If you see black streaks in your film after using the auto-wind feature on your camera, disengage it and manually rewind the film.

- If your film is fogged, check the following to make sure that they are all tightly sealed: (1) the door to your darkroom, (2) your camera back, and (3) your changing bag.

- If you have patterns on your film, the pressure plate in your camera might be dirty or, if it is an old camera, it might be silver. A silver pressure plate will cause light to reflect back onto the film and cause patterns on the negatives. Get the pressure plate replaced with a black one.

- If you find fingerprints on your film, they were probably caused either by your normal hand oils or by sweat that was deposited while you were rolling the film. Since fingerprints show more on infrared film than on regular film, it is especially important to make sure that your hands are clean and dry when you are loading film. Try rolling your film by holding the edges. Do not touch the center.

- If the bottom portion of your film is fogged, it may be because your camera has an infrared counter. If you discover that your camera has this kind of counter, don't worry. You do not have to go out and buy a new camera! Compose your picture, take two steps back, refocus, and shoot. When you are printing, crop off the very bottom of the frame. The rest of the image will be fine.

MAKING DIGITAL INFRARED IMAGES

A little over 150 years ago, when photography was invented, painters were upset because they thought that this new invention would threaten the viability of their medium. But they soon realized that photography was just another tool, not something that would bring the end of painting. Now, at the turn of this century, a similar debate is taking place. Are digital technologies going to mean the end to film or photography? Is one better than the other? That debate will go on for a long time. For me, I look at computers as just another tool. Now I have more choices about how I photograph or print my work. Both techniques have good and bad points, but one thing is sure: Digital is here to stay.

You can use digital applications to mimic infrared effects by using any image and playing with the channel mixer on the computer in Photoshop. Or you can capture infrared radiation using your digital camera in the same way that you would use a traditional camera to capture it. With both techniques, the grain structure of the digital images is different than traditional infrared images, but the mood can be similar. The following instructions are basic and are meant to get you started. As with any process, it takes practice to master this technique. Your Photoshop manual or a good book on digital imaging will help you fine-tune your digital skills.

GETTING STARTED

For both techniques you need to have an up-to-date computer that is equipped with Photoshop. If you are going to be starting with nondigital images (negatives, slides, or prints), you will need a scanner. If you want to shoot with a digital camera, you will need a digital camera, a #87 (dark red) filter, and a tripod. Most higher-end digital cameras have infrared blocking filters, which allow minimal amounts of infrared light to be recorded. Exposures are made long by the opaque red filter and even longer by these blocking filters; therefore the tripod is a must.

CREATING INFRARED EFFECTS

As mentioned above, you can mimic infrared effects by manipulating the image on the computer using Photoshop's channel mixer function. Author and photographer Rick Sammon often sends me images and asks if I can tell whether they are digital or film. I have to admit, some digitally generated infrared images are pretty close to "the real thing," depending on how much of a glow and what type of grain has been added to the image.

Briefly, if you're starting with a print, you'll need to scan it to create a digital version of the image. Open the image in Photo-

Vinalhaven, Maine, 2001. *I transformed this image from a color to a black-and-white infrared image using Photoshop. I removed the color (Image>Mode>Grayscale), then went to Filters>Distort>Diffused Glow and changed the levels until I got the desired effect. I then changed the image back into an RGB file so that it would be saved at a larger file size (Image>Mode>RGB). When I saved this image I changed the name so that these changes would not affect the original image file.*

shop. First turn the photograph into a black-and-white image, using the Image>Mode>Grayscale feature. Then go to Filters>Distort>Diffused Glow. There are three features here: Grain, Glow, and Amount. Play around with these levels until you achieve the desired effect. Then add grain to the image by going to Filters>Artistic>Film Grain. Go to Image>Adjust and adjust the levels and curves for the proper contrast. Finally, go to Image>Mode>RGB to put a color code back into the file to get a larger file size.

CAPTURING A DIGITAL IMAGE

The second way to create a digital infrared image is to capture one using a digital camera. You can shoot either in color or in grayscale. Because you are going to upload the images onto the computer and make changes anyway, it does not really matter which mode you choose. There are arguments for both, and I have not seen a difference in the end result.

Before going on a full-day photography excursion, you'll want to do some tests with the infrared features on your camera. When I first experimented with taking digital infrared images I went outside and took exposures from 1/15 second all the way to 10 seconds. Then I ran inside and looked at the results on my computer. Each type of camera is different, so you need to do a test to see how sensitive your digital camera is to infrared radiation. Testing various conditions will make it easier to know what you are getting ahead of time—to a certain extent, anyway. When shooting digitally I still make a few exposures because, as with film, the atmosphere affects the end result. Each digital camera captures infrared film differently. With some cameras you can use a #87 filter and others need a #89. You will need to do a test to see which you like best.

When taking pictures, don't be turned off by what you see on the LCD screen. If you are shooting in color, the image will probably look very red or pinkish. If you are shooting in black-and-white, the image may just look dull. Remember that you are going to change things in the computer, so don't worry.

After your shooting session, upload the images into Photoshop. Choose the image that you want to work on and, using the "save as" feature, make a copy. (I treat my original digital files the same way I treat my negatives. I would never make permanent changes to my negatives!) To get rid of the red cast from the filter, change the image to grayscale. You should now have a flat (gray) image. Everyone has his or her own way to fix images in Photoshop. Some use the Levels feature, some prefer the Curves function. It does not matter, but as soon as you start working in one of these areas, your image will look more and more like a film-captured infrared scene.

CHOOSING BETWEEN FILM AND DIGITAL INFRARED

Why would you choose film over digital, or vice versa? There is no quick answer. The choice is personal and depends on how you like to work. Both methods can be used along with other alternative processes or by themselves as finished images. Personally, I just love having options, but here are a few things to keep in mind:

* With a digital camera you can shoot in many different ways using one camera. With traditional cameras, if you wanted to have options during one photo shoot, you would need to keep multiple cameras, each loaded with a different type of film.

* One of the main aesthetic differences between film and digital infrared is the grain. Film has a pronounced grain that digital does not have. Personally, I really like the grain on film, but several software programs can be used to add grain to the digital files. (See Sources, page 155.)

* Infrared film has a visible glow (particularly in the white highlight areas) that is made from the antihalation backing on the film. Digitally generated images will not have the same glow, although again, software programs can be used to add glow to the highlights on your digital files.

* When shooting digitally you must use a tripod, even in the brightest conditions, because of the need for slow shutter speeds. Also, any movement in the scene will show as a subject blur.

* When shooting with film you can usually print an underexposed negative. However, with digital infrared, if you have underexposed the image, you will get digital show or noise, which might make it unappealing to print.

LIQUID EMULSION PRINTS

L IQUID EMULSION HAS BEEN AROUND since about 1965 when the Rockland Company started packaging a product they call Liquid Light. It mimicked the way photographers sensitized paper in the early days of photography, with one very important advantage: a standard black-and-white darkroom setup could be used to create images on any type of support wanted by the visual artist. Liquid emulsion has been a favored technique for alternative photographers ever since.

Liquid emulsion prints are made with silver-based sensitizers that are applied to a support, exposed using an enlarger, and processed with conventional chemicals. These are not "prints" in the traditional sense of the word—because with liquid emulsion, instead of using precoated factory-made photo paper as the support (as you do for traditional photo processes), you can use an infinite range of paper or other surfaces. Canvas, china, concrete, glass, leather, various metals, paper, cloth, plastic, and wood all become possible supports that you can use in a standard black-and-white darkroom.

Several companies produce liquid emulsion, which can be purchased at most camera stores. The instructions in this book provide guidelines for using these products. However, you'll still want to check the bottle for the particulars on how to process your liquid emulsion prints—for instance, whether or not to use stop bath or hardener in the fix. Each company suggests slightly different variations and these components can affect the outcome of your work.

Cortona, Italy, 1996. *For this image I applied Silverprint to nine individual tiles. In order to get the emulsion to adhere to the tiles I first had to apply two coats of gelatin sizing and let it dry and harden overnight. After exposing, developing, and fixing the image, I selectively bleached and toned the tiles using polytoner. I often use tiles in my work instead of paper to break up the image in geometric forms.*

Opposite page:
Kathy and Scott's Window, 1998. *For this piece I used Silverprint and sepia toner on Arches 140-lb hot-pressed watercolor paper.*

CREATING LIQUID EMULSION PRINTS

Liquid emulsion solutions are complete in one bottle; no additional chemicals are necessary to sensitize your surface. The emulsion is solid at room temperature and must be warmed to become liquid. One pint of liquid emulsion will cover approximately 16 square feet (which works out to approximately 24 prints if you're working in an 8 x 10-inch format).

In general, if you are using watercolor paper, the liquid is applied to the surface, dried, and exposed with a normal black-and-white enlarger. However, some handmade papers may need to be sized first. I have found that if the paper has a high fiber content or if it is very soft, sizing first will stop the sensitizer from soaking too far into the fibers of the paper. The only way to know this is to do a test on a small piece of the paper. If you have chosen another support, such as glass or wood, a sizing solution must be made and coated onto the surface before the emulsion can be applied and exposed. The base support is then developed and processed with (essentially) standard black-and-white chemicals before being washed and dried. The finished prints can be hand colored or toned just like a photographic print on commercial paper.

GETTING STARTED

Many of the items required to make liquid emulsion prints are standard darkroom materials that were discussed in Chapter 2. (*See* Basic Darkroom Equipment and Materials, page 12.) Unlike the other alternative processes in this book, you can use an enlarger to expose your image onto your support; therefore you can use any size negatives that your enlarger will allow. Before you get started, make sure that you have the following items on hand:

Black Garbage Bags	**Mask**
Brushes	**Newspaper**
Cleansers	**Painter's Masking Tape**
Darkroom Thermometer	**Paper Safe**
Gloves	**Pencils**
Goggles	**Plastic Cups**
Hair Dryer	**Plastic Spoons**
Hot Plate	**Pot and Pyrex Measuring Cup**
Light-tight Containers	

In addition, you should note the following:

Chemicals You will need normal black-and-white paper developing chemicals for this process, including developer, fixer, and perma wash (hypo clear).

Graduates You will need three graduates: one large one to hold the hot water, one small one to hold the emulsion, and one large one to hold the brushes as you work.

Safelight Your safelight should be dark yellow, light amber, or red and should be kept slightly darker than it would be for a normal darkroom. You can use safelight bulbs or safelights that are equipped with filters and use regular light bulbs.

Size You may or may not need to size your support before applying the liquid emulsion. (*See* Sizing Formulas, page 22.)

Supports You can use a wide range of base supports for this process. (*See* Preparing Your Base Support, page 50.) Be sure to have extra supplies, as you will want to test your surface before making the final print.

Trays Making liquid emulsion prints does not require special (plastic) trays; you can use the same trays as for normal silver printing. You will need a total of seven trays.

LIQUID EMULSION

With the growing interest in liquid emulsion, several manufacturers have added to (or expanded) their liquid emulsion products. At the time of the printing of this book, four companies were offering liquid emulsions:

Bergger They make a product called EL3, which has a contrast equal to a grade #3 filter. You cannot use filters with this product but you can control the contrast in other ways.

Several companies now make liquid emulsions, including (from left to right) Photographers' Formulary (Formulight), Luminos (Silverprint VC), Rockland (Liquid Light), Bergger (EL3), and Cachet (Black Magic).

Cachet They have three liquid emulsion products called Black Magic (all of which include hardener and gelatin that can be used on the support, mixed in the emulsion, or mixed in with the developer). The three variations include normal contrast, which has a contrast equal to a grade #2 filter and cannot be used with filters; hard contrast, which has a contrast equal to a grade #3 filter and cannot be used with filters; and variable contrast, which can be used with any type of enlarging filter to add or take away contrast. Photographers' Formulary carries this product under the name Formulight.

Luminos Their product is Silverprint VC. The VC stands for "variable contrast." Any type of enlarging filter can be used with this product to add or take away contrast.

Rockland They have several products, including Liquid Light, Liquid Light VC, and AG Plus. Liquid Light is a very slow product, which means it is less sensitive to light. It has a contrast equal to a grade #1 filter, but you cannot use filters with it. The emulsion has a slight greenish cast and it is said that this emulsion makes images look nostalgic. Liquid Light VC has a contrast equal to a grade #2 filter but it is a variable-contrast version of Liquid Light, so any filters can be used to control the contrast of the image. AG Plus has a contrast equal to a grade #2.5 filter and cannot be used with filters. It has a higher silver content than the Liquid Light products, about equal to the other products on the market. AG Plus can also be used with reversal developer to make tintypes.

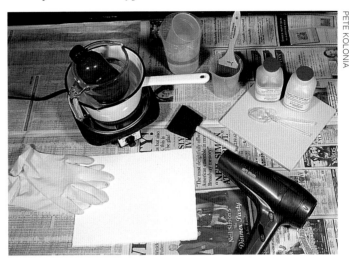

Here are a few of the materials you will need to make liquid emulsion prints: newspaper, gloves, brushes, hot plate, pot, Pyrex measuring cup, graduates, plastic spoons. Note also the liquid emulsion (pictured in the Pyrex cup) and the gelatin and chrome alum, which are used for sizing nonpaper supports.

Italy Well, 1998. *For this image I used Silverprint with selenium toner on Fabriano Artistico 140-lb cold-pressed watercolor paper.*

Preparing Your Base Support

To prevent discoloration and to obtain a permanent image, many base supports need to be sized before the liquid emulsion is applied. There is no real rule. While most papers need no sizing, some handmade papers will not work unless they are sized the same way as tiles. Some kinds of rubber do not need sizing at all. Guidelines are listed below. However, the only way to know for sure how a support is going to respond is to take a small sample of the material you want to use and try it out.

The standard sizing recipes are listed in Chapter 2. (*See* Sizing Formulas, page 22.) In general, the Knox gelatin size and gelatin and hardener size recipes work well for liquid emulsion prints. In addition, Cachet's hardener can be added to a gelatin sizing solution to produce the same effect as chrome alum does when it is added to a gelatin size. This recipe appears at the end of this section. Most of the instructions that come with the different liquid emulsions recommend a sitting time of at least 4 hours between sizing and applying liquid emulsion to the sized support. For even better results, I have found that it is best to leave the supports for 24 hours. If you are working under humid conditions, the sizing may take a little longer to set.

Life-size Chessboard, 1998. *I prepared the metal by degreasing it with vinegar, washing it with washing soda, and thoroughly rinsing it with warm water. After the material was totally dry, I applied two coats of Knox Gelatin Size then let it dry overnight before applying two coats of True Liquid Emulsion (now called Formulight). I exposed the support at f/8 for 10 seconds and then developed it normally.*

Ceramics, Stone, and Wood These materials should be sized in some way before the liquid emulsion is applied. Any color oil-based (alkyd) primer can be used to add color to these materials and at the same time function as sizing. If you do not want color, then use two coats of spray gloss polyurethane. (You can try the matte or semigloss versions but these sometimes cause the liquid emulsion to flake.) Oil-based polyurethane works better than water-based, so check the label.

Glass, Plexiglas, Metal, Eggs These materials should be cleaned with vinegar, isopropyl rubbing alcohol, stop bath, or lighter fluid. Then they should be washed with washing soda to remove the protective wax or oily surface. Finally, they should be rinsed with warm water and dried thoroughly before being coated with a sizing solution.

Most Papers, Cloth, Unprimed Canvas, and Rubber These materials generally do not require sizing. You can apply liquid emulsion directly onto these surfaces.

Surfaces with Water-based Finishes Liquid emulsion prints do not adhere well to water-based finishes, such as acrylic latex paints, or to lacquer, shellac, or liquid plastics. Primed canvas, which is often treated with water-based gesso, must be sized with oil-based (alkyd) primer before it is coated with liquid emulsion.

CACHET'S HARDENER

Cachet provides a hardener with Black Magic, its liquid emulsion product. This hardener can be used for any support material. Cachet recommends using the hardener in one of three ways; pick whichever method you prefer. While there is some flexibility in how this product is used, the hardener should *not* be added to your stop bath because it is acidic and can cause harmful vapors.

Method 1. Add the hardener to the working solution of developer at a ratio of 1:20 (1 part hardener to 20 parts working solution). This method is unique in that you add the hardener to the developer instead of the fixer. Use the developer as you would normally.

Method 2. Dilute the hardener with distilled water at a ratio of 1:20. In the darkroom you can then add the diluted hardener to the liquid emulsion at a ratio of 1:3. Use the liquid emulsion as you would normally. Use all of the enhanced liquid emulsion within a couple of hours, because emulsion that has been mixed with hardener does not keep.

Method 3. The Cachet hardener can be added to a gelatin sizing solution to produce the same effect as chrome alum does when it is added to gelatin sizing. The combination of the gelatin and the hardener helps ensure good adhesion of the liquid emulsion on difficult surfaces (i.e., glass, metal, etc.). This recipe simply makes another type of sizing solution; it should be applied in the same way as regular size. Cachet's instructions for mixing are as follows: Dilute the hardener 1:20 with distilled water to make a working solution. Then take the hardener working solution and mix that 1:3 with a gelatin sizing.

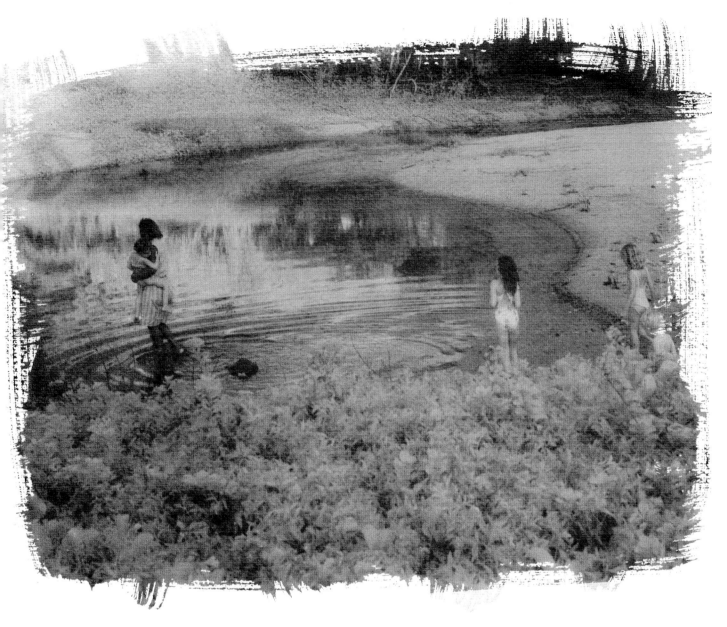

Hawaii River, 1996. *I used Silverprint and printed this image with a #3 filter on Arches 140-lb hot-pressed watercolor paper. When I made this piece, variable-contrast Silverprint had just become available, so I decided to try it out with this image.*

PREPARING THE LIQUID EMULSION

At room temperature, "liquid" emulsion is, in fact, a solid gel. It needs to be warmed up before it can be used; otherwise, it will be difficult to spread the emulsion on the support and you will get a lot of air bubbles (which will cause the emulsion to flake off in the developer). While there are a number of ways to liquefy emulsion, a few general rules apply to all of these methods. First, use containers and tools made only of plastic, rubber, or glass; metals—such as steel or brass—may contaminate the emulsion. Second, ensure that both the temperature and the humidity in your darkroom are moderate, to minimize drying time.

It is important to remember that liquid emulsion is just as light-sensitive as the emulsion on store-bought photographic paper. Therefore, liquid emulsion cannot be opened in the light. Before opening the bottle to transfer the emulsion into smaller containers you must be in the darkroom with the safelights lowered.

Liquid emulsion melts at 110°F and it takes approximately 45 minutes to liquefy a full bottle. While your liquid emulsion

is warming, do not shake the bottle, as bubbles may form. It is not necessary to melt the entire container of liquid emulsion at one time. In fact, it is preferable to melt the emulsion in smaller quantities because repeated heating and cooling is said to reduce the shelf life of the emulsion. You can melt small quantities of liquid emulsion in one of two ways:

Method 1. Fill a large graduate with very hot water. Squeeze or spoon out the desired amount of liquid emulsion into a small, light-tight container, then place this container in the water. Black film canisters work well; they are both light-tight and water-tight. As the liquid emulsion warms up, the water will cool. Replace the cool water with warm water until the emulsion reaches the desired consistency.

Method 2. Place a pot filled with water on a hot plate. Put a Pyrex measuring cup in the water. This will act as a double boiler and protect the emulsion from overheating. Squeeze or spoon out the desired amount of liquid emulsion into a light-tight container and place the container inside the Pyrex cup. Now add water to the Pyrex cup so that the container holding the emulsion is sitting in water. Turn the hot plate on low so that the emulsion heats up slowly and liquefies. I keep a darkroom thermometer in the water to make sure the water doesn't get hotter than 110°F, which may fog the emulsion.

COATING YOUR BASE SUPPORT

When working with liquid emulsion, you should illuminate your darkroom with a dark yellow, light amber, or red safelight. Each company recommends a different preferred safelight color. Be sure to check the paperwork that comes with the emulsion. Your workspace should be slightly darker than a normal darkroom. As you're working, be aware of how long each piece of coated support is exposed to the safelight—especially if you are coating many pieces of support and/or are applying more than one coat. Most store-bought photographic papers start to show signs of fogging after 7 minutes in safelight. With the liquid emulsion process, the emulsion will be exposed to the safelight for much longer than 7 minutes (between coating, drying, exposing, and developing) so fogging can occur. If you notice gray edges around your prints after developing, make your darkroom darker.

You can use anything that you are comfortable with to apply the liquid emulsion to the support. Bristle brushes, sponge brushes, paint rollers, and spray guns all work. You can also simply pour the emulsion directly onto the support and drain off the excess. Again, this is a matter of personal choice. Each application process will give a different result. For example, a sponge brush creates a smoother surface than a bristle brush. (The latter technique tends to leave brush marks, an effect that some people really like.) This is an individual choice.

BRUSH METHOD

If you decide to use a brush, you will need to transfer the liquefied emulsion into a graduate with an opening that is wide enough for your brush. This graduate needs to be able to float in hot water to keep your emulsion in a liquid state as you are working.

1. Slowly pour the liquefied emulsion into the graduate. If you have ever poured beer into a glass, trying to create as little foam as possible, you have the technique down! The idea is to pour the emulsion slowly and gently down the side of the graduate so that air bubbles do not form.

2. Float the graduate of emulsion in a larger graduate that is filled with hot water. This method keeps the emulsion liquefied during the coating session.

3. If I am coating a lot of support, I often keep a third graduate filled with hot water on hand as well as one or two additional brushes. I use this third graduate to keep my brushes warm so that the emulsion doesn't harden on them and scratch my support. As I put one brush into the hot water, I take the other one out. This method works well for me. However, make sure to squeeze out excess water before you dip your warmed brush back into the emulsion.

For an even coating, follow the directions given in Chapter 2. (*See* Brush Method, page 27.) However, it is a good idea to experiment with how you apply your emulsion, since it plays an

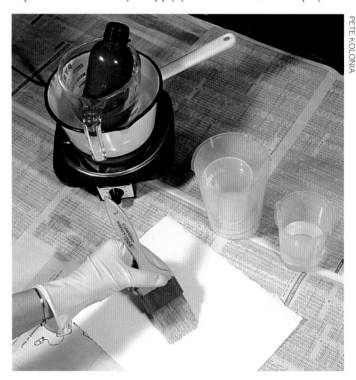

Carefully pour just enough liquid emulsion into a small graduate to coat a few supports at a time and then float this graduate in a slightly larger graduate, creating a "double-boiler" effect. Brush the emulsion onto your support first horizontally and then vertically for an even coat. I use another graduate filled with warm water to keep my brushes warm and soft.

important role in the outcome of your image and is just as important as your choice of support materials.

Depending on the look you want, you may find that one coat does the trick—or you may find that you want to apply multiple coats of emulsion to the support. As with paint, a thin coat will show streaks and brush strokes, which some people like. If you want a smooth, unified look, two thin coats are better than one thick coat. Apply the second coat after the first has become tacky. Because each type of support will require slightly different exposure and developing times, you should coat extra pieces of your chosen material to use as test strips.

SPRAY METHOD

Liquid emulsion can also be sprayed onto the support with a small spray gun, provided that the nozzle has no metal parts. Make sure that you wear gloves, a mask, and goggles to protect yourself and that the room is well ventilated. If the liquefied emulsion is too viscous for your spray gun, dilute it with a small amount of isopropyl rubbing alcohol.

This method takes practice. The distance you need to be from the support will depend on how even a coating you want. A good example would be a large piece of metal. Place it at an angle against a wall (which is covered with newspaper for protection). Spray the metal by moving across from left to right, moving down until the entire area is covered. Every few minutes stop spraying and stand at an angle to the support so that you can view what the coating looks like and decide how much more spraying may be needed. Because spraying takes a while, especially if you are using a large support, a hair dryer is another good tool to have on hand. If you keep it on a slow, warm setting (not hot, which can burn the emulsion) you can keep the support warm, which in turn will keep the emulsion liquefied as you work.

POUR METHOD

Pouring liquefied emulsion over glass or any other large support is another method that is popular with artists. As with the spray method, keeping the support warm plays an important role in producing an even coat. There are several variations to this method. Experiment with them all—and others as you think of them.

The first variation involves placing the support at an angle against a wall, with the base of the support in a tray. The tray serves as a basin in which to catch the unused emulsion, which gives you the option of using it again. Keep the support warm by using the hair dryer on a low, warm setting and pour a liberal amount of emulsion slowly from the top part of the support. You can let the support sit until the extra emulsion has drained off into the tray or you can turn the support so that it drains from all corners.

The second variation involves using a tray that is slightly smaller than the support and filling it with hot water. Place the support on top of the tray and let it sit for a few minutes so that the hot water can heat it up. Pour a liberal amount of emulsion

over the support, then lift and rotate it so that the extra emulsion will drip off into a container (so it can be reused).

The third variation involves pouring the emulsion over the support and using a paint roller to move the emulsion across the support. Instead of creating a smooth coating, the paint roller gives the emulsion some texture.

DRYING YOUR BASE SUPPORT

As was mentioned earlier, most supports that have been coated with silver-based liquid emulsion sensitizer start to show signs of fogging after being exposed to a safelight for as little as 7 minutes. Therefore, it is best to keep your supports in total darkness throughout the drying process. Chilling the coated support will speed the setting-up time, while warming will retard it. For faster drying, use a fan or a hair dryer (set on "cool") after the emulsion has set up or become tacky.

While each company recommends a different drying requirement for their emulsion, I have had the best results when I have allowed my support to dry for 24 hours. The contrast is better and I have had fewer problems with emulsion lifting off the support. While this may not always be possible, just be aware of some of the problems that may result from too short a drying time.

The companies that manufacture liquid emulsion products say that, once they're coated and dried, base supports can be stored like ordinary black-and-white paper. I have found this not to be true—older supports don't produce as much image contrast. Therefore, I recommend using the support within a few days of coating.

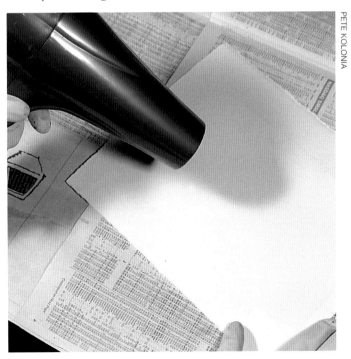

Dry your paper using the "cool" setting on a hair dryer or let it dry naturally in total darkness.

In any event, your supports must be stored in total darkness to prevent fogging. You can purchase a paper safe in many sizes. If your supports are too large or unwieldy to fit in a paper safe, you can enclose them in a few industrial-strength black garbage bags.

PETE KOLONIA

You can use a paper safe to store supports for several days after you have coated them with emulsion. Even though the supports are safe from light, it is best to use the coated supports as soon as possible because the tonal quality will degrade after a short period of time.

EXPOSING YOUR BASE SUPPORT

Depending on the characteristics of the base support, you can expose the image by using an enlarger or by contact printing. Paper can be exposed using both methods, and with the enlarger you can use the easel just as you would for normal black-and-white printing. The only tricky thing I have discovered with paper is that it tends to curl while the liquid emulsion is drying. This isn't worth fretting over, however, as it does not seem to affect the end product much. (The easel helps keep the paper flat during exposure.)

Before making the actual exposure, position a noncoated support on your table in the location where you will be exposing your coated support. Whenever possible, have extra non-coated support materials on hand to use for focusing and for proper placement under the enlarger. Focusing should always be done on the *same type* of material you are printing on—even with papers, as they are not always the same thickness, which can change the focus.

Before you place your coated support under the enlarger, mark the desired position, using blue painter's masking tape. Exposing liquid emulsion is the same as exposing a piece of black-and-white photographic paper. The best place to start is with a test strip. Remember to use a support for the test strip that is the same type of material as the support you are using for the final image (because each material will respond differently to the emulsion).

The exposure time required will be based on three factors— the kind of base support, the exposure method, and the type of liquid emulsion you are using. While experimentation is the key,

INCREASING THE CONTRAST OF YOUR IMAGE

One of the advantages of working with liquid emulsion is that you can use a regular darkroom enlarger to project any size negative onto your supports. Most of the companies that sell liquid emulsions have more than one product—for instance, one emulsion that has a specific contrast level and another that can be used with normal black-and-white printing filters. Filters of 1.5 and below decrease contrast, while filters of 2.5 and above increase contrast. Make sure you check the filter instructions for the liquid emulsion that you are using.

In lieu of using filters, Rockland suggests adding a small, precisely measured amount of paper developer to the emulsion after you have liquefied it and before you have applied it to the support. I have found that you can use this with any of the liquid emulsions, not just Liquid Light. This slight adjustment provides maximum speed and contrast. You need to be very careful with this method, however. If you add too much developer, the emulsion will fog. (This will be immediately apparent, because the emulsion will turn gray in the graduate.) The emulsion needs to be used immediately after the developer has been added because the mixture has a shortened shelf life. If you wait too long

to use it, your end product will look as if it has been fogged (instead of having more contrast).

The formula is:

1 ounce black-and-white paper developer

2 ounces distilled water

8 ounces single-contrast liquid emulsion

1. In a small graduate, mix the developer with the distilled water to make the working solution.

2. Pour the liquid emulsion into a second small graduate.

3. Add ½ ounce of the working solution to the liquid emulsion.

4. Mix the solution well but slowly, being careful not to generate any air bubbles.

Apply this mixture to the support the same day that it is made. Throw any unused mixture away. Dry and expose the support as usual.

there are a few general guidelines worth noting. For example, glass and other translucent supports need double the exposure of opaque supports. Liquid Light needs to be exposed considerably longer than most other emulsions. As a test, I coated one piece of paper with Liquid Light and one piece with Silverprint. Using the same negative I made a test strip on each piece of paper. Silverprint required a 10-second exposure at f/8 while Liquid Light required a 4-*minute* exposure with the lens wide open.

El Peten Hands, Guatemala, 1998. *While my assistant and I were waiting for our horses to take us into the rain forest, we walked around the village and discovered a whitewashed wall that had been decorated with small handprints. The image seemed to capture this region's emphasis on children and traditions. For this print I used an old bottle of Silverprint on Fabriano Artistico and worked with 140-lb cold-pressed watercolor paper. I liked the way the emulsion turned colors in unpredictable ways and so I kept using it.*

DEVELOPING YOUR PRINT

Developing a liquid emulsion print is similar to developing normal black-and-white fiber-based paper. However, liquid emulsion prints are much more fragile than prints on normal store-bought photographic paper and extra care must be taken to ensure a successful end product. For instance, the emulsion can scratch easily. You also should not process liquid emulsion prints at the same time as you process conventional black-and-white papers, as using the same trays will cause contamination (especially in the fixer).

Temperature is also an important variable. It is important to let the liquid emulsion "set up" and harden onto the support. If your darkroom is hot or your chemicals are on the warm side of 70°F, the emulsion can melt off the support in the tray. During the summer, I freeze water in film containers and drop them in my chemicals to keep them cool.

Normal printing trays can be used if you are working with paper or other types of flat (or small) supports. Presoaking is recommended for all liquid emulsion supports. However, this step is especially important for large supports that require the developer to be applied to a portion of the print at a time, as wetting the emulsion with cool water prior to development evens out the developer.

If you have printed your image on paper (or another flat surface), you can develop it like a normal fiber-based print in a tray. The setup in your darkroom should be as follows: prewash, developer, fixer, fixer, wash, perma wash (hypo clear), and final wash. I do not have that much room in my darkroom, so I usually have a "hold" tray with cool running water that serves as my first wash. When I am done printing for the day, I set up the perma wash and final wash. This way I can get away with having fewer trays out at one time.

You can use any developer you like. Now comes the questionable part: Every company recommends something different after the developer. Did you notice that I did not list stop bath? Stop bath is an acid and can etch through the soft emulsion if you are not careful. So why take the chance? I use a fixer bath as a quick stop (30 seconds to one minute), which neutralizes the developer. This fixer will exhaust quickly, so I change it often. (I use hypo check every two or three prints to see when the fixer is exhausted.) Next I use another fixer tray and agitate gently for 10 minutes (if I'm using powdered fixer) or 6 minutes (if I'm using liquid, rapid fixer). (The long fixing time is to limit the brown staining you can get if the emulsion was thickly coated on the support.) The chalky white pigment disappears as the image is properly fixed, leaving the highlights completely transparent. Then I turn on the lights to check my work. Manufacturers sometimes recommend different fixers—because if the fixer is too strong, it can either etch the emulsion in the same way a stop bath can or it can bleach the emulsion quickly. I have used both rapid and powdered fix and have not had problems with either.

If you are using larger materials as a support, there are several ways to develop the image. All require you to wear gloves, goggles, and a mask for protection against splashes and fumes. One method is to not use trays but to place the object directly into the sink (if it is big enough) and gently pour the chemicals over the support. Make sure that the sink is flushed well with water between chemicals. Another method is to stand the support up against a wall with the bottom resting in a tray. Fill a different spray bottle with each chemical and spray the surface repeatedly with the chemicals. Wash with another spray bottle or with a hose. A third method is to use a soft sponge or paper towel to repeatedly soak the support with each chemical. Use care as you touch the surface to prevent scratches.

The times will vary with these types of processing methods. They all involve a fair amount of guesswork and intuition. You will want to make sure that the image area has been covered as evenly as possible with the developer and that the fixer has cleared the highlights before you turn the lights on to check your work.

FINISHING YOUR SURFACE

Drying time depends on the type of support and the air conditions in the room where the supports are drying. I would leave them for at least 24 hours, then check for moisture by touching the edges. The color and texture of the base support will show through a liquid emulsion print, but if additional (or other) color is wanted, the print can be toned with conventional toners, painted with artist's oil or acrylic paint, or any other artist's medium you would like to try.

Most base supports will not require a protective coat. However, if your support is likely to encounter extremes of moisture, temperature, or abrasion, you may want to protect the surface. Any type of varnish, lacquer, or acrylic can be used. However, polyurethane varnish provides the best protection and adhesion. To dull the glossy surface that the varnish will cause, make sure the support is dry, then apply a matte polyurethane spray.

It is possible to remove a liquid emulsion image from its base support. Liquid emulsion prints that have not been hardened with fixer can be easily removed from a surface with hot water. Liquid emulsion prints that have been hardened with fixer can be dissolved with bleaching solutions, such as Clorox or Purex.

TROUBLESHOOTING

A lot of little things can go wrong with the liquid emulsion process—including problems while heating the emulsion, coating the support, or developing the image. Remember that not all problems are horrible and sometimes you can make "surprises" work for you. I have mentioned a few common problems below. If more than one problem arises, be patient. By working through the various problems, you'll eventually make the process work for you.

Cannibal Hill, Fiji, 1998. *We climbed up this beautiful hill that was sprinkled with ruins to see a breathtaking view. We were then told that this is where the cannibals used to come to kill and eat their enemies. For this image I used a single coat of Silverprint on Fabriano Artistico 140-lb cold-pressed watercolor paper.*

- If the liquid emulsion turns gray during or after coating, then (1) you may have added too much developer to the liquid emulsion, (2) you may have coated the paper too close to a safelight and it fogged, (3) you may have opened the bottle of liquid emulsion in daylight and fogged the contents, or (4) you may have heated the emulsion for too long or in water that was too hot.

- If the emulsion bubbles or peels during processing or washing, then (1) you may not have prepared the base support correctly, (2) you may have placed the support in a stop bath or rinsed it in water before hardening in the fixer, (3) you may not have used enough hardener in the fixer or may not have agitated the support in the fixer for long enough, or (4) you may need to add Cachet Black Magic liquid hardener to the developer.

- If the emulsion melts (i.e., the surface smudges with a fingertip) during processing or washing, then your solutions are too warm. This can happen at any stage along the way. In other words, every tray—not just the developer—should be kept at a cool temperature (below 70°F).

- If no image or a weak image appears, then the support has not been significantly exposed.

- If the black tones are not deep enough or are streaked, then the emulsion coat was too thin, or was too fresh for maximum blacks. Try adding developer to the emulsion. (*See* Increasing the Contrast of Your Image, page 54.)

- If the image is marred with spots or blotches of brown, yellow, or purple, then (1) you used too strong a solution of liquid fixer (try using powdered fixer instead), (2) you did not allocate sufficient fixing time, (3) the fixer bath did not contain a sufficient quantity of fixer to wash away the unwanted salts in the emulsion, (4) the agitation at the fixing stage was insufficient, or (5) the fixer was weak or stale.

- If the image fades over time, you may not have washed it sufficiently.

- If the print is out of focus, you may not have correctly estimated the height of the support. Each support has a different height. Don't forget to focus on the same type of surface that you will be printing on.

- If the emulsion flakes off in the developer, the emulsion could be old.

ENLARGED NEGATIVES

MOST OF THE ALTERNATIVE PROCESSES mentioned in this book are contact print processes. This means that they require the same size negative as you wish your final image size to be. Of course, the best option would be to shoot with a large-format camera (4 x 5 inches or larger) so that you could make all your prints from an original negative, which would produce the greatest tonal range and sharpness. However, this is not always possible, so other options need to be explored. Photographers constantly debate how to make the best type of negative for each process; suggestions will be made throughout this chapter as to how to make an educated decision.

This chapter covers alternative ways of making negatives other than shooting with large-format cameras. You can easily make an enlarged negative, called an internegative, from a smaller negative—such as a 35mm or 2¼-inch negative or slide. Using these materials, I will discuss how you do a one- or two-step process using a darkroom, creating computer-generated internegatives as well as a few alternative ideas.

As with most of the techniques in this book, there are many possible variations, so you'll want to experiment to see what works best for you. As you become comfortable with this process, you may find that you want to tailor your internegatives according to the final process with which you will be working. For example, if your internegatives will ultimately be used to make cyanotypes and Van Dyke brown prints, you will want to create a higher contrast than you would for internegatives that will be used to make platinum and palladium prints. So keep notes, look carefully, and have fun.

Arboretum Benches, 1987. *I shot the original image on Kodak HIE 35mm infrared film, then scanned the negative using a Nikon film scanner and printed it out onto Pictorico OHP transparency film. The image is 6½ x 9½ inches. Positive prints of this image can be seen on pages 42 and 138.*

Opposite page:
Vassarette, 1994. *I shot this image with Kodak HIE 35mm infrared film, then enlarged the negative onto Arista APH halftone film to make a 6½ x 9½-inch internegative. A hand-painted black-and-white print of this image can be seen on page 140.*

CREATING TRADITIONAL INTERNEGATIVES

Internegatives should be made in a darkroom that is equipped with a *red* or *amber* safelight. This creates a slightly dark working environment. However, orthochromatic film—which is the film that is used for this process—can be safely handled under this light. Dust marks, fingerprints, and scratches are among the biggest problems in creating enlarged negatives. To minimize these blemishes, clean both the glass and your darkroom area very well before you start, and wash your hands frequently as you work.

Making internegatives is either a one- or a two-step process, depending on which type of film you use. While each generation has slightly more contrast than the last, the final outcome depends on both the film that you use and how you develop it. Therefore, negative-to-negative film (which involves the one-step process of creating an enlarged negative from a small negative) tends to create slightly less contrasty internegatives than does negative-to-positive-to-negative film (which involves the two-step process of creating an enlarged negative from an enlarged positive that was made from the original, small nega-

tive). As with printing, making negatives is an individual art that can take practice to master. However, you'll want to polish your techniques for this process, since making successful final prints depends on this crucial stage.

GETTING STARTED

Many of the items required to make enlarged negatives are standard darkroom materials that were discussed in Chapter 2. (*See* Basic Darkroom Equipment and Materials, page 12.) Before you get started, make sure that you have the following items on hand:

Clothesline	**Painter's Masking Tape**
Clothespins	**Paper Safe**
Gloves	**Tongs**
Negative Sleeves	**Workable Fixative**

IMPORTANT POINTS TO REMEMBER

Making internegatives can be a slightly tricky process. Here are a few suggestions that will make this process easier.

* When making a positive-negative contact, remember that the blank film goes on the bottom so that the exposure is through the positive. This can get confusing when you are using a contact print frame because you put the sheets of film in one way, then turn the frame over for the exposure. Remember to: (1) put the exposed positive film down so that the shiny side is toward the glass, (2) add a new sheet of film, emulsion side (light, milky side) down, (3) add a black sheet of paper, (4) close the back, and (5) turn the contact print frame over.

* When using an interpositive to make an internegative you need to make sure that you expose your film emulsion-to-emulsion; otherwise the resulting negative will not be sharp and any words or numbers will be backward.

* The enlarger needs to be raised high enough so that the light covers the entire area of the contact print frame. This ensures that the negative will be exposed evenly. I use blue painter's masking tape to mark off the area on my baseboard where I will place my contact print frame. I can see the tape once the white lights are off and it does not leave a sticky adhesive on my baseboard when I remove the tape at the end of a printing session.

* When making internegatives, keep an empty negative carrier in the enlarger so that the light is directed, and make sure that the enlarger is out of focus so that any dust from the condenser will not show as specks on the film.

* Make sure to test your darkroom for fogging. If the safelights are too bright, the film will fog quickly. I tend to keep the room darker when I'm working with film than I do when I'm working with paper (i.e., I use red or amber filters in my safelight) and I have never had a problem. I also use a light-tight paper safe while I am printing. This way, if I happen not to close the box of film completely, the unexposed film will still be secure inside the paper safe.

* The more diluted the developer is, the more quickly it goes bad. Make sure to check your developer often.

* To avoid having your tests look markedly different from the final negatives (in terms of density and contrast), follow these rules: (1) Do not make a test and then wait a while before making the final negative. (2) Do not mix fresh developer and then go for a snack. (3) Do not make a test, then mix fresh developer before making your final negative.

Italy Doorway with Olive Jug, 1999. *These three images show the process of creating an internegative with orthochromatic film using the two-step process. The original (2¼-inch) image was shot with a Hasselblad camera using Kodak T400CN film. The 8 x 10-inch interpositive (enlarged positive) shown on the left was made by exposing Bergger BPFB-18 film with an enlarger, then developing the film in Kodak Dektol developer for 5 minutes.*

The interpositive was allowed to dry fully and was then used to create an internegative using a contact print frame. The interpositive was put down first, a new piece of film was positioned on top of it, a black piece of paper was placed on top of that, the back was closed, the contact print frame was turned over, and the film was exposed using an enlarger.

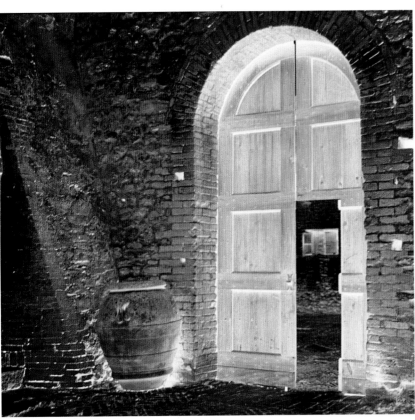

The film was developed, producing this 8 x 10-inch internegative. A cyanotype print of this image can be seen on page 29.

In addition, you should note the following:

Black Paper A thin piece of black paper (any kind) is used to make sure that no light reflects back onto the film as it is being exposed, which can cause it to fog. Using black paper also eliminates the chances that any marks on the easel (or on the back of the contact print frame) will be exposed onto the film.

Chemicals The same chemicals that you use to process regular black-and-white film and paper are used to make interpositives and internegatives, including developer, stop, fixer, hypo clearing agent, and Photo-Flo. Selenium toner can also be used to enhance the final internegative. Note that you have a choice of using film developer or paper developer. Each will give a slightly different tonal range and grain. My favorite combination is a paper developer (Kodak Dektol developer) and Berger BPFB-18 film. The Dektol develops the film with a good tonal range. Other photographers like to mix developers and use film developer such as D-76 along with paper developer such as Dektol.

Cleaning Supplies Make sure that you have ample cleaning supplies on hand, including canned air, film cleaner, and Q-tips. These items will help you prevent dust marks and other blemishes on your internegatives.

Contact Print Frame or Glass The contact print frame, which is also called a contact printer, is used to make sure the new piece of film has a good contact with the interpositive when making an internegative. Contact print frames can also be used instead of an easel or glass to make an interpositive. It is up to you which you prefer to use.

Easel This is used to make both interpositives and one-step internegatives.

Enlarger A regular darkroom enlarger enables you to take any size negative and blow it up to make an enlarged negative for alternative processes.

Opaque This is used for spotting orthochromatic negatives and is available in either red or black.

Safelight Use a *red* or *amber* safelight. If you have been using amber safelights to print your black-and-white film, I would just stick with them. However, make sure that the room is much darker than it would normally be. For example, when I print with normal black-and-white paper, I may have four amber safelights on, but when I am making enlarged negatives, I only use one safelight.

Trays Making internegatives does not require special (plastic) trays; you can use the same trays as for normal silver printing. You will need a separate tray for each chemical plus one holding tray and one washing tray, for a total of seven trays.

FILM

Many different types of films can be used to create enlarged neg-atives. I recommend orthochromatic films, which can be used in regular darkroom light because they are only sensitive to the blue and green spectrum (whereas panchromatic films are sensitive to the blue-to-green as well as the red-to-orange spectra).

Negative-to-negative Film This is also called duplicating or one-step-process film. You make an enlarged negative directly from a "small" negative by placing the original negative in the enlarger and exposing the duplicating film much as you would a piece of paper. The negative image appears on the film because this is a "duplicating" process. Kodak SO-132 is one kind of duplicating film.

Negative-to-positive-to-negative Film Using an enlarger, you first make an enlarged positive (interpositive) onto film, then contact-print that interpositive with another piece of film to make the enlarged negative (internegative). This two-step-process film is made by a lot of companies. Bergger BPFB-18 (my favorite), Kodak Ortho, and Arista APH halftone film are all two-step-process films.

PETE KOLONIA

When you are preparing to enlarge your original negative, make sure to adjust your focus on the same kind of film that you will be using to make your final. This way, the focus of your final internegative will be perfect.

EXPOSING YOUR FILM

Making internegatives is an individual art. As you become more familiar and comfortable with this process, you will learn how your film responds and will make your own adjustments. However, the steps below are a very good place to start. This section clarifies the steps required to enlarge an original negative and expose both one-step- and two-step-process films. Before you start the exposure process, make sure that your work area is free of dust, that your unexposed film is secure in the paper safe, and that your room is a little darker than you have it when printing normal black-and-white film.

1. Using an enlarger, project the original negative to the desired size onto either a regular paper easel, a contact print frame, or a piece of glass.

2. If you are using glass or a contact print frame, place blue painter's masking tape on the baseboard to mark where the image is reflecting onto the glass.

3. Using a "scrap" piece of film identical to the kind of film you will be using to make your final, focus the image. (Negative-to-negative film should be positioned so that the notch is in the upper right corner. Negative-to-positive-to-negative film should be placed emulsion side [milky side] up.) Once you're satisfied with the focus, remove this film. If you are using a contact print frame, make sure that you put the focus film inside the frame so that it will be at the same depth as the new piece of film when you are making your exposure.

4. Following the orientation guidelines in step 3, remove the unexposed film from the paper safe and position it in the easel/contact print frame/glass.

5. Place a piece of black paper between the film and the easel/contact print frame/glass to ensure that no marks on the easel or baseboard will be reflected back onto the film during the exposure.

6. Close the lens down for sharpness (f/11 should work well)

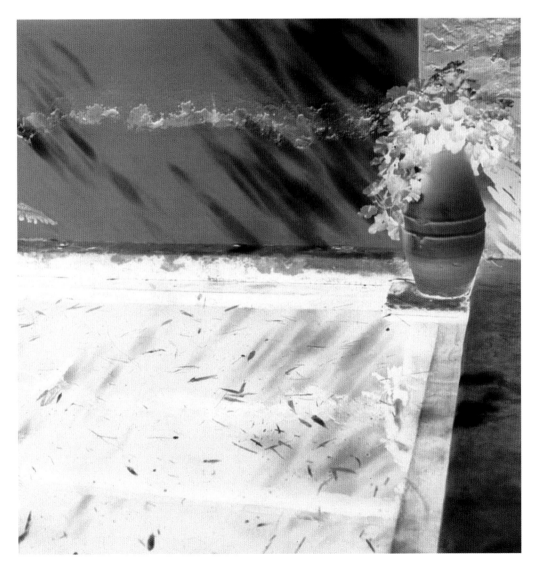

Yves St. Laurent Garden, Morocco, 1999. *I originally shot this image with a 2¼ x 2¼-inch Hasselblad camera using Kodak T400CN film. I then made an interpositive and an internegative using Bergger BPFB-18 film and the two-step process. A kallitype print of this image can be seen on page 97.*

and make a test strip. For negative-to-negative films, expose the test strip at 40-second intervals. For negative-to-positive-to-negative films, expose the test strip at 5-second intervals.

Develop the test strips according to the instructions below. You need to expose the film longer if (1) you are using negative-to-negative film and the test strip is *black* or (2) you are using negative-to-positive-to-negative film and the test strip is *white*. To determine the correct exposure, look at your film on a light box after the film has gone through the developer, stop, and fixer. You want to make sure that you have detail in the highlights and shadow areas.

Once you have determined the proper exposure time for your final, follow steps 4 and 5 to position the film, then expose it for the estimated time. If you are using negative-to-positive-to-negative film, you can burn and dodge at this stage as you would if you were making a regular print; however, if you are exposing duplicating film at this stage, you need to do the opposite of what you are used to doing. In other words, if you want to make something darker, dodge and give it less time; if you want to make something lighter, burn in and give it more time.

DEVELOPING YOUR FILM

Internegative film is developed in much the same way as regular 35mm film. The main difference is that instead of being developed in a canister, it is developed in trays (similar to the way regular black-and-white prints are developed). During the development process, the film is delicate and can easily be scratched. Therefore, it is important not to put more than one piece of film in any single tray at the same time. Internegative film can also be fogged easily, which is why it is important to use a *red* safelight (or a very dark room illuminated by an *amber* safelight) as well as to keep the film in a paper safe when you're not using it.

Each of the various kinds of film that can be used to make internegatives is developed slightly differently. Development times are determined by a number of variables. The times listed below should be used as guidelines; you will fine-tune this process through trial and error. Develop your film according to the instructions listed in the appropriate paragraph below and then jump to the numbered steps for the remaining processes. All chemicals should be room temperature (between 68°F and 71°F).

If you are working with duplicating film, try Kodak Dektol that has been diluted with distilled water at a ratio of 1:1. Develop the film for 2½ minutes, using constant agitation. If you take the film out of the developer before 1½ minutes, you will get streaks. Also watch for fingerprints. If an image appears at 45 seconds but then gets too dark, dilute your developer more and try again with another piece of exposed film.

If you are working with Kodak Ortho or Arista APH halftone (negative-to-positive-to-negative) film, try Dektol that has been diluted with distilled water at a ratio of 1:7, using constant agitation. Develop the film for 3 minutes. Your image should come

up at about 45 seconds. If the image comes up too soon, you need to decrease your exposure. As was mentioned earlier, it is sometimes desirable to make the interpositive a little on the flat side when working with two-step-process films. To control the contrast of the interpositive, you can use Dektol that has been diluted anywhere from 1:1 up to 1:15. The more diluted the developer is, the flatter the image will be. When the developer is this diluted, it goes bad quickly, so make sure that you change the developer often (after every four or five negatives). You can use any paper or film developer to get continuous-tone quality or you can use orthochromatic developer (which comes in two parts: A and B) to get a contrastier result.

If you are working with Bergger BPFB-18 (negative-to-positive-to-negative) film, try Dektol that has been diluted with distilled water at a ratio of 1:2 for 5 minutes, using constant agitation. If the image comes up too fast, it is better to decrease your exposure time than to pull your film early from your developer. Taking the film out of the developer before 5 minutes can cause streaks throughout the image. Bergger film is flatter than the other orthochromatic films mentioned.

After the film is developed, proceed with the following steps:

1. Holding the film with a pair of tongs, allow the developer to drain off, then transfer the film to the stop bath. Agitate for 30 seconds.

2. Using tongs again, allow the stop to drain off, then transfer the film to the fixer. Agitate for 2 to 6 minutes, depending on the kind of film you are using. Kodak, Arista, and duplicating films, which are thin, don't require as much time in the fixer as does Bergger, which is thick.

3. Rinse the film for 1 minute under running water. If the internegative/interpositive is too thin, refer to the section on enhancing your negatives on the facing page before proceeding to the hypo clearing agent bath.

4. Transfer the film to the hypo clearing agent or perma wash. Agitate it for 1 minute.

5. Rinse the film for 15 minutes under running water.

6. Fill a tray with water and place 1 drop of Photo-Flo in it. Place the film in the tray, agitate for 5 to 30 seconds, and lift the film out by one corner. Make sure you do not overagitate or lift the film out too quickly, which will cause bubbles.

Hang the internegative/interpositive to dry on a clothesline by clipping one *corner* of the film with a clothespin. (This is important because wherever the film touches a clothespin there will be a mark.) Once the internegative/interpositive is dry, store it in a plastic sleeve made for sheet film or prints.

If you are using negative-to-positive-to-negative film, you will also need to follow the steps listed in Exposing Your Film (Part 2) on the facing page before you achieve the final desired result—an internegative.

ENHANCING YOUR INTERNEGATIVES/INTERPOSITIVES

If your internegatives/interpositives are too thin, you can use selenium toner after the first rinse. The selenium toner does not increase the grain or change the shadow areas. However, because it adheres to silver deposits and because its reddish-purple hue holds back light, the toner increases the density of the highlights, which helps even out your internegatives/interpositives for contact-printing purposes.

Ideally the selenium toner should be used after the film has been rinsed and before it is placed in the hypo clearing agent (or perma wash). However, if your internegatives/interpositives are already fully processed and dried, soak them for 10 minutes in water so that the emulsion softens, then process them in the toner as described below.

Method 1. (Combined-step Method)

1. Fill a tray with a solution of 2 parts hypo clearing agent (or perma wash) to 1 part selenium toner.

2. Place the internegative/interpositives in the tray and continuously agitate for 5 to 10 minutes.

Method 2. (Separate-step Method)

1. Fill a tray with a solution of selenium toner mixed 1:3 with water.

2. Place the internegative/interpositives in the tray and agitate it for 5 to 10 minutes.

3. Fill a second tray with hypo clearing agent (or perma wash).

4. Place the internegative/interpositives in the second tray and agitate it for 3 minutes.

Once you have toned the internegatives/interpositives, wash and dry them as you would normally.

EXPOSING YOUR FILM (PART 2)

The instructions in this section only pertain to negative-to-positive-to-negative film, which (as was mentioned earlier) involves a two-step process. Expose and develop the film as described in the previous sections. With two-step-process films, this first step results in the successful creation of an interpositive (enlarged positive). Once the interpositive is dry, you will need to make an internegative (enlarged negative). There are two different methods—using a contact print frame and using plate glass. For both methods follow steps 1 through 3 listed below, then follow steps 4 through 7 under the method of your choice, and finally continue with steps 8 and 9.

1. Place an empty negative carrier in the enlarger so that the light from the enlarger will be controlled on the table or baseboard.

When you are developing both interpositives and internegatives, carefully run the sheets of film one at a time through the chemical trays to avoid scratches.

2. Turn the enlarger on and raise it to the proper height for the size you are making the internegative. Make it slightly larger for full coverage.

3. Mark the table or baseboard with painter's masking tape so that you know where to place the contact print frame or glass plate.

Method 1. (Contact Print Frame Method)

4. Place the interpositive on the glass, shiny side toward the glass.

5. Place the new film on top, emulsion (milky) side down.

6. Place a black piece of paper on top of the film.

7. Close the contact print frame and turn it right side up, positioning it within the blue tape marks.

Method 2. (Plate Glass Method)

4. Place a piece of black paper on the table underneath the enlarger, positioning it within the blue tape marks.

5. Place the new film on top of the paper, emulsion (milky) side up.

6. Place the interpositive on top of the film, shiny side up.

7. Place a piece of plate glass on top of the interpositive.

Now you are ready to expose the film.

8. Open up the enlarger to at least f/8 so that any dust will not show.

9. Expose the film.

As you did when creating the interpositive, you should make a test strip before exposing the final internegative. Your test strip should be spaced at 4-second intervals and developed in the same manner as the interpositive. (*See* Developing Your Film, page 64.)

ALTERNATIVE TECHNIQUES

There are many ways to achieve a desirable internegative. The main thing to keep in mind is that the internegative needs to be the size that you want the final image to be. I cannot possibly mention here every technique that can be used to make an internegative, but I have picked a few to get you started.

CONTACT-PRINTING TECHNIQUE

To save film costs, you can contact-print 35mm negatives several at a time onto orthochromatic film (making sure that all the negatives are the same exposure) to create small interpositives. After developing and drying the film, cut the positives and, using an enlarger, project these onto large film to make internegatives.

PAPER NEGATIVE TECHNIQUE

Using a black-and-white RC print or Xerox as a paper "negative," you can contact-print the image onto sheet film, thus creating a same-size negative. This negative is not usually as sharp as a film negative would be, but it can be used to create lovely results. When you contact-print the paper "negative" onto orthochromatic film, you will automatically create an enlarged negative with more contrast. Therefore, you should make sure that the original paper "negative" is lower in contrast than would normally be desired and that you have burned and dodged to get the detail that you want.

PINHOLE CAMERA TECHNIQUE

You can also use a pinhole camera (which is essentially a box that has been punctured with a pinhole that acts as a lens) to get an original large-format negative. Photographs made with pinhole cameras have wonderful depth of field because everything in front of the camera is equally in focus. You can make a pinhole camera easily yourself or buy one already made from a number of companies, including the Pinhole Resource Co. (*See* Sources, page 155.)

POLAROID FILM TECHNIQUE

You can use Polaroid type 55 positive/negative film to make an original 4 x 5-inch negative. I tend to use this film with my pinhole camera, but you can use it with any 4 x 5-inch camera. The film gives you both a positive and a negative and does not need to be developed in the darkroom. If you plan to use the film outside your studio, however, you need to bring a small plastic container filled with hypo clearing agent (or perma wash) so that you can fix the film immediately. This film can be quite delicate. I find that it helps to put small pieces of paper towel in between the exposed negatives while they are soaking in the hypo clearing agent/perma wash so that they don't scratch each other. One bit of advice: The positives always look very white and overexposed, so do not pay much attention to the positive as far as exposure is concerned. Look at the positive for composition evaluation only.

COLLAGE/PHOTOGRAM TECHNIQUE

A photogram is a camera-less photograph that is made by placing one or more objects between a light source and coated paper. Collages are made when you cut and paste different materials to make one end product. These are fun ways to skip the internegative step and make one-of-a-kind images. If you want to repeat what you are making, place these objects onto one of the films mentioned in this chapter and make a photogram that you can use over and over again.

TROUBLESHOOTING

A lot of little things can happen to the film from the time you take it out of the box to the time when you place the finished internegative in its protective sleeve. These tips are meant to help you fix the most common errors.

- If you discover little black fingertip-shaped spots on your interpositives or internegatives, you have probably touched chemicals and contaminated the film. I keep a bottle of liquid soap in my darkroom and wash my hands (and thoroughly dry them) after each chemical run. I use tongs or gloves when running film through chemicals, but wash my hands often to make doubly sure that I do not get fingerprints in the image area.

- If you discover scratches on your film, you are probably putting too many pieces of film into a tray at a time. When creating internegatives and interpositives, it is important to put only one piece of film into a tray at one time.

- If your film has streaks, you need to watch how you drain the developer off the film when processing it. Picking the film up by one corner and letting it drain on the diagonal can cause a streak of extra density through the center of the image. Hold the film so that it will drain off the edges, then place it into the stop bath. I tend not to drain my film very long, but to compensate I change my stop bath often. Streaks can also come from putting the film into the developer too slowly. Make sure that you put the film into the tray in one sweeping motion and that you agitate it immediately. Also, make sure you are generous with the amount of developer in the tray. If you have too little developer, messy blotches of uneven density are likely to appear, and you increase the possibility that the film will stick to the bottom of the tray.

Italy Flowers, 1999. *I originally shot this image with a 2¼ x 2¼-inch Hasselblad camera using Kodak T400CN film, then made an interpositive and an internegative on Bergger BPFB-18 film. A cyanotype print of this image can be seen on page 85.*

American Church Garden, Florence, 1999. *As with the image above, I originally shot this image with a 2¼ x 2¼-inch Hasselblad camera using Kodak T400CN film, then made an interpositive and an internegative on Bergger BPFB-18 film. A palladium print of this image can be seen on page 118.*

CREATING DIGITAL INTERNEGATIVES

This section assumes that the reader has some knowledge of Photoshop and scanners. Making digital negatives is labor-intensive for the novice and, in my opinion, this process should be preceded by taking a course in Photoshop or by doing tutorials on your own. (Dan Burkholder's book *Making Digital Negatives for Contact Printing* is a wonderful resource for in-depth instructions.) This is not something that you can master in an hour, but the instructions here will get you started. The major benefit of sticking with this process is that once you perfect your style, you'll find that making digital internegatives can be faster than making internegatives in a wet darkroom—especially if you are making multiple copies.

There are several ways to make digital internegatives, all of which have their advantages and disadvantages. The most expensive way is to get your negatives professionally drum scanned, then take them to an image setter (called a service bureau) to have whatever size negative you need made. The scans and negatives can be used to make beautiful reproductions and the process is relatively painless because someone else is doing it for you. There is nothing wrong with this method, but personal scanners and printers are becoming less expensive and can create excellent internegatives, so more people are learning how to do it themselves.

If you are going to make the digital negatives yourself, you have two options. You can either capture your digital image with a digital camera, or you can scan a photograph, slide, or negative. You can also do a "live scan" by placing an object on the scanner so that it looks like a photogram. If you used a digital camera, then you can skip the information about scanning and jump to the material about adjusting the image.

Most photographers are very aware of the archival properties of prints and of the fact that extensive exposure to sunlight (ultraviolet light) can cause them to deteriorate. One thing that many photographers *don't* think about is how ultraviolet light affects alternative printing processes—and in particular how it affects digitally generated negatives. Because the very act of contact-printing involves exposing internegatives to *ultraviolet light,* the process of creating final prints causes negatives to degrade more quickly than they would if you were printing with another method. Therefore, I suggest that you make an extra copy or two of each negative and store them in a dark box. Alternatively, you can keep a record of the settings you used to print a negative, then pay careful attention to your prints and make a new negative when you notice that your images are not coming out as well as they once did. The film used by image setters is not the same as the acetate used in a home ink jet printer. A digital negative printed out by an image setter will last as long as any other conventional film.

Depending on your printer, it can take from 5 to 12 minutes to print out your computer-generated internegative. Once the transparency emerges, remove it and place it face up in a dust-free area to dry for several hours before using it to make a print.

GETTING STARTED

It goes without saying that you need decent, up-to-date equipment to get great digital internegatives—and to enjoy the process of making them. This includes a memory-rich computer, one of the newer versions of Photoshop, and a really good ink jet printer. If you are going to be starting with traditional images, you will need a good scanner (either film or flatbed, depending on whether you are going to be scanning slides and negatives or reflective/flat art); if you want to begin this process digitally, you will need a good digital camera. I also suggest getting a CD or DVD writer so that you can save your work and keep your hard drive clean of images. And finally, you will need transparency film. Several companies make transparency materials. Try several to see which one you prefer to use for the type of images you are making.

SCANNING AND ADJUSTING YOUR IMAGE

Begin the process by selecting an image—slide, negative, or print—that you want to work with and scanning it at 360dpi or higher. Remember that you are going to use these negatives to make contact prints, so you want all the detail in the original piece to be in the final internegative. While I'm working I am pretty crazy about how often I save my images. Every time I do anything I save it (using the "save as" feature) and rename the file so that if my computer crashes or I do not like the way I changed something at any point, all my information is safe. Whether you "save" or "save as" is up to you and up to the space capacity of your hard drive! It is like coming up with your own filing system. See which approach is best for the way that you work.

1. Once you have scanned the image, save it as a TIFF file in Photoshop.

2. Create a positive image. Some scanners automatically turn a negative image into a positive image. If your scanner does not have this feature, invert the negative image through the Image>Adjust>Invert command.

3. Enhance the tonal quality of the image by adjusting the curves and levels. This can be achieved through either the Image>Adjust>Curves command or the Image>Adjust>Levels command. Try to create the best-looking positive image possible. This stage can be compared to working on a print in a darkroom, but the great thing about working on the computer is that you don't have to run paper through chemicals before you see the results of your work. Inspect the image carefully as you work, paying particular attention to the tones in the highlights and shadows as well as the midtones.

4. Spot all the dust and scratches by using the Rubber Stamp tool. Make sure to enlarge the image so that you can see even the smallest spots.

5. Sharpen the image by using the Filter>Sharpen>Unsharp Mask command. Under Unsharp Mask, there are several settings that can be adjusted. A good starting point is: Amount = 155, Radius = 2.0, and Threshold = 1. If you have never used this filter before, experiment with it by going to the extreme ends of the settings so that you can see what they do. You do not want to sharpen too much because it will make your final negative look pixellated (which is similar to reticulation in a traditional negative).

Cartagena Church, 2001. *I made this 6 x 9-inch computer-generated internegative on an Epson ink jet printer. I shot the original 35mm negative with a Nikon N90S using Kodak HIE 35mm infrared film, scanned it into the computer using a Nikon negative scanner, then printed it on Pictorico OHP transparency film. A hand-painted black-and-white print of this image can be seen on page 145.*

6. At this point, you may want to make final adjustments. For instance, you might want to readjust the curves or levels. You will determine this by trial and error, much as you do when making internegatives in the darkroom. By practicing, you will learn to gauge what characteristics in your negatives work best for you.

7. Set the image size by using the Image>Image Size command.

8. Invert the image from a positive to a negative by using the Image>Adjust>Invert command.

At this stage in the process Dan Burkholder suggests "loading" curves that have been specially made for outputting digital

Wash Basin, 1993. *I shot this image for* American Heritage Magazine *for a story on Willa Cather. I made this internegative using the same techniques described in the caption on the facing page. A palladium print of this image can be seen on page 106.*

negatives. He has made one curve for platinum printing and another for silver printing. These curves make the on-screen image look very pale, but the resulting printout will be fine. There are a number of ways to create these curves. Buying his book is the obvious shortcut, but you can also create them yourself through experimentation. I suggest working with a few images, taking good notes, and trying out different variables. I have found that no matter what someone says about the "correct" curve, successfully reaching your desired end product depends on your image, your monitor, your printer, and your style of alternative process printing.

PRINTING YOUR INTERNEGATIVE

The next step is printing the internegative. Of course, the question is, which printer should you use? The quick answer is to use an ink jet printer that can give you high-resolution results. "Older" printers—even printers that are just a few years old—may give an inconsistent dot pattern, so make sure your equipment is up-to-date. At the time that this book went to press laser printers did not produce a fine enough tonal range for perfect digital negatives. However, this may soon change, so discuss your particular needs with someone who is knowledgeable about technology before purchasing any major equipment.

When you are ready to set up your printer for output, you need to make a number of adjustments before you can print the image onto transparency film. The instructions may vary depending on the type of printer, but once again, I offer a starting point. Most of the adjustments that follow are made in the Page Setup dialog box. Go to File>Page Setup, then make the necessary changes.

1. Adjust the paper size function so that it matches the size of your transparency film.

2. Adjust the orientation to either portrait (vertical) or landscape (horizontal).

3. Reduce or enlarge your image, as desired. (Note: It is desirable to size your image earlier in the process and print it at 100%.)

4. Define the printable area. Do you want the image centered on the page? If so, check where it says "centered." I usually center my images so that I have margins that are safe to touch all around the image area.

5. Decide whether or not you want registration marks. If you are going to do multiple printing (i.e., do more than one process on one sheet of paper), you may want to put registration marks on your negative.

6. Select "Options." A new window will appear with additional choices.

7. Determine your media type. Select photo-quality ink jet paper. Even though you are using transparency film, select the paper setting, as this will allow you to choose a higher dpi than if you selected transparency film. This is very important for higher-quality negatives.

8. Define your mode. Select "Custom," and once the new dialog box appears, select "Advanced."

9. Select the type of ink you want to use—color or black and white. Now, this is a can of worms! I have been advised to print in color even when the image is grayscale. The logic is that this process applies more inks, making the negative cleaner and the tones better. However, I have done it both ways and found that both produce good results, so try both and see which you prefer.

10. Define your print quality. This depends on the printer you are using. For example, at the time that this book was printed, the Epson1280 could go to 1440dpi while the Epson 2000P could go as high as 2880dpi. By changing the setting to photo-quality ink jet paper, you can select the highest dpi that your printer will allow.

11. Uncheck "High Speed." At this point, both "Microweave" and "Finest Detail" should be checked (and grayed out so you cannot change them), but check this. (These are the Epson terms. Other printers have similar settings with different names.)

12. Determine the color management details. First, check "PhotoEnhance4" and several options will appear, including "Tone" and "Effect." The prompts you receive under each of these categories will depend on the type of printer you are using. For instance, on the Epson1280, the options under "Tone" are "normal, hard, vivid, sepia, monochrome." I have been printing on "hard" simply because that is how I learned, but do a test to see which you prefer for your image. Under "Effect," select "Sharpness>Digital Camera Correction."

13. Select "Save Settings" and give this printing profile a name. This way, the next time you print this (or a similar) image you will not have to select all these options again.

14. Hit "OK." Go to File>Print. Check one last time that all your settings are correct, then hit "Print."

It will take a few minutes for your negative to print. (The higher the dpi, the longer the image will take to print.) The negative takes about an hour to dry and can then be sprayed with workable fixative to protect it against scratches. Store the negatives in plastic negative sleeves.

Willa Cather's Bedroom, 1993.
I took this image during the shoot for the Willa Cather story described in the previous caption. I made the original negative with a Nikon N90S using Kodak HIE 35mm infrared film, then scanned the negative into the computer using a Nikon film scanner and printed it out, using an Epson ink jet printer, onto Pictorico OHP transparency film. This internegative is 6½ x 9½ inches. Two different kallitype prints of this image can be seen on pages 98 and 99.

INK JET TRANSFERS

EVER SINCE THE 1980S, when color copy centers became prevalent, artists have flocked to copy stores and made cheap renditions of their artwork, then hurried home to transfer these copies onto watercolor paper and other supports. With these kinds of "prints" it was necessary to use fresh color copies so that the dyes would not sink into the copy paper. The copy paper was soaked with solvent and then rubbed so that the dyes would be transferred to the new supports. Personally, I experimented with all sorts of solvents—lighter fluid being one—that were not particularly healthy to use but that produced interesting results.

Thankfully, we have healthier (and easier) alternatives available today. Throughout the 1990s ink jet printers continued to become cheaper and better—so much so that now they are almost a staple in most studios and homes. So how long do you think it took visual artists to figure out how to transfer ink jet prints onto other materials? About five minutes!

Several years ago a student of mine came to class and showed me a piece she had done that looked like a Polaroid transfer but didn't have the Polaroid film borders. Looking closely I saw some strange lines and then noticed that some areas were sharp while others were soft—similar to the look of a watercolor painting. I immediately asked her how she did it and was amazed to learn how simple it was to accomplish.

The process of making ink jet transfers is fun, fast, and easy, and allows you to transfer computer images onto almost any surface. You have some time to manipulate the image depending on whether you use wet or dry supports and how long it takes for the inks to dry. As with making digital internegatives, making ink jet transfers is a way to utilize your computer, which means that you can readily duplicate your results. As for wondering how long the prints will last, check on the Web site www.wilhelmresearch.com for the latest information on inks and papers.

Montana Feathers, 2000. *This was a close-up photograph of a Native American headdress that I wanted to make into an abstraction. Printing this out as an ink jet image allowed me to blend the feathers together so that they created a design.*

Opposite page:
New Jersey Shore, 2000. *I printed this ink jet image on the dark side and then, using a small brush, I blended the colors selectively, leaving some areas alone, so that the different textures could play off each other in the final image.*

USING INK JET PRINTERS CREATIVELY

The past few years have witnessed a huge leap in technology and ink jet printers have become wonderful creative tools. The beauty of this process is that you can do it at home and use images that you have downloaded or scanned into your computer. Keep in mind that you will not get a sharp rendition of your original photograph. However, some artists work hard at distressing the image, so if your image is not perfect, you can pretend that you worked really hard to achieve that "effect." This section includes advice about the basics, but experimentation is crucial—as is saving your images as you make changes and print them out.

GETTING STARTED

To make ink jet transfers you need a computer setup similar to that required for digital internegatives. The primary requirement is a computer equipped with an imaging software program such as Photoshop. A flatbed scanner or negative/slide scanner is helpful, but if you are using a digital camera, a scanner is not necessary. You also need a high-quality ink jet printer. It is wonderful if your printer is equipped to use archival inks, but this isn't crucial. I have an Epson 1280 that is set up with inks that are said to have a long life, as well as a 2000P; my family printer is an Epson 740. They all print beautifully. The main difference between them is the number of inks that are used.

In addition to the equipment mentioned above, many of the items required to make ink jet transfers are standard darkroom materials, discussed in Chapter 2. (*See* Basic Darkroom Equipment and Materials, page 12.) Before you get started, make sure that you have the following items on hand:

Brush	**Hair Dryer**
Cups and Bowls	**Paper Towels**
Distilled Water	**Tray**
Drying Screens	**Watercolor Pencils or Paints**

In addition, you should note the following:

Computer Image High-resolution TIFFs generally create the best transfers. Make sure your digital files are sharp and have good contrast.

Transfer Paper Any waxy paper will work for this process. For instance, label sheets that are designed for computers have a waxy paper backing. This backing is ideal for making ink jet transfer images because you can run the paper through your printer, but the inks do not dry for a long time. Another option is release paper, which is made by a company named Seal. While it was designed to serve as a protective overlay in a dry-mount press, it is also a wonderful surface to use as a transfer paper.

Paper Hot-pressed watercolor and printmaking papers work best for ink jet transfers because they are smooth and therefore the inks transfer evenly. However, you should try cold-pressed papers as well for a more painterly effect.

MAKING YOUR TRANSFERS

Before you get started, make sure you have enough label paper or release paper so that you can play around a little. You will need to transfer the image onto watercolor paper within a few minutes of printing it out and you might want to make more than one print—especially when you're first becoming familiar with the process.

1. If you are using label paper and there are still labels on it, remove them so that only the waxy backing paper remains.

2. Place the transfer paper into your printer, shiny side up.

3. Adjust the image so that it is about 20% darker and about 5% higher in contrast than you would make it for a normal print.

4. Select the highest-quality print mode and print the image.

5. As the image is printing, soak watercolor or printmaking paper in a tray so that it becomes damp. Blot any excess moisture from the watercolor paper using a paper towel.

6. Immediately after the image has printed, remove it from the printer and place it face down on the damp paper.

7. Using one hand to hold the transfer paper firmly in place, gently rub the back of the transfer paper. Make sure the label paper doesn't slide at this point, as this will cause the image to smudge. Once you've rubbed the transfer paper well, carefully lift it off.

8. If you want to blend the inks, lightly wet a brush and then brush the image. As you do this, the inks will start to run and will give you a watercolor effect.

9. Manipulate the image as desired. You can paint the image using watercolor paints or pencils at any point after the image has been transferred. Whether to work on a wet or a dry print is up to you. However, the paper must be totally dry before you use pastel chalks.

10. Once you are satisfied with the print, either use a hair dryer to dry the print or place the paper, face up, on a screen and allow it to air dry.

TROUBLESHOOTING

Making ink jet transfers is probably the easiest process to do in the entire book. Staying playful can give you very interesting results. Nevertheless, there may be things that you won't be able to figure out. I discuss a few of these trouble spots—and how to fix them—below.

- If the final ink jet transfer image looks too light, you may not have adequately adjusted the settings on the computer file. As the initial image comes out of the printer, the colors will look muted (almost as if there is no color). However, when you transfer the inks onto the watercolor or printmaking paper, the image should be adequately dark.

- If the ink jet transfer has a dot pattern, the paper you transferred it to was probably too damp. Try to avoid soaking the paper too long and make sure you blot it with paper towels to dry it out before you transfer the image.

- If the paper pills as you work the image, your brush may be too stiff. Try using a softer brush or a foam brush, which might be gentler on your paper.

- If the image has white lines running through it, the printer has to be cleaned. When using transfer paper, you will need to clean your printer more often than usual because the ink sits on top of the paper instead of soaking into the surface. To clean your printer, select the tool icon in the print window (File>Print>Tool) and follow the instructions for cleaning.

- If the image includes words or numbers and they are backward, go into Photoshop and flip the image before you print it (Image>Rotate Canvas>Flip).

These three images illustrate the simple process of making an ink jet transfer. The initial print on the label paper looks very dull as it comes out of the printer.

Put the ink jet image face down on the watercolor paper. Gently rub the back of the label paper, then carefully lift it off.

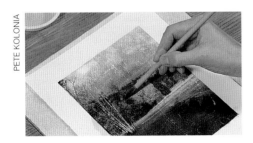

Use a brush to blend the inks together for a watercolor effect.

Montana Farm, 2000. *Here is the final image.*

CHAPTER SEVEN

CYANOTYPES

THE CYANOTYPE—which is also known as ferroprussiate or blueprint—was invented by Sir John Herschel in 1842, when he discovered that ferric (iron) salts could be reduced to a ferrous state by light and then combined with other salts to create a blue-and-white image. Thus, "color" photography was born. Anna Atkins, who was one of a handful of women involved with photography in the mid-1800s, published the first book using photograms (photography) instead of illustrations. The book was called *British Algae: Cyanotype Impressions* and was published in several volumes between 1841 and 1853. In 1854 Atkins produced a larger work entitled *Cyanotypes of British and Foreign Flowering Plants and Ferns.*

Today a variation of the blueprint process is commonly employed by architects and engineers to create architectural drawings. They use precoated diazo paper or vellum to expose drawings that are then processed (by machine) with ammonia fumes. This machine can generate either blue or brown colors. However, unlike cyanotypes, architectural blueprints fade with time because the diazo paper and the ammonia that develops it are not stable.

Cyanotypes can range in intensity from a very light to a deep blue. They can also be toned to create a number of interesting colors. Because they are simple and inexpensive to make and can be created with basic darkroom materials, cyanotypes are a perfect introduction to nonsilver photographic techniques. And, once mastered, this process can be mixed with other nonsilver techniques—such as platinum and palladium printing, as well as hand painting—to create unique effects.

White Room, 1998. I made this cyanotype by exposing a Kodak Ortho internegative made from infrared film for 15 minutes. The print is on Rives BFK printmaking/ drawing paper.

Opposite page:
Delray Beach, 1999. *I took this image with a 4 x 5-inch pinhole camera, exposing the Polaroid type 55 positive/negative film for approximately 5 seconds. I then exposed this negative for 15 minutes to make this cyanotype, which is on Whatman watercolor paper.*

CREATING CYANOTYPES

Cyanotypes are created with a simple solution of ferric ammonium citrate (which provides light sensitivity) and potassium ferricyanide (which provides color). This sensitizer can be used to prepare a wide range of papers, fabrics made from natural fibers (such as cotton or silk), and canvas. Cyanotypes are created by a contact print process (which means that the negative is the same size as the finished product) that involves a fairly lengthy exposure (between 5 and 40 minutes) to ultraviolet light. After the base support is exposed, it is simply washed in water. The resulting print is sometimes light in color, but can be changed to a deep blue by treating it with any of a number of (natural or chemical) acidic baths. The prints can be toned further to create a range of color effects, including red-brown, deep purple, and violet.

The cyanotype technique can be used in conjunction with other processes, including platinum and palladium printing, gum printing, hand painting, and others. Cyanotype images are permanent, provided that they are not washed with harsh detergents. If the color fades (which happens if the print is exposed to sunlight or washed often), placing the cyanotype in the dark for a week or two will restore the color to the original darker blue. Using hydrogen peroxide will bring the cyanotype back to the original color immediately by oxidizing the cyanotype sensitizer.

While many photographers use enlarged negatives to make cyanotypes, it is also possible to place objects on a sensitized support and create a photogram. One day the right supplies did not show up for my experiments class, so I took some seamless paper

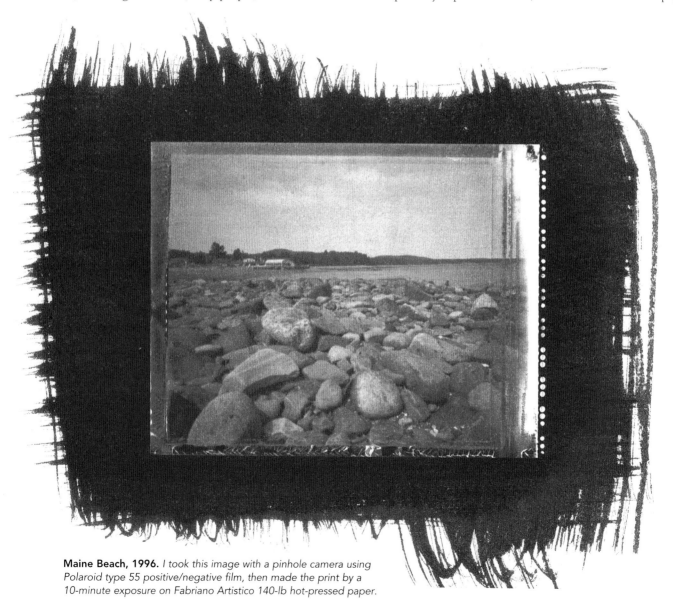

Maine Beach, 1996. *I took this image with a pinhole camera using Polaroid type 55 positive/negative film, then made the print by a 10-minute exposure on Fabriano Artistico 140-lb hot-pressed paper.*

from the studio and had my class coat it with cyanotype sensitizer. We dried it, covered it with Saran Wrap, then rolled it up and took it outside. We unrolled the paper on the sidewalk along Fifth Avenue, lay down on it, and made a class portrait.

GETTING STARTED

Many of the items required to make cyanotypes are standard darkroom materials, discussed in Chapter 2. (*See* Basic Darkroom Equipment and Materials, page 12.) The major difference is that the chemicals used for the cyanotype process react with metals, which can cause oxidation and staining. Thus it is important that your darkroom is equipped with *nonmetallic* utensils, bottles, and trays.

Before you get started, make sure that you have the following items on hand:

Apron	Gloves
Cheesecloth	Hair Dryer
Clothesline	Mask
Clothespins	Mixing Rod
Contact Print Frame	Newspaper
Cups and Bowls	Pencils
Distilled Water	Plastic Spoons
Drafting Tape	Plexiglas
Drying Screen/Blotter Book	Scale
Fan	Tongs
Glass	Wax Paper

In addition, you should note the following:

Brushes Sponge brushes work well for cyanotypes. If your bristle brushes have metal on them, you can use nail polish to cover the metal so that no contamination will occur.

Glass Rod If you desire clean, straight edges, you can use a glass rod instead of a brush to sensitize your support.

Graduates You will need three small graduates to measure stock solutions when making the working solution.

Storage Bottles If you are mixing your own sensitizer, you will need three one-pint dark brown *plastic* or *glass* bottles. I usually mix the toners fresh, as I need them, directly in the trays. More often than not the toners are exhausted by the time I am finished with them, so I do not save them in bottles. However, there is always the possibility that you will need a few extra bottles for some toners.

Trays You will need one *plastic* tray for washing your prints and as many as seven extra *plastic* trays for toning them (depending on how many toners you are going to use).

BASE SUPPORTS

A wide range of base supports can be used for this process. How to decide on a base support is going to be a personal journey into materials and trials and errors. I sometimes find that I tell my students that they *have* to do one thing, only to be proven wrong by a wonderful project. So if you have an idea, try it out.

Paper Supports Virtually any paper (except for alkaline-buffered paper) can be used for cyanotype printing. Papers that have good wet strength (i.e., etching and watercolor papers) work best. However, as always, the key is to experiment. Rice papers and most 100% rag papers also work well. One of my students made some great cyanotypes using subway maps. Take-out menus, coffee filters, paper bags, and paper towels can also work. Just remember that paper with a high acid content will not be archival and may yellow within a year or two.

Fiber Supports Supports that are made entirely of all-natural fibers (such as cotton or silk) work well for cyanotypes. If the support contains any synthetic fibers, the image will not have strong, even blue tones. Duck canvas generates especially rich blues. Canvas can be sensitized as is—unless it has gesso on it, in which case it should be sized with either Knox gelatin size or gelatin and hardener size before it is sensitized. (*See* Sizing Formulas, page 22.)

CHEMICALS

If you want to mix the sensitizer yourself, you will need to buy ferric ammonium citrate, potassium ferricyanide, and potassium dichromate (all of which come in crystal form). If you want to tone your prints, stock up on hydrogen peroxide, tannic acid, sodium carbonate, household ammonia, gallic acid, and pyrogallic acid. (*See* Altering the Color of Your Print, page 84.) If mixing sensitizer from scratch is not for you, you can purchase cyanotype kits from a number of companies. Another option is a single-solution sensiziter invented by Dr. Mike Ware, a chemist-turned-photographer from the U.K., which is believed by some to be more light sensitive and to generate a richer blue than traditional cyanotype sensitizer. Luminos, Bostick & Sullivan, and Photographers' Formulary all carry both the kits and Dr. Ware's sensitizer. (*See* Sources, page 155.)

LIGHT SOURCES

When you are mixing cyanotype chemicals or coating your support, your workspace should be illuminated with subdued "white light" (such as a normal 40-watt household bulb). Regular fluorescent bulbs should be turned off at this stage because they contain small amounts of UV light. Once the support is coated with the sensitizer you can either force it dry by using a hair dryer on a cool setting or let it dry naturally by air (or by using a fan). If you are going to leave the support to dry on its own, you need to darken the room. The best approach is to leave the support in darkness or as close to darkness as you can get your workspace.

You can expose cyanotypes in natural light or in a UV light box equipped either with black-light bulbs or with aqua bulbs.

(*See* Light Sources, page 18.) Exposure times can range from 5 minutes in bright summer sunlight to 40 minutes in a small exposure unit.

NEGATIVES

As stated above, making cyanotypes involves a contact print process that requires negatives the same size as the finished product (*if* you are going to use negatives, see below). Cyanotypes do not have as great a tonal range as black-and-white prints, so some details will inevitably be lost. However, there are a few things to look for in your negatives. First, make sure they are not overly dense; otherwise, the exposures will be too long and burning may occur. Second, avoid overly flat negatives, which will create cyanotypes with poor blue tonal quality.

Cyanotypes can also be made without enlarged negatives. Photogram materials—such as glasses, beakers, plates, fruit, lace, and leaves—can create wonderful images, as can drawings made with a wax pencil or charcoal on either tracing paper or acetate. Printing from a collage of small (35mm) negatives or using paper negatives is an additional option.

MAKING YOUR STOCK SOLUTIONS

Cyanotype chemicals can be bought in many forms—in bulk in crystal form, as a kit, or premixed. (*See* Sources, page 155.) Cyanotype sensitizer is made from a combination of ferric ammonium citrate, potassium ferricyanide, and potassium dichromate as an optional contrast booster. Other chemicals (which are listed later) can be used as toners to change the color of a print from deep blue to red-brown, violet, or green.

SENSITIZER

Each of the following three stock solutions should be mixed *at least* a day before being used to make sensitizer (your "working solution"). Use only distilled water to mix stock solutions. Since the three basic chemicals have similar names (and therefore may be easily confused when mixing sensitizer), I have found it helpful to label each solution with its chemical name as well as "A," "B," and "C," respectively. Store your solutions in dark brown glass or plastic bottles. Each solution will keep for about 6 months.

FERRIC AMMONIUM CITRATE

This solution provides light sensitivity to the sensitizer.

250ml distilled water

50g ferric ammonium citrate

Pour the distilled water into a Pyrex measuring cup. Gently sprinkle the ferric ammonium citrate onto the water. Stir with a mixing rod until all the crystals have dissolved. Pour the solution into a dark brown glass or plastic bottle. Label this bottle "Ferric Ammonium Citrate/Cyanotype A." This solution may form mold after a few weeks. If this happens, simply skim the mold off or filter the solution with a cheesecloth and use it as if nothing had happened.

POTASSIUM FERRICYANIDE

This solution provides the distinctive color to cyanotypes.

250ml distilled water

35g potassium ferricyanide

Pour the distilled water into a Pyrex measuring cup. Gently sprinkle the potassium ferricyanide onto the water. Stir with a mixing rod until all the crystals have dissolved. Pour the solution into a dark brown glass or plastic bottle. Label this bottle "Potassium Ferricyanide/Cyanotype B."

POTASSIUM DICHROMATE

This solution provides contrast if your negatives are too flat or if you feel that the blue is not coming out strong enough in your prints.

100ml distilled water

1g potassium dichromate

Pour the distilled water into a Pyrex measuring cup. Gently sprinkle the potassium dichromate onto the water. Stir with a mixing rod until all the crystals have dissolved. Pour the solution into a dark brown glass or plastic bottle. Label this bottle "Potassium Dichromate/Cyanotype C."

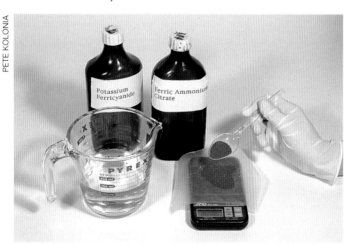

Here are a few of the materials you will need to mix stock solutions: dark brown glass or plastic bottles, a Pyrex measuring cup, distilled water, plastic spoons, and a scale.

PREPARING YOUR SENSITIZER

Before dispensing chemicals, make sure that your room is prepared properly. First of all, you should be working in subdued light, such as a room illuminated with a 40-watt bulb. Cyanotype sensitizer stains anything it comes in contact with. You may not see the sensitizer until you turn on the lights (which exposes the chemicals, causing them to turn blue), so you have to be careful. Before you mix the sensitizer, cover your table with newspaper to protect your workstation. It might be a good idea to wear an apron, a smock, or an old shirt to protect your clothing. Try to keep the area clean throughout the process by changing the newspaper frequently.

Cyanotype sensitizer (the working solution) should be used shortly after it is mixed. It should not be stored for more than a few days. It is so easy to combine the stock solutions that there is absolutely no reason not to create fresh working solution as you go. Once you are ready to sensitize your base support, mix the working solution as follows:

1. Evaluate how much working solution you will need, noting that 2 ounces of the working solution will be enough to coat approximately 10 sheets of 8 x 10-inch paper, with a little overcoating.

2. Find a cup or bowl with an opening that is wide enough to accept your brush and deep enough to hold your working solution.

3. Using one small graduate for each stock solution, mix solution "A" with solution "B" at a ratio of 1:1.

4. Adjust the working solution according to your individual needs: (1) If your negative is very contrasty, weaken the solution by adding a little distilled water. (2) If your negative is flat, add some of the potassium dichromate stock solution ("C"). (About 6 drops of solution "C" per 2ml of working solution is a good starting point.) (3) If you want to make the working solution faster (i.e., speed up the exposure time), add more ferric ammonium citrate ("A").

Italy, 1999. *I made this print by exposing a Bergger BPFB-18 internegative on sensitized Strathmore Bristol 500 series for 10 minutes. I made this image lighter than most of the others because I felt that it enhanced the delicate balance of the doorway, vine, and wall.*

COATING YOUR BASE SUPPORT

Before you begin coating, your workspace should be covered with newspaper to protect the surfaces, and remember that you still need to be working in subdued light. While coating your base supports, make sure that you are not near any windows or fluorescent lights.

If you are using paper as the base support, you can use the brush method, glass rod method, or tray method for coating the sensitizer. (*See* Sensitizing Techniques, page 25.) With the brush and glass rod methods, you need to pay particular attention to working neatly. If you get sensitizer on the back of the paper, it will show through on the front of the image as a stain. Using a sheet of paper bigger than the negative size will make it easier to not go over the edges. A bigger sheet of paper will also provide some holding room without getting fingerprints on the sensitizer. If you are using the tray method, the back should coat evenly, but you will need to be careful about fingerprints along the edges.

If you are using fabric as the base support, you must first remove all the manufacturer's sizing by washing the material two or three times. (Otherwise the sizing will cause the sensitizer to coat unevenly.) If you are going to use the fabric for multiple exposures, you might want to size it yourself at this point. (*See* Sizing Formulas, page 22.) There are several ways to coat a piece of fabric with sensitizer. (*See* Sensitizing Techniques, page 25.)

Keep good notes while you are sensitizing and exposing your support so that (if you like them) you can repeat the results or (if you don't like them) you can figure out what you may have done incorrectly. If you are working with paper or fabric as a support, you can use a pencil to note the following right on the back: the solution (for instance, did you add water or potassium dichromate?), the type of paper, the exposure time, and the light source. If you are exposing outside, you should also write down the time of day and the season.

DRYING AND STORING YOUR BASE SUPPORT

After sensitizing your support, dry it thoroughly before exposing it. (*See* Drying Techniques, page 29.) The sensitizer should appear bright yellow once the support is fully dry. If you decide to use a hair dryer, make sure it is on the "cool" setting, as excessive heat will burn the sensitizer. You will know that you have burned the sensitizer if it appears dark and brownish, instead of bright yellow.

Personally, I like to use my sensitized supports right away. However, other artists have devised systems for preserving their sensitized supports so that they can be exposed at a later time. Erma Yost, an artist who uses cyanotypes in her quilts and other types of fabric arts, preserves her sensitized fabric by wrapping it in industrial-strength aluminum foil, placing it inside a black plastic bag, then storing it in the freezer. (I personally have not had very good luck with this method.) I have read that John Dugdale stores his sensitized paper in a plain cardboard box. In the summer he puts the box in the refrigerator and in the winter he leaves it at room temperature. If his paper happens to darken, he simply chooses denser negatives to expose.

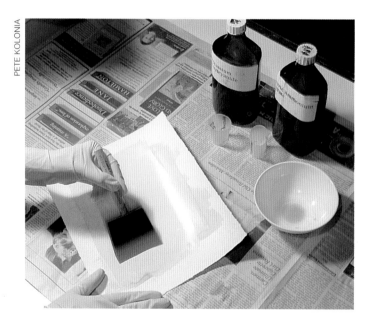

In subdued (40-watt) light, brush your paper both horizontally and vertically to apply an even coat of the sensitizer.

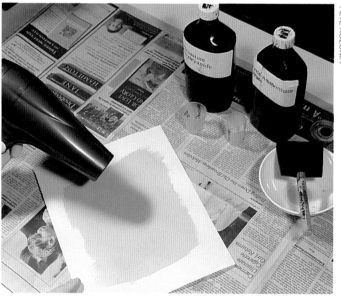

When drying your paper support, use the cool setting on your hair dryer to ensure that you do not burn the sensitizer.

EXPOSING YOUR BASE SUPPORT

Before you expose your support, check it for discoloration. The sensitizer *should* be bright yellow. A blue tone indicates a lack of salts in the sensitizer, which can be caused by contaminated or spoiled chemicals. A brownish yellow tone indicates that the sensitizer has been burned, probably during the drying process. In either case, the support has spoiled and should be discarded.

Exposing cyanotypes is a fairly slow process. A typical exposure can be anywhere between 5 and 40 minutes. Black-light bulbs, aqua bulbs, mercury vapor lamps, and strong sunlight are the best light sources. Sunlamps are not recommended for cyanotypes because they emit too much heat, which can burn the sensitizer/paper or fabric or cause the negative to melt into the sensitizer. The best way to make cyanotypes is with a contact print frame that opens on one side while still holding the negative down on the other.

If you are using fabric, its size will determine whether or not it will fit into your contact print frame. If the fabric is too big or too bulky, use a piece of plate glass that is thick enough to create a

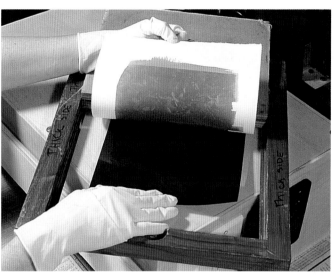

You can check your exposure every 5 minutes or so by lifting one side of the contact print frame. The other side will hold the negative and support in place so that you do not lose your registration.

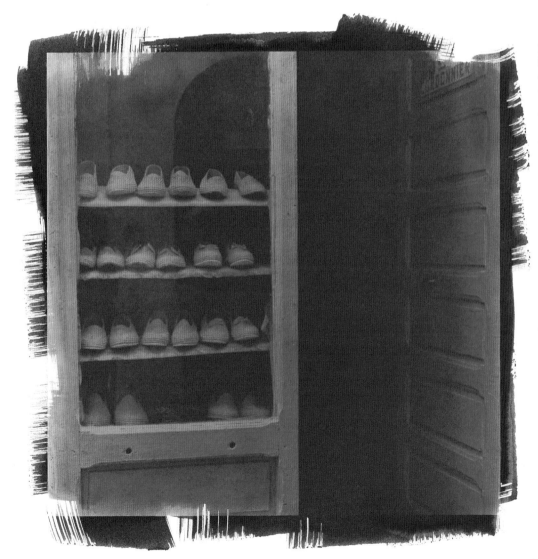

Essaouria, Moroccan Shoe Store, 1999. *I made this print exposing a Bergger BPFB-18 internegative for 15 minutes. The print is on Rives BFK, vellum surface.*

good contact between the negative and the fabric. Be sure to use Scotch Magic removable tape to secure the negative so that you can check the exposure periodically without losing the registration.

Every 5 to 10 minutes you can turn off the ultraviolet light box or take your frame inside and check to see if your exposure is finished. Look at the shadow areas, not the highlights. The longer the negative is exposed, the darker the blues in the print will be. During the exposure the coated support (if it was white to begin with) should change from greenish-yellow to light green to a bluish gray and finally to a blue green. Some papers may become more of a blue-gray. Look for solarized grays in the shadow areas where you want deep blues. The shadow areas should almost look as though they are shimmering. Depending on the support, you might get an olive-green look instead. Just keep in mind that the areas that are light blue will wash out to white.

Some people like to make test strips. I have found this time-consuming and believe that it makes more sense to learn how to check your print. Once you have printed a few times, you will get used to checking the shadow detail. There is no wrong or right way to work; you will figure out what is easiest for you within a few tries of working with the cyanotype sensitizer.

PROCESSING YOUR PRINT

Wash the print in cool running water until all of the yellow stain disappears (about 15 minutes). If all of the blue color washes off, you've underexposed the print. If blue stains remain in the highlights, the print may have been overexposed or fogged when you

When the exposure is complete, wash the cyanotype with cool running water until all of the yellow rinses away.

were coating the sensitizer onto the support.

Identifying the color of your image to asses whether it has washed long enough may be slightly complicated if you have used a colored paper or fabric. Just remember, the color of your support affects the final tone. For instance, the "blue" shadows on a red support will appear purple, and the shadows on an orange support will appear brown.

Striking just the right balance at this stage in the process can be tricky. If you don't wash the print for long enough, soluble ferric salts will remain on the image and will cause the print to fade when it is exposed to light. However, if you wash the print for too long, the image can also lighten just from overwashing and leaving it in the water. You can usually salvage the print by putting it in a dark room or drawer, which will restore the color after a few weeks, or by putting it in a tray of hydrogen peroxide, which will bring the image back immediately. (See Altering the Color of Your Print, below.)

DRYING YOUR PRINT

Drying cyanotype prints is no special feat. You can dry prints by (1) hanging them up on a clothesline with clothespins, (2) placing them in a blotter book, or (3) laying them on screens as you would dry regular photographic prints. If you use screens, make sure to dry the prints *face up.* Cyanotype sensitizer is very soft; if you put prints face down on the screens, not only will they get marks, you will also contaminate your screens.

Thin papers tend to curl as they dry. To help flatten a dry print that is on thin paper, place it between two pieces of paper from a blotter book and place heavy books or plate glass on top of them. If I am not in a rush, I usually find that putting the dry prints in an archival storage box—face to face, back to back— for a week or so works just as well.

ALTERING THE COLOR OF YOUR PRINT

Cyanotypes do not reach their true tone for several days unless you "tweak" them by putting them in a tray of water and hydrogen peroxide. Therefore, if you want to change the color of your cyanotypes, it is best to allow them to dry for at least a day or two before you tone them. This allows the prints to fully settle into their end color, which in turn helps you evaluate which tone(s) you want to add. The range of possible tones varies from deep blue and red-brown to deep purple and violet. With the exception of the deep blue "toner" (which is used to enhance cyanotypes that are on the light side or have faded), generally these toners work best with prints that are a little on the dark side. To ensure that your prints tone evenly, presoak them in water for a few minutes before you start the toning process. Make sure that all your trays are *plastic,* as the cyanotype sensitizer reacts to metal.

When working with toners it is important that they fill the tray, as this will ensure proper coverage of your images. However, everything else about the process is fairly loose—even the

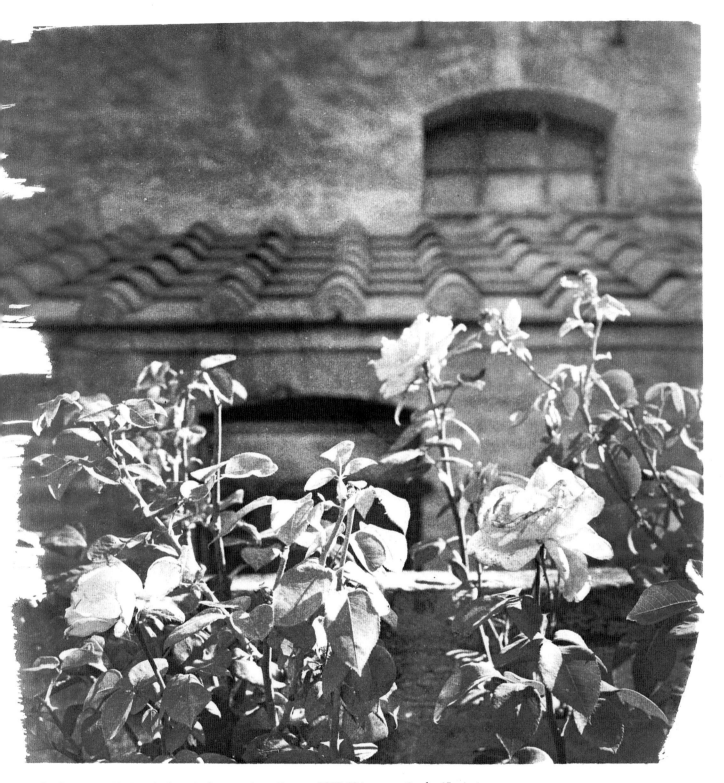

Italy Flowers, 2000. *I made this print by exposing a Bergger BPFB-18 internegative for 15 minutes. After washing it, I bleached the print in sodium carbonate for 45 seconds to bring out the highlights in the flowers. This print is on Fabriano Uno 140-lb hot-pressed watercolor paper.*

ratios of chemicals to water. If you want to tone an image more slowly, dilute the toner more than is specified in the recipe; if you want to tone it more quickly, add more chemicals. This is one area in alternative processing where "recipes" are not critical. The toners are nontoxic (hydrogen peroxide is used to clean cuts and scrapes; sodium carbonate is used for heartburn). So pour some in a tray, mix it well, and experiment.

DEEP BLUE

Even properly washed cyanotypes can fade slightly with time. Luckily, they can be brought back to their original color either by leaving them in the dark for a few weeks or by rinsing them in a hydrogen peroxide water bath. Hydrogen peroxide is not a "toner" in the precise sense of the word. Rather, it facilitates the oxidation of the cyanotype, which, if done right after the wash cycle, turns the shadows to their natural, rich blue colors. If the print has faded, the rich blue will be reinstated once the print is put in a tray of water and hydrogen peroxide.

Prepare two trays as outlined below, then follow these steps:

1. Soak the print in the tray of water for 5 minutes so that the print is very wet and will tone evenly.

2. Transfer the print to the acidic tray and agitate the tray for a few minutes. You will see the print getting progressively darker. After a few minutes it will not change anymore.

3. Remove the print and wash it thoroughly under running water.

RED-BROWN

This is my favorite toner combination because the possibilities are endless. If you put the print into the tannic acid tray first and then the sodium carbonate tray, you will create one effect. If you put the print into the sodium carbonate tray first and then the tannic acid tray, you will create another effect. If you go back and forth between the two trays you will create a third effect. And if you use Q-tips or small brushes to apply the toners to selective areas on the print, you will create yet another effect. So with just two chemicals (both of which are nontoxic), you can play for hours.

DEEP BLUE TONER

You will need two trays for this process—one for the water and one for the acidic solution.

distilled water

2 teaspoons hydrogen peroxide

Prepare two trays by filling them with distilled water. Add the hydrogen peroxide to the second tray. If you don't have hydrogen peroxide, you can substitute vinegar, lemon juice, or pineapple juice—in other words, almost anything acidic.

Follow the instructions below to create a uniform tone or go back and forth between the trays for a split-tone effect. I have included the "proper" measurements for these toners, but try throwing a few additional teaspoons of chemicals into a tray and see what happens. In other words, loosen up and have fun.

After preparing the chemical bath as outlined below, follow these steps:

1. Soak the print in a tray of water for 5 minutes.

2. Place the print in the tannic acid solution and agitate it constantly for between 30 seconds and 5 minutes. The longer you leave the print in the tannic acid, the more the color will change to a darker brown. However, you will not see a change in color until you put the print into the sodium carbonate.

3. (Optional) Rinse the print in running water for about 30 seconds. I have noticed that while my chemicals last longer if I use this rinse bath, I do not like the color change as much as when I just go straight from one chemical to the next. The rinse bath sometimes causes a mottling (uneven tone) to occur.

4. Place the print in the sodium carbonate solution, agitating constantly. Remove the print from the solution as soon as you see the tone you want.

5. Wash the print in running water for 10 minutes.

As each of the toner baths becomes dark, discard and replace the chemicals. Using the water rinse between trays will allow you to tone as many as 10 to 15 prints in each tray before you notice the chemicals darkening and getting exhausted. However, if you do not use a water rinse between the toners, or if you go back and forth between the two, they will exhaust quickly, maybe every 5 prints or so.

RED-BROWN TONER

You will need four trays for this process—two for water, one for tannic acid, and one for sodium carbonate.

To prepare the first toner tray, you will need:

180ml distilled water

6g tannic acid

Tannic acid dissolves in water very quickly. Pour the water directly into the tray, then add the tannic acid. Mix the solution with tongs until the crystals dissolve.

To prepare the second toner tray, you will need:

360ml distilled water

6g sodium carbonate

Pour the water directly into the tray, then add the sodium carbonate. Mix the solution with tongs until the crystals dissolve.

Sometimes when I'm using the two solutions in combination, I do not rinse my print in between. This method provides quicker stoppage, but it also contaminates your toner baths. Therefore, when I'm using this method, I need to change my chemicals frequently. This is one of the methods I use:

1. Soak your print in a tray of water for 5 minutes.

2. Place your print in the sodium carbonate solution until it starts to bleach.

3. Then place it the tannic acid solution until you get the desired color.

4. Return the print to the sodium carbonate solution for a few seconds.

5. Rinse the print well in running water.

You may find that you have to go back and forth between the chemicals several times before you get the desired result. This method takes practice and, if you are not careful, you can end up with a muddy print. Make extra cyanotypes of your image so that you can play with them and try to write down what you have done to each copy. However, be aware that the likelihood of being able to repeat your process is slim. Try to look at this method as making one-of-a-kind images.

In addition to the suggestions listed above, there are a number of other ways to use these two chemicals. Sodium carbonate toner is a bleach and can be used by itself to counteract a print that has been overexposed. However, this can be tricky, since the print will continue to bleach for a few minutes *after* it is put in the wash. Therefore you have to pull the print out of the sodium carbonate bath *before* it bleaches to the desired color, and you have to rinse it well. If you want to use sodium carbonate to bleach a print, you might want to use a weaker mix than that described above. (Start by trying a solution that is half the strength of the above recipe.)

Another way to use the sodium carbonate solution as a bleach is to brush it onto selective areas of a print (instead of submerging the whole print in the sodium carbonate bath). If you use a brush to apply the tannic acid to a small area first, then use another brush to go over the same area with sodium carbonate, you will get the brownish tone described earlier, but only in the area where the toner was brushed. The rest of the image will stay the original blue cyanotype color because it has been untouched by the toners. You can also use a brush to bleach or tone selective areas only to get a split-tone effect.

I always keep a tray of water and hydrogen peroxide in the sink. If a print has gotten too flat or too light, I soak it in this tray for a few minutes. As I said before, the hydrogen peroxide causes an oxidation that can make the print darker immediately. It will stop changing itself so there is no way that you can over-do this step. After I am done I wash my prints for 15 minutes in running water before drying.

Paris Café, 1996. *I created this cyanotype by exposing a computer-generated internegative for 30 minutes. I made the internegative from an infrared negative that was scanned using a Nikon scanner and then printed with an Epson ink jet printer onto Pictorico OHP transparency film. The final print is on Fabriano Artistico 140-lb cold-pressed watercolor paper.*

I toned this version of the image in tannic acid for 1 minute, sodium carbonate for 20 seconds, and then hydrogen peroxide for 30 seconds. The tonal range is very subtle. Because the print didn't soak in the sodium carbonate for very long, the middle tones look almost purple and the highlights have just a hint of brown. The hydrogen peroxide caused the darker shadow areas to go back to their original dark color.

DEEP PURPLE

After just a few minutes the household ammonia will bleach the print and the tannic or gallic acid will add color. You can go back and forth as described in the tannic acid/sodium carbonate combination (*see* Red Brown, page 86), or you can use the following recipe.

Prepare the chemical baths as outlined below, then follow these steps:

1. Soak the print in water a tray of water for 5 minutes.

2. Bleach the print in the household ammonia solution.

3. Wash it in running water for 30 seconds.

4. Tone the print in the tannic acid (or gallic acid) solution.

5. Wash the print thoroughly.

DEEP PURPLE TONER

You will need four trays for this process—two for water and two more for the toner baths.

To prepare the first chemical tray, you will need:

300ml distilled water

20ml household ammonia

Pour the water directly into the tray, then add the household ammonia. (It smells, so you might want to wear a mask.) Mix the solution with tongs.

To prepare the second tray, you will need:

200ml distilled water

2g tannic acid or gallic acid

Pour the water directly into the tray, then add the tannic acid or gallic acid. Mix the solution with tongs until the crystals dissolve.

VIOLET

The pyrogallic acid will change the blue to a wonderful violet. Sometimes this toner works and sometimes it does not. It depends on the water, the humidity, and the type of paper you are using.

After preparing the chemical baths as outlined below, follow these steps:

1. Soak the print in a tray of water for 5 minutes.

2. Place the print in the pyrogallic acid solution for a few minutes, agitating constantly. The color will change before your eyes. As soon as you like the color, pull the print out of the solution.

3. Rinse the print off in running water.

4. Submerge the print in the hydrogen peroxide solution, agitating constantly for about a minute to create a richer tone. You can go back and forth between these two trays until you get the desired result.

VIOLET TONER

You will need four trays for this process—two for water, one for pyrogallic acid, and one for hydrogen peroxide.

To prepare the first chemical tray, you will need:

360ml distilled water

12g pyrogallic acid

Pour the water directly into the tray, then add the pyrogallic acid. Mix the solution with tongs until the crystals dissolve.

To prepare the second chemical tray, you will need:

360ml distilled water

4 teaspoons hydrogen peroxide

Pour the water directly into the tray, then add the hydrogen peroxide. Mix the solution with tongs.

TROUBLESHOOTING

- If (during washing) the blue totally rinses out of your print, it was not exposed long enough.

- If the paper starts to turn blue, green, or brown before you expose it, the sensitizer has been fogged.

- If white spots appear throughout the image, either the fibers of the paper are showing through or there were air bubbles in the sensitizer. If this is not what you intended, switch papers. If the white spots were caused by air bubbles, you were probably too rough or applied too much pressure when you coated the paper. Be gentle!

- If you discover strange lines on the image, you may have contaminated the support either by placing it on a wet spot in your darkroom or by allowing some of the cyanotype sensitizer to dribble onto the back. Check the back of the support. It probably has a similar design. To avoid this problem in the future, be more careful about how you handle the support—particularly when sensitizing it.

- If the white areas of the print turn blue while you are drying it, you did not wash it long enough.

- If the print is still a little yellow after it is dry, you did not wash it long enough.

- If some of the sensitizer sticks to the negative, the support was not fully dry (therefore the two surfaces adhered to one another during the exposure).

- If the image is just not exposing or getting dark enough even after it has been under the lights for more than 40 minutes, check to make sure you mixed the sensitizer correctly. You might not have mixed enough crystals in with the water for the stock solutions. Start again!

- If the print appears thin, you may not have added enough sensitizer. Adding a second coat of sensitizer (after you have allowed the first coat to dry fully) adds density to the final print. You need to test this out according to the paper you are using.

- If you get strange colors on the untoned print, you may be putting both toned and untoned prints into the same wash bath and contaminating the wash water. Rinse baths that are used to wash toned prints and that aren't continuously being flushed with running water eventually become toner baths. If you mix prints in the same holding tray or wash—some that have been toned and others that have not been toned—some of the toner will wash off the toned prints and cause staining on the untoned prints. Make sure to wash all toned prints well before you put them in a tray with other prints.

Laura's Table, 1998. *I took this image with a pinhole camera using Polaroid type 55 positive/negative film. I used the Luminos Cyanotype solution, which is a one-bottle formula developed by Dr. Mike Ware. Within 1 hour of receiving the bottle, my paper (Arches Platine hot-pressed) was coated, dried, and exposed in my UV light box—no mixing, no mess—and a beautiful blue tone emerged on my print. I then toned the print slightly using violet toner for about 1 minute.*

KALLITYPES

I N 1842, TWO MONTHS AFTER SIR JOHN HERSCHEL read his paper on cyanotypes to the Royal Society in England, he added a postscript pointing out that ferrous salts (which are fundamental to the cyanotype process) can also reduce silver to its metallic state. This discovery was the technical beginning of the brownprint or kallitype process—though the name "kallitype" was bestowed on the process more than forty-five years later by Dr. W. W. J. Nichol, a lecturer on chemistry at Mason College in Birmingham, England.

The kallitype technique came on the market under such names as polychrome, sensitol, and platinograph. However, the kallitype process never quite caught on—probably because of the timing of its release and the characteristics of its competition. The kallitype technique was presented to the public about a decade after platinum papers were introduced commercially and just as gaslight papers were becoming popular. Kallitypes were neither as permanent (at the time) as platinum prints nor as convenient as making prints from gaslight paper.

Today, kallitypes are a valued option for the experimental photographer. While the process is not as versatile as platinum, it is an economical way of achieving platinum-like print quality. Like platinum prints, kallitypes have a long tonal range. In addition, because the sensitizer is self-masking, they do not suffer loss of contrast in the deep shadows.

This chapter includes Van Dyke brown (which photographers generally shorten to "VDB") prints and kallitypes. While both of these techniques fall under the broader kallitype category and produce prints that are brown in tone, each is made with different chemicals. VDB prints are made with ferric ammonium citrate (the light-sensitive chemical used in cyanotypes) and silver nitrate; kallitypes are made with ferric oxalate (which is used for platinum/palladium prints) in combination with silver nitrate. Each process has its own tonal range, but they are sometimes hard to tell apart. I have always gotten a nice rich tone with VDB sensitizer. However, with kallitypes, you can change the tones from reddish-brown to darker browns just by changing your developer. As with the other processes discussed in this book, experimentation is key—but make sure you keep good notes as you go along so that you can duplicate your successes.

Sheep, 2000. *I originally shot this image with Kodak HIE 35mm infrared film. I then enlarged the original negative to 9 x 12 inches using Bergger BPFB-18 film. To make this print I used the kallitype process with ammonium citrate developer, which produced this reddish tone.*

Opposite page:
Girl by Manhattan Bridge, 1994. *I shot the original image using 4 x 5-inch Polaroid type 55 positive/negative film. I then created this VDB print by a 5-minute exposure on Arches Platine 310-g hot-pressed paper made for platinum and other printing techniques.*

CREATING VAN DYKE BROWN PRINTS

The Van Dyke brown (or VDB) process is one of the simpler kallitype techniques and, when done correctly, it can produce detailed, rich brown images worthy of its namesake, the Baroque painter Anthony Van Dyke. The key is in the preparation of three solutions—ferric ammonium citrate, tartaric acid, and silver nitrate—which are mixed together to make the sensitizer. To achieve permanence with VDB printing, the photographer must adequately remove the ferric salts and the unexposed silver during processing.

VDB images are created by a contact print process (which means that the negative is the same size as the finished product) that involves a fairly lengthy exposure (between 5 and 15 minutes) to ultraviolet light. After exposure, the print needs to be processed with a wash, fix, another wash, hypo clear, and a final wash. As with the other kallitype process discussed in this chapter, VDB prints are made with silver metal and therefore can be toned just like regular black-and-white photographic paper (with polytoner, selenium, sepia, berg, and other toners) to produce purples, pinks, and blues. VDB prints can also be hand painted or combined with other processes to create stunning effects.

Florida Everglades, 1999. *I shot the original image with Tri-X 2¼ x 2¼-inch film in a Diana plastic camera and later made an 11 x 14-inch internegative using Arista APH halftone film. I used a foam brush to apply the VDB sensitizer, exposed it for 3 minutes, then toned the print with platinum/palladium (before the fixer) to get a richer brown. This image is on Fabriano Uno hot-pressed 140-lb watercolor paper.*

GETTING STARTED

Many of the items required to make VDB prints are standard darkroom materials that were discussed in Chapter 2. (*See* Basic Darkroom Equipment and Materials, page 12.) The major difference is that the sensitizer involved with the VDB process reacts with metals, which can cause oxidation and staining. Therefore it is important that your darkroom is equipped with *nonmetallic* utensils, bottles, and trays. Before you get started, make sure that you have the following items on hand:

Clothesline	Goggles
Clothespins	Hair Dryer
Coffee Filters or Wax Paper	Mixing Rod
Contact Print Frame	Newspaper
Distilled Water	Scale
Fan	Scotch Magic 811
Glass or Plexiglas	Removable Tape
Gloves	Tongs

In addition, you should note the following:

Brushes Any type of brush works well with VDB prints. If you are using a bristle brush, make sure that any metal on it has been coated with nail polish to prevent contamination.

Cups You will need three plastic cups—one for each of the stock solutions of the sensitizer.

Eyedroppers One eyedropper is needed for the potassium dichromate.

Glass Rod If you desire clean, straight edges, you can use a glass rod instead of a brush to sensitize your support.

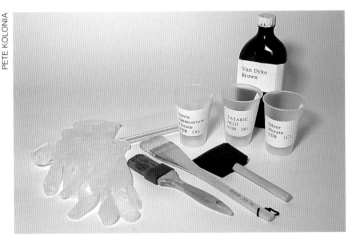

PETE KOLONIA

Here are a few of the materials you will need to make VDB prints: cups, gloves, and brushes or glass rod. The three cups are used to mix the stock solutions; the working solution is stored in the brown bottle.

Graduate You will need three large graduates—one for mixing the potassium dichromate, one for mixing the sodium thiosulfate, and one for diluting the rapid fixer.

Storage Bottles You will need one one-gallon bottle and two one-pint bottles. All three should be dark brown plastic or glass bottles. The one-gallon container is for the fixer (sodium thiosulfate); the two one-pint containers are for the potassium dichromate and the sensitizer (which is made up of ferric ammonium citrate, tartaric acid, and silver nitrate).

Trays You will need five *plastic* trays for developing, fixing, and washing your prints and as many as six extra trays for toning them.

BASE SUPPORTS

A wide range of base supports can be used for this process. Any all-natural material will give you a good tonal quality.

Paper Supports Virtually any paper can be used for VDB printing. Papers that have good wet strength (i.e., etching and watercolor papers) work best. Rice papers and most other 100% rag papers also work well. However, as always, the key is to experiment.

Fiber Supports Supports that are made of any all-natural material work well for VDB prints (cotton, silk, etc.). If the support contains any synthetic fibers, the image will not have a good tonal range. Canvas can be sensitized as is—unless it has gesso on it, in which case it should be sized with either Knox gelatin size or gelatin and hardener size before it is sensitized. (*See* Sizing Formulas, page 22.)

CHEMICALS

If you want to mix the chemicals yourself, you will need to buy ferric ammonium citrate, tartaric acid, silver nitrate, potassium dichromate, and sodium thiosulfate. (However, you also have the option of purchasing a VDB print kit through either Photographers' Formulary or Bostick & Sullivan.) If you want to tone your prints, stock up on polytoner, selenium, sepia, and berg toners—the same kind that you would use to tone regular black-and-white prints. (*See* Further Altering the Color of Your Print, page 105.)

LIGHT SOURCES

When you are mixing VDB chemicals or coating the support, your workspace should be illuminated with a *red* safelight. Most sources say that you can mix sensitizer, coat paper, and develop prints in subdued light, but I have found this not to be the case. I was having fog problems and decided to see if I could combat it by working under a safelight. I have not had any fogging since. You can expose VDB prints in natural sunlight or in a UV light box that has been equipped either with black-light bulbs or with aqua bulbs. (*See* Light Sources, page 18.) Exposure times can range from 5 minutes in bright summer sunlight to 15 minutes in an exposure unit.

Buonconvento Interior, Italy, 1999. *Because this negative was slightly flat, I exposed this print for 3 minutes and then used potassium dichromate in a tray of water before the first wash for this VDB print. The image is on Arches Platine 310-g hot-pressed paper made for platinum and other printing techniques.*

NEGATIVES

As stated above, making VDB prints involves a contact print process that requires negatives the same size as the finished product (*if* you are going to use negatives, see below). Paper that has been sensitized with VDB chemicals responds similarly to soft photo paper, so you will achieve the best results by using negatives that lean toward the contrastier side. For example, negatives that would require a #1 filter for printing on regular silver gelatin paper would work well for the VDB process. Thin negatives, on the other hand, produce muddy prints with the VDB process.

VDB prints can also be made without enlarged negatives. Photogram materials—such as glasses, beakers, plates, fruit, lace, and leaves—can create wonderful images, as can drawings made with a wax pencil or charcoal on either tracing paper or acetate. Printing from a collage of small (35mm) negatives is a third option.

MAKING YOUR STOCK SOLUTIONS

VDB chemicals can be bought in many forms—in bulk in crystal form, as a kit, or premixed. (*See* Sources, page 155.) These chemicals include three stock solutions that are used to make the sensitizer, one solution for contrast control, and a final solution for the fixer. Other chemicals (which are listed later) can be used as toners to change the color of your print from black to reddish brown.

SENSITIZER

Making VDB sensitizer is slightly different from making sensitizers for the other processes discussed in this book. While stock solutions for other sensitizers are made ahead of time and then allowed to age before the working solution is mixed, with VDB the stock solutions are made separately and then all three solutions are poured together *immediately*. The working solution should then be allowed to age for 2 or 3 days before it is used.

An alternative to VDB sensitizer is Dr. Mike Ware's argyrotype sensitizer, which is carried readymade by Luminos (Fotospeed) and Rockland (FA-1); the from-scratch recipe can be found on his Web site. (*See* Sources, page 155.)

FERRIC AMMONIUM CITRATE

This solution provides light sensitivity to the sensitizer.

33ml distilled water

9g ferric ammonium citrate

Pour the distilled water into a plastic or glass cup. Gently sprinkle the ferric ammonium citrate onto the water. Stir with a mixing rod until all the crystals have dissolved. Label this "Ferric Ammonium Citrate/VDB A" and set it aside.

TARTARIC ACID

This solution is used to help clear the highlights and prevent them from getting muddy.

33ml distilled water

1.5g tartaric acid

Pour the distilled water into a plastic or glass cup. Gently sprinkle the tartaric acid onto the water. Stir with a mixing rod until all the crystals have dissolved. Label this "Tartaric Acid/VDB B" and set it aside.

SILVER NITRATE

This solution provides the silver salt that, when developing, turns into metallic silver to make up the kallitype image. It can cause blindness if you get the crystals in your eyes, so make sure to wear gloves and goggles while mixing this solution.

33ml distilled water

3.8g silver nitrate

Pour the distilled water into a plastic or glass cup. Gently sprinkle the silver nitrate onto the water. Stir with a mixing rod until all the crystals have dissolved. Label this "Silver Nitrate/VDB C" and set it aside.

CONTRAST CONTROLLER

Potassium dichromate can be added to the developer/water to enhance the contrast of the print. It is not required to make VDB prints, but it can produce strong results. In addition, since this solution is also used to make cyanotypes, I find it helpful to keep a bottle of this stock solution on hand. The key difference, however, is that with cyanotypes this solution is a key ingredient in the working sensitizer, while with VDB prints it is used as a supplement during the development process. This solution should be mixed *at least* a day before you use it.

POTASSIUM DICHROMATE

This solution provides contrast if your images are too flat.

50ml distilled water

5g potassium dichromate

Pour the distilled water into a pot and heat it on a hot plate to 125°F. Transfer the hot water to a large graduate. Gently sprinkle the potassium dichromate onto the water. Stir with a mixing rod until all the crystals have dissolved. Pour the solution into a dark brown glass or plastic bottle. Potassium dichromate is used for other processes, so label this bottle "Potassium Dichromate" and store the excess. This solution will keep for about 6 months.

FIXER

VDB prints and kallitypes both require a weaker-than-usual solution of fixer. That said, a number of different kinds of fixer can be used. Sodium thiosulfate is pure fixer; the instructions below show how to dilute it to the correct level for VDB prints. While sodium thiosulfate is the preferred choice, I have also used film/paper rapid fixer without the hardener (in other words, solution A *not* B) when I have been out of this solution.

SODIUM THIOSULFATE

This solution provides a pure fixer that you can mix to the dilution you need for a given process.

2000ml distilled water

100g sodium thiosulfate

Pour the distilled water into a pot and heat it on a hot plate to 125°F. Transfer it to a large graduate. Gently sprinkle the sodium thiosulfate onto the water. Stir with a mixing rod until all the crystals have dissolved. Pour the solution into a dark brown glass or plastic bottle. Label this bottle "Sodium Thiosulfate/VDB Fixer." This fixer will last for a year or so.

DILUTED RAPID FIXER

Rapid fixer comes in liquid form. Part "A" is the hypo (fixer) and part "B" is the hardener. This process only utilizes the hypo portion.

distilled water

rapid fixer

Check the directions on the packaging for the amount of water required to dilute the product for paper. Pour the distilled water into a graduate or bucket, depending on the quantity that you are making. Add the rapid fixer and stir with a mixing rod. Dilute the solution further by adding 1 liter of water for each 2 ounces of rapid fixer. Pour the solution into a dark brown, glass or plastic bottle. Label this bottle "VDB/Diluted Rapid Fixer." This fixer will last for about 1 year.

PREPARING YOUR SENSITIZER

Unlike cyanotype sensitizer, which should be used immediately, VDB sensitizer should be made ahead of time and allowed to "age" for 2 or 3 days prior to use. The working solution for the sensitizer should be made in a darkroom under a *red* safe light.

Before you begin, cover your workspace with newspaper to protect the surfaces. Then mix the working solution as follows:

1. Pour solution "A" into a dark brown plastic or glass bottle.

2. Add solution "B" and stir with a glass rod. (Note: It is important to add "B" to "A" and not the other way around.)

3. While *slowly* stirring solution "C," pour it into the mixture.

Silver nitrate tends to sink to the bottom of the container. Make sure that you stir the solution well both before you use it to sensitize your support and periodically during use. Sometimes a precipitate will form, but it can be either disregarded or removed by straining the solution through a cheesecloth. Stored properly, the working solution will last approximately 3 to 6 months.

COATING AND DRYING YOUR BASE SUPPORT

Before you begin coating the base support, cover your workspace with newspaper to protect the surfaces. Because VDB has silver nitrate in the sensitizer, I coat my support under darkroom lights instead of room light. I make it pretty bright, as the sensitizer is not affected by the red or amber glow of a normal darkroom safelight. As you are coating the support the sensitizer should be yellow. If it appears brown or grayish, it has either gone bad (from age or because it was not mixed well) or has been fogged at some point.

If you are using paper as the base support, you can coat it by using either the glass rod method or the brush method. (*See* Sensitizing Techniques, page 25.) If you use a sheet of paper that is bigger than your enlarged negative, it will be easier to keep your sensitizer to the front and not go over the edges while you are coating. A large sheet of paper also provides some holding room, which helps you avoid leaving fingerprints in the sensitizer.

If you are using fabric as the base support, you must first remove all of the manufacturer's sizing by washing the material two or three times. (Otherwise the sizing will cause your sensitizer to coat unevenly.) If you are going to use the fabric for multiple exposures, you might want to size it yourself at this point. (*See* Siz-

When using the glass rod method to coat the support, apply the sensitizer evenly along the length of the rod.

Move the rod gently back and forth to spread the liquid evenly across the paper.

ing Formulas, page 22.) There are several ways to coat a piece of fabric with sensitizer. (*See* Sensitizing Techniques, page 25.)

As you are sensitizing, be extra careful not to put your fingers on the surface of the coated support—even if you are wearing gloves (which you should be). Not only is the sensitizer bad for your skin, touching the support increases the chances that you will have fingerprints on the surface of the VDB print.

Keep good notes while you are sensitizing and exposing the support so that (if you like the results) you can repeat them or (if you don't like them) you can figure out what you can do to make the next print better. If you are working with paper as a support, you can use a pencil to note the following right on the back: the solution, the type of paper, the exposure time, and the light source. If you are exposing outside, you should also write down the time of day and the season. Make sure you also note if you used potassium dichromate to develop the image.

After sensitizing the support, dry it thoroughly before exposing it. (*See* Drying Techniques, page 29.) The sensitizer should appear yellow once the support is fully dry. If you decide to use a hair dryer, make sure it is on the "cool" setting, as excessive heat will burn the sensitizer. You will know that you have burned the sensitizer if it appears grayish brown instead of yellow.

EXPOSING YOUR BASE SUPPORT

Exposing VDB prints is a fairly slow process, but it is faster than cyanotypes. A typical exposure can be anywhere from 5 to 15 minutes. However, cloth may need about 50% more time than paper. If you are using fabric, its size will determine if it will fit into your contact print frame. If the fabric is too big or too bulky, use a piece of plate glass that is thick enough to create a good contact between your negative and fabric. Be sure to use Scotch Magic removable tape to secure the negative so that you can check the exposure periodically without losing the registration.

Black-light bulbs, aqua bulbs, mercury vapor lamps, and strong sunlight are the best light sources. Sunlamps are not recommended for VDB prints because they emit too much heat and can burn the sensitizer. The best way to make VDB prints is with a contact print frame that opens on one side while still holding the negative down on the other.

I recommend doing test strips when working with the VDB process because exposures and tones will vary with your choice of support. Using a small support that you have coated at the same time as the larger support, do the test strip in 2-minute

Yves St. Laurent Garden, Morocco, 1999. *By taping the support with drafting tape before I coated it with sensitizer I was able to get very straight edges. Using the glass rod method enhanced this effect and ensured that no brush strokes would be visible. This VDB image was created by a 3-minute exposure. The print is on Fabriano Uno 140-lb hot-pressed watercolor paper.*

Willa Cather's Bedroom, 1993. *I made this VDB print with a 3-minute exposure onto Fabriano Uno 140-lb hot-pressed watercolor paper. I then toned the print with selenium, using a dilution of 1:20 before the fixer.*

intervals using opaque black paper taped to the contact print frame. It is better to try out a small support than to waste so much silver on a full print. If you are processing a test strip, you can skip the wash and simply rinse the support after the fixer. However, make sure to dry your test completely before deciding on your correct exposure, as VDB images tend to darken as they dry. For instance, a print that looks reddish-brown when it is wet often turns to a deeper brown as it dries.

Every 2 to 3 minutes you can turn the ultraviolet lights off or take your frame inside and check to see if the exposure is finished. At this point, you can turn off the safelights and turn on a 40-watt bulb so that you can check the exposure. The sensitizer should not fog in the short period of time that you are looking at the support. When the image has detail in the midtones and yellow-brown tones in the highlights, the exposure is done. The image should be a slight "cocoa" color and look underexposed (as it will darken during processing and drying).

PROCESSING YOUR PRINT

With the VDB process these final steps are very important to ensure permanent, beautiful prints. The excess iron and silver salts need to be removed at this point or the print will fade.

I process with the safelights on (although I know people who do this successfully in subdued white light). Make sure your trays are all properly labeled and that you reserve each of them only for a single purpose within this process. This will help avoid contamination for future prints. As with normal black-and-white printing, each of the wash and chemical trays should be prepared ahead of time and should be at room temperature.

You can increase the contrast of the print by adding a small amount of the potassium dichromate stock solution to the first wash tray. You will need to experiment with the exact amount, but a good starting point would be to add 9 or 10 drops of the

solution to 500ml of water. This will increase the contrast of your print by about one grade.

Selenium toning is an option for VDB prints. It cools the browns and brings out the middle tones. If you want to tone a print with selenium toner, place it in the toner after the second wash and before you transfer it to the fixer, but toning can be done after the final wash as well. To make a selenium toner bath, start with a solution that is diluted at a ratio of 1:20 and see if you like the effect it creates. You can vary the dilution until you get the desired effect. Toning happens quickly and it will vary the colors, so make sure that you watch the process carefully. At the precise moment you see the desired color, remove the print from the toner, then submerge it in a tray of running water so that the toning will stop. Because the correct moment to pull the print is sometimes hard to see, it is helpful to have an untoned print (called a match print) to refer to so that you can compare the difference and know when to pull the print out of the toner. Then proceed to the fixer as normal.

To process the print, proceed with the following steps:

1. Place the print either in a tray of running water or in a tray of potassium dichromate, if you are adding contrast to your image. If the former, wash the print for 1 minute or until the water runs clear. If the latter, agitate the print constantly for 1 to 2 minutes, then transfer it to a tray of running water. First put the print face up, cover it with water, then turn it face down. As the water runs through the tray, keep turning the print back and forth with either tongs or gloved hands, being careful not to crimp it. The unexposed iron salts and silver salts will sink to the bottom of the tray. During this wash the print will lighten and become yellowish.

2. Transfer the print to a second tray of running water and allow it to wash for 3 to 5 minutes. Note: If you want to tone the print

Willa Cather's Bedroom, 1993. *By comparison, I made this VDB print with a 3-minute exposure using Cromatica mylar. This mylar was too thin (100g) and so it wrinkled. I also had the white light (instead of the safelight) on while I was coating and the image fogged. (Notice the grayish appearance in the wallpaper).*

with selenium toner, do not proceed with the fixer at this time; rather, follow the instructions in the introduction above.

3. Remove the print, let it drain, and place it in the fixer. The tray should be filled with enough fixer to cover the paper, and it should be discarded after 1 or 2 prints. The sodium thiosulfate will remove the excess silver ions. It is much more diluted than regular paper fixer (which would etch away the image from the paper if used at full strength). Agitate the print for 1 to 4 minutes as described above—first placing the print face up, then face down, and carefully flipping it while slowly agitating the tray. During the fixer bath the print will darken and become brown. However, if you leave the print in the fixer for longer than 5 minutes, it will fade.

4. Transfer the print to a third tray of running water and allow it to wash for 5 minutes. This will remove most of the sodium thiosulfate.

5. Transfer the print to the hypo clearing agent or perma wash. This should be prepared as it would be for regular silver printing. Agitate constantly for 2 minutes.

6. Transfer the print to the fourth and final tray of running water and allow it to wash for 30 minutes.

TROUBLESHOOTING

These tips relate to both of the processes discussed in this chapter—VDB prints and kallitypes.

• If the sensitizer looks brown instead of yellow after you've coated the support, either the sensitizer was bad or the support has fogged. Make sure that (1) you do not open the bottle of sensitizer in a room that is illuminated with a light brighter than a 40-watt bulb, and (2) you coat the base support in a darkroom with a *red* or *amber* safelight.

• If a really long exposure is required to produce an image, you may have coated the support with too much sensitizer. Try making another print with a support that was less saturated with sensitizer during coating.

• If the negative sticks to the support, either the support was not fully dry or the lights were too hot or too close to the contact printer.

• If the print bleached during the wash cycle, you probably used a wash tray that had been used for other processes. Just like the other trays, your wash trays need to be allocated just for VDB printing and should be labeled "VDB/Wash 1," "VDB/Wash 2," etc.

• If the print is uneven and blotchy, the paper may be too soft. Either choose a different paper or try sizing the paper before applying the sensitizer. (*See* Sizing Formulas, page 22.) When a paper is too soft, the sensitizer sometimes soaks into the fibers too deeply and unevenly. The sizing should help to clear this up.

• If the sensitizer looks grayish-brown (instead of yellow) before it is exposed, it may have been contaminated. Make sure that your brushes are clearly marked for each process and that you thoroughly wash and dry any dishes you use to hold the sensitizer.

• If you exposed the support too long and created a dark print, you can leave it in the fixer for longer than the recommended 5 minutes. This will bleach the print.

• If your darkroom is too small to accommodate so many wash trays, fill one tray with distilled water and place the print in it, agitating for about 30 seconds. Dump the distilled water out, pour some more in, and agitate again for 30 seconds. Do this a total of 12 times and you should have a very clean VDB print.

CREATING KALLITYPES

Kallitype is a more traditional brown print process than VDB. However, because there are so many more choices of developers involved with this process, it can also be much more complicated to do. This chapter provides a good starting point and plenty of tips to produce handsome results. When kallitypes are made correctly, they are often confused with platinum/palladium prints. They can range from a beautiful warm brown tone to a reddish-brown.

Mixing the sensitizer correctly is the key to the success of this process. Once, when I was teaching a class at the International Center of Photography, my teaching assistant mixed the sensitizer incorrectly. Everything was working beautifully until we immersed the prints in the developer—and watched the images disappear. We made up a new sensitizer and had wonderful results in the end. The instructions for making kallitype sensitizer are very similar to those for making platinum/palladium sensitizer. In particular, you will have three bottles of stock solution—labeled "A," "B," and "C"—that contribute to making the sensitizer. So the moral of the story is, follow these instructions step by step.

GETTING STARTED

The basic utensils and equipment required to create VDB prints are also required for traditional kallitypes. (*See* Getting Started, page 93.) In addition, you will need the following items:

Graduate You will need as many as three large graduates, depending on how many different developers you use.

Storage Bottles You will need two one-gallon bottles and three one-pint bottles. The two one-gallon containers are for EDTA (which is used as the clearing bath) and sodium thiosulfate (which is used as the fixer). The three one-pint containers are used to store the following chemicals: ferric oxalate solution, potassium dichromate, and silver nitrate.

Eyedroppers You will need three eyedroppers, one for each of the solutions for the sensitizer.

Trays You will need nine trays for developing prints and as many as five more for toning them.

MAKING YOUR STOCK SOLUTIONS

Because kallitype sensitizer contains silver nitrate, I recommend making your stock solutions in a *red* or *amber* safelight instead of room light. The chemicals required to make traditional kallitypes are similar to those required for platinum and palladium prints. However, kallitypes are made with metallic silver instead of platinum or palladium metals. During the kallitype process the support is coated with silver nitrate and ferric salts. Exposure to light reduces some of the ferric salts to a ferrous state.

Once you immerse the print into a developer, the silver metal salts reduce to a metallic silver. Choose your developer according to the color you desire for your final image.

There are many formulas for the kallitype sensitizer. I have included the two most common ones here. The first is the formula that I learned with many years ago. Many photographers like this one-bottle recipe. The second formula (which involves three separate bottles) seems to be the best recipe for contrast

Vassarette, 2001. *I shot this image in a studio using strobes to illuminate the setting and to simulate window light. I used Kodak HIE 35mm infrared film because I wanted grain and softness. I enlarged the original negative to 9 x 12 inches using Kodak Kodalith film. This kallitype was made using brown-black developer, which contains borax and Rochelle salts, to achieve the brown tone. This was a 4-minute exposure on Whatman 140-lb hot-pressed watercolor paper.*

control. (I like being able to control the contrast with the sensitizer instead of the developer, but that is a personal choice.) As with most of the processes described in this book, most photographers who work with kallitypes have strong opinions about the pros and cons of these sensitizers. Try them all and see what works best for you.

The kallitype fixer is the same as VDB fixer. (*See* Sodium Thiosulfate, page 95.)

SENSITIZER (FORMULA 1)

Since this sensitizer doesn't contain potassium dichromate, you will want to control contrast during the development stage. This sensitizer should be prepared a day or two before it is needed and allowed to ripen. The shelf life for this solution is 3 to 6 months. Silver nitrate tends to sink. Make sure that you stir the solution before you sensitize the support, as well as periodically during use. If a precipitate forms, disregard it, or filter the liquid through a cheesecloth.

WORKING SENSITIZER

This is one of the older kallitype formulas.

47ml distilled water

0.5g oxalic acid

7.8g ferric oxalate

3.1g silver nitrate

Pour the distilled water into a pot and heat it on a hot plate to 100°F. Once it is heated, pour it into a large plastic cup. Add the oxalic acid. Stir well with a mixing rod. Then add the ferric oxalate. Stir well. Finally, add the silver nitrate. Again, stir well, then pour the solution into a dark brown glass or plastic bottle. Label this bottle "Working Sensitizer/Kallitype."

SENSITIZER (FORMULA 2)

There are so many formulas in books and on the Web that there is plenty of information out there to experiment with, which really encapsulates the spirit of all these alternative photographic processes. This recipe incorporates elements from two popular formulas and works well for me. The kallitype process is similar to the platinum and palladium technique in that you keep each of the chemicals separate in small brown bottles and use eyedroppers to make the working solution as you need it. I have found it helpful to label each of these stock solutions with its chemical name as well as "A," "B," and "C," respectively. (It is also important to label your eyedroppers "A," "B," and "C," and to use each eyedropper for only one chemical.) The stock solutions have a shelf life of 3 to 6 months.

FERRIC OXALATE

This is also one of the standard stock solutions for platinum/palladium printing. You can buy it either as a premixed liquid or as crystals, which need to be dissolved. The premixed liquid has a shelf life of 3 to 6 months, while the crystals, if kept in low humidity, can last for years. If you are working from crystals, make your stock solution a day or two before you are going to use it, following the instructions below.

100ml distilled water

20g ferric oxalate

Pour the distilled water into a pot and heat it on a hot plate to 100°F. Once it is heated, pour it into a large plastic cup. Gently sprinkle the ferric oxalate onto the water. Stir with a mixing rod until all the crystals have dissolved. Pour the solution into a dark brown glass or plastic bottle that has an eyedropper on top. Label this bottle "Ferric Oxalate/Kallitype A."

POTASSIUM DICHROMATE

This solution increases the contrast of your prints. (This is the same solution used to add contrast to cyanotypes, so if you already have it made for cyanotypes, you can use it here.) If you don't want to use potassium dichromate in the sensitizer but still want to increase the contrast of your prints, you can add 10 to 40 drops of potassium dichromate to 1 liter of developer and use this solution during the development stage. This stock solution should be made a day or two before it is going to be used.

100ml distilled water

1g potassium dichromate

Pour the distilled water into a pot and heat it on a hot plate to 100°F. Once it is heated, pour it into a large plastic cup. Gently sprinkle the potassium dichromate onto the water. Stir with a mixing rod until all the crystals have dissolved. Pour the solution into a dark brown glass or plastic bottle that has an eyedropper on top. Label this bottle "Potassium Dichromate/Kallitype B."

SILVER NITRATE

Wear goggles, gloves, a mask, and an apron when handling this chemical, as it can cause blindness. Silver nitrate can react to the amount of humidity in your workspace as well as in the support you are using, which is why it has a reputation of being unstable and why it is sometimes difficult to repeat exact color results. This stock solution should be made a day or two before it is going to be used.

100ml distilled water

10g silver nitrate

Pour the distilled water into a pot and heat it on a hot plate to 100°F. Once it is heated, pour it into a large plastic cup. Gently sprinkle the silver nitrate onto the water. Stir with a mixing rod until all the crystals have dissolved. Pour the solution into a dark brown glass or plastic bottle that has an eyedropper on top. Label this bottle "Silver Nitrate/Kallitype C."

PREPARING YOUR SENSITIZER

Because kallitype sensitizer contains silver nitrate, you should coat your support under a *red* or *amber* safelight. Cover your working area with newspaper. Before you start to mix the working solution, make sure that your three eyedroppers are clearly marked "A," "B," and "C" and that all three droppers have the same size holes.

I mix my working solution in either a plastic cup or a small plastic dish. Using the eyedroppers, mix equal parts A and C. To cover an 8 x 10-inch negative, you will need approximately 48 drops total (24 each). If you want to add the potassium dichromate to the sensitizer (as opposed to the developer, as described above), add 1 drop of B to the 48-drop A/C mixture. (You can also adjust the potassium dichromate by diluting it with distilled water, if your print is too contrasty, or by using more drops, if more contrast is needed.) Stir the mixture slightly before you start to coat the support. If you are using fabric or a porous support, you might need to adjust the number of drops slightly. As you are coating the support, the sensitizer should be yellow. If the sensitizer appears brown, it has either gone bad from age, was not mixed well, or has been fogged.

PREPARING AND EXPOSING YOUR BASE SUPPORT

Because of the similarities in these two processes, preparing the base support for the kallitype process is virtually identical to preparing it for the VDB process. (*See* Coating and Drying Your Base Support, page 96.) Likewise, the exposure process is also virtually identical. (*See* Exposing Your Base Support, page 97.)

PREPARING YOUR DEVELOPER

As described earlier, there are two different points during the process when you can alter the tone of a kallitype. One is the developing stage and the other is the toning stage (which comes immediately after the clearing bath and before the fixer). You can adjust the color of the print at either or both of these stages. The first decision you need to make is which of the following four developers you want to use. With the exception of Formula 2 (which can be made under regular white light), all of these developers should be made under a safelight.

REDDISH-BROWN DEVELOPER

Developing time is about 2 minutes. Bostick & Sullivan carries an essentially ready-made version of this developer (which is also use for platinum/palladium printing).

distilled water

ammonium citrate developer

To "prepare" this developer, simply add distilled water to "top off" the bottle that the developer comes in and pour the mixture into a tray. You can keep using this developer and topping it off with fresh ammonium citrate as you lose some to spillage or general usage. Make sure to label the bottle "Reddish-brown Developer/Kallitype." Even though it is the same developer that you may use for platinum/palladium prints, you cannot use the same solution for both processes.

BROWN-BLACK DEVELOPER

Developing time is about 5 minutes, with continuous agitation. This developer has a shelf life of up to 6 months. This developer works best when warm.

1000ml distilled water

96g borax

72g Rochelle salts (sodium potassium tartrate)

Pour the distilled water into a pot and heat it on a hot plate to 100°F. Transfer the liquid to a large graduate. Slowly add the borax and stir with a mixing rod until dissolved. Then add the Rochelle salts and stir until they are dissolved. Pour the solution into a dark brown glass or plastic bottle. Store in a dark brown glass or plastic bottle labeled "Brown-black Developer/Kallitype."

WARM BROWN DEVELOPER

Developing time is about 5 minutes, with continuous agitation. This developer has a shelf life of up to 6 months. This developer works best when warm.

1000ml distilled water

48g borax

96g Rochelle salts

Pour the distilled water into a pot and heat it on a hot plate to 100°F. Transfer the liquid to a large graduate. Slowly add the borax and stir with a mixing rod until dissolved. Then add the Rochelle salts and stir until they are dissolved. Pour the solution into a dark brown glass or plastic bottle. Store in a dark brown glass or plastic bottle labeled "Warm Brown Developer/Kallitype."

SEPIA DEVELOPER

Because it contains no borax, this developer can be used at room temperature. However, the development time is longer—about 10 minutes with continuous agitation. This developer has a shelf life of up to 6 months.

1000ml distilled water

48g Rochelle salts

Pour the distilled water into a pot and heat it on a hot plate to 100°F. Transfer the liquid to a large graduate. Slowly add the Rochelle salts and stir with a mixing rod until they are dissolved. Store in a dark brown glass or plastic bottle labeled "Sepia Developer/Kallitype."

DEVELOPING/WASHING YOUR PRINT

To prevent fogging, it is safest to develop your prints in a bright safelight darkroom. However, to check the exposure, you can *briefly* turn on the white light. Make sure your trays are all properly labeled and that you reserve each of them only for a single purpose within this process. In addition, all your chemicals should be prepared ahead of time and should be at 68°F (with the exception of developers that contain borax, which should be at about 100°F for maximum effectiveness).

Proceed with the following steps.

1. In one continuous motion, immerse the print in a tray filled with the developer of your choice. Agitate continuously for the required time.

2. Transfer the print to a tray of running water and wash it for about 1 minute.

3. Prepare *two* identical trays of clearing solution. Each should be filled with a solution of 1 to 2 teaspoons of EDTA tetra sodium to 1 liter of water. Place the print in the first tray and agitate it for 5 minutes. Then place the print in the second tray and agitate it for 5 minutes. This process dissolves the iron in the emulsion, leaving only the silver.

4. If you want to tone the print, now is the time to do it (between the clearing bath and the fixer). (*See* Further Altering the Color of Your Print, page 105.)

5. Prepare the fixer tray. Either sodium thiosulfate or diluted rapid fixer can be used. (*See* Fixer, page 95.) Place the print in the tray and agitate for 2 minutes. The print will get a lot lighter during this stage. You cannot use regular paper fixer as it will etch the image off the paper because the silver metal is still unprotected. Do not let the print sit longer than 5 minutes in the fixer or it will start to fade.

6. Transfer the print to a second tray of running water and allow it to wash for 5 minutes.

7. Place the print in a tray of perma wash or hypo clearing agent and agitate it for 2 minutes. The hypo clearing bath that you mix should be diluted to half the strength that you would need for normal black-and-white silver printing. Check the container of the brand that you buy.

8. Transfer the print to a third and final tray of running water and allow it to wash for 30 minutes.

Italian Road, 1999. *To make this image I used argyrotype sensitizer on Arches Platine 310-g hot-pressed paper made for platinum and other printing techniques. The exposure was 4 minutes.*

Gargoyle Angel, 1998. *I took the original image with Kodak T400CN film using a 2¼ x 2¼-inch Hasselblad camera. The internegative was made using Bergger BPFB-18 8 x 10-inch film. I used argyrotype sensitizer on Rives BFK paper.*

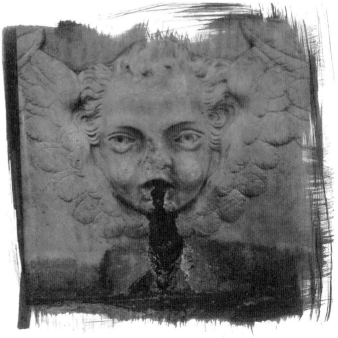

I decided to try something else for the finished print, so I toned it with polytoner.

FURTHER ALTERING THE COLOR OF YOUR PRINT

In addition to determining the color of the print by the developer you choose, you can also alter the color by toning the print. This stage occurs after the print has cleared and before it has been fixed. Some people recommend toning to ensure the permanence of the kallitype, while others like the colors achieved during development and are happy leaving well enough alone. To tone or not to tone is a judgement call. You need to step in as the artist and decide.

Make the base toner first, then choose, make, and add one of the three enhancement formulas. The enhanced toner should be made at least a day before it is needed so that it can age. These toners should last for many years, depending on the conditions in your darkroom. (A high humidity level exhausts toner.) When you are ready to tone the print, place it in the toning solution, constantly agitating for about 5 minutes. At first the print will appear to sharpen or clear. Then you will begin to see changes in the highlights and shadow areas. After toning the print, proceed with the fixer, wash, perma wash, and final wash stages as described on page 103.

BASE TONER

This solution should be created first, then any *one* of the following three enhancements can be added.

1 liter distilled water

5g citric acid

Pour the water into a dark brown glass or plastic bottle. Add the citric acid and mix well.

TONER ENHANCEMENT (FORMULA 1)

This enhancement creates the deepest browns of the three formulas listed here.

5ml 5% gold chloride

Add the 5% gold chloride to the base toner and mix well.

TONER ENHANCEMENT (FORMULA 2)

This enhancement creates a nice middle brown. This is the palladium solution (the metal) from the platinum/palladium process.

5ml palladium solution (*See* page 111.)

Add the palladium solution to the base toner and mix well.

TONER ENHANCEMENT (FORMULA 3)

This enhancement creates the coolest browns of the three formulas listed here. This is the platinum solution (the metal) from the platinum/palladium process.

5ml platinum solution (*See* page 111.)

Add the platinum solution to the base toner and mix well.

TROUBLESHOOTING

- If solarization occurs or the print has veiled highlights, the light source in your darkroom is too strong. Kallitype sensitizer should be made and used under a *red* or *amber* safelight.

- If there is a line across the print, you may have developed the print unevenly. Make sure to fill your tray with enough developer to cover the print and to slide the print into the developer in one sweeping motion.

- If the image is faded, you may have left it in the fixer too long.

- If you do not like the color of the final print, recoat another support and repeat the process with a different developer or toner. The possibilities for kallitype printing are numerous.

- If you think the tonal range of the print is too cool, heat up the developer or first wash tray to warm up the brown.

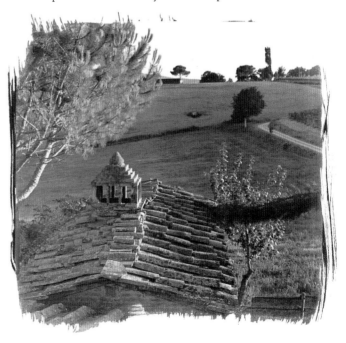

Buonconvento Bedroom View, Italy, 1999. *I made this kallitype using brown-black developer to achieve this tone. This was a 5-minute exposure on Arches Platine 310-g hot-pressed paper made for platinum and other printing techniques.*

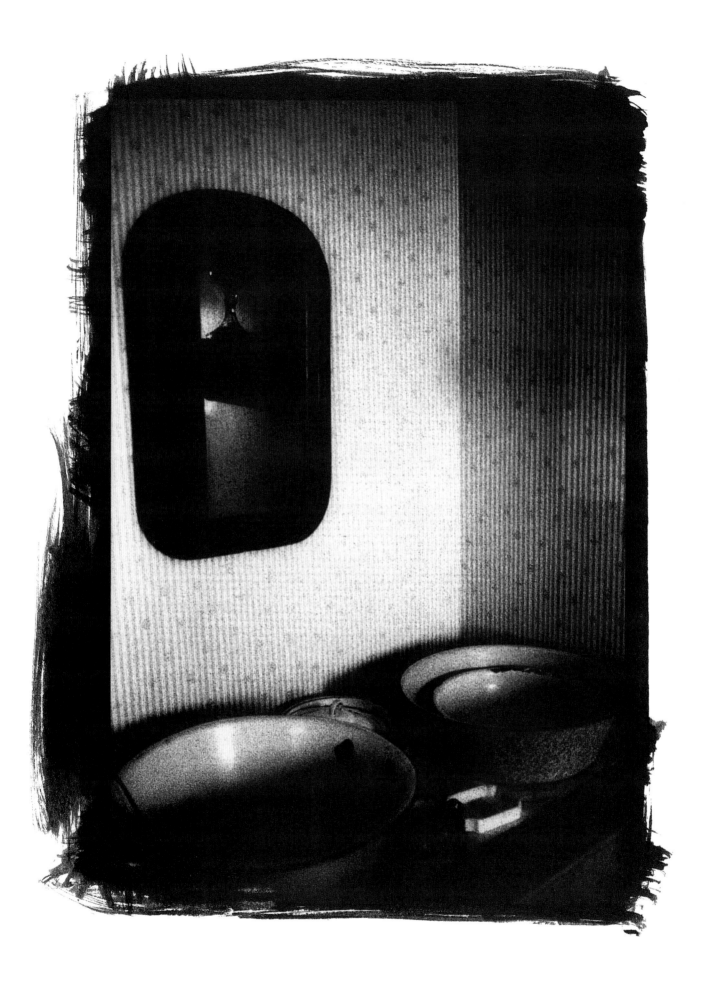

PLATINUM AND PALLADIUM PRINTS

THE SENSITIVITY OF PLATINUM SALTS to light was first noticed and recorded by Ferdinand Gehlen in 1804. Sir John Herschel and Robert Hunt experimented further with platinum, but in 1859 C. J. Burnett was the first to exhibit platinum prints. William Willis received the first patent on a platinum printing paper and began to manufacture it under the name Platinotype in 1879.

Soon ready-made platinum and palladium papers became generally available throughout the world. The former was very popular with the Pictorialists, members of the Linked Ring Society, and the Photo-Secessionists, which included such photographers as Paul Strand, Clarence White, and Alfred Stieglitz. These photographers valued ready-made platinum papers for their long scale and subtle richness of shadow areas. Edward Weston used Palladiotype—a commercial palladium paper manufactured by Willis and Clements—to photograph Mexico in 1923. In 1937, when the high cost of the metals made both platinum and palladium papers too expensive to produce, they were phased out in favor of cheaper silver bromide and gaslight papers. Nevertheless, many photographers today continue to work with these processes, including the members of the California-based Platypus Group.

Other than the color differences, the processes of the platinum and palladium techniques are identical. Platinum images can range from a cool gray-black to split tones of brown. Palladium prints usually range from warm black to very warm brown. Many people mix the two metals to produce a warm brown and to cut the cost of the more expensive platinum metal. They both have superb tonal range and archival properties and are said to be the highest-quality processes in photography.

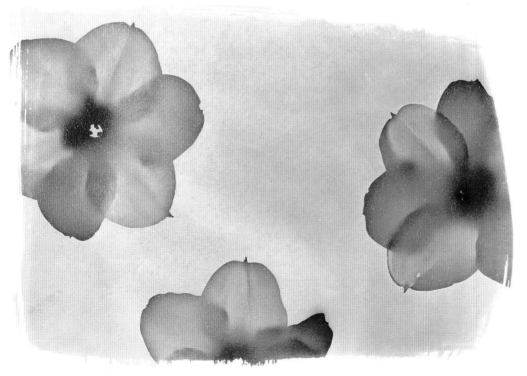

Flowers, 1995. *So that I would be able to repeat this photogram, I placed flowers on top of Kodak's Kodalith film to make an 8 x 10-inch internegative. I printed this image on Canson Opalux vellum because of its translucent feel, which enhances the flowers. This was an average negative. I used 21 drops of platinum and only 3 drops of palladium and exposed the vellum for 4 minutes.*

Opposite page:
Wash Basin, 1993. *I took this image for American Heritage Magazine for a story on Willa Cather. Since this scene is from an early twentieth-century home, I wanted the image to be warm and a little dark. I sensitized my support using palladium salts, opting for a solution that would work with a flat negative and a 7-minute exposure. Unless otherwise noted, all the prints in this chapter are on Arches Platine 310-g hot-pressed paper made for platinum and other printing techniques.*

CREATING PLATINUM AND PALLADIUM PRINTS

Platinum and palladium printing are similar to kallitype printing and other iron-sensitive processes, except that platinum and/or palladium salts are used instead of silver salts. Like the silver nitrate that is used to make Van Dyke brown prints, all platinum and palladium salts are somewhat light sensitive. They are made more sensitive when they are combined with iron salts.

In recent years the Palladio Company has manufactured ready-made platinum paper, but it found that the paper companies were often not consistent in their stock and they discontinued this product. They are discussing starting the business again, but for now it is safer to say that you must coat your own support. Sensitizing can take place in subdued white light. Both platinum and palladium prints are created by a contact print process (which means that the negative is the same size as the finished product) that involves a relatively short exposure (between 2 and 8 minutes) to ultraviolet light. When the image is developed, the unexposed platinum, palladium, and ferric salts dissolve away. All of the iron is removed in the clearing bath and what remains is an image that consists entirely of platinum and/or palladium salt.

Almost any paper support can be used for platinum/palladium (which most photographers abbreviate as PT/PL) prints. Sizing is generally not required, but I would suggest trying a print both with and without size. The decision is yours and depends on the surface texture of your support and how you want the finished print to look. If you are using a particularly porous paper, such as Rives BFK or Arches 88, sizing will help keep most of the expensive platinum salts from sinking into the pores. When choosing which sizing solution to use, be aware that starch size tends to produce warm tones in PT/PL prints, while gelatin size produces cool tones. (*See* Sizing Formulas, page 22.) Whether or not it is sized, cloth soaks up a lot of the platinum salts, so it is not recommended unless you have *a lot* of money!

PT/PL prints are considered the most archival of all photographic processes. However, if they are not treated correctly, they will stain or fade just as quickly as anything else. You must take care to clear your prints of all iron and unexposed PT/PL salts and to completely wash them. It is also important to make sure any mat boards or boxes you use are archival.

GETTING STARTED

Many of the items required to make PT/PL prints are standard darkroom materials that were discussed in Chapter 2. (*See* Basic Darkroom Equipment and Materials, page 12.) The major difference is that the chemicals involved with these processes react with metals, which can cause oxidation and staining. Therefore, it is important that your darkroom is equipped with *nonmetallic* utensils, bottles, and trays. In addition, your equipment should be reserved solely for making PT/PL prints; you cannot use the same equipment that you would use for silver prints as the chemicals used for the PT/PL technique will stain and contaminate all the bottles, trays, etc. and cause staining on your silver prints (and vice versa).

Before you get started, make sure that you have the following items on hand:

Contact Print Frame	**Hair Dryer**
Cups and Bowls	**Hot Plate**
Distilled Water	**Mask**
Drafting Tape	**Mixing Rod**
Eyedroppers	**Newspaper**
Glass	**Pot**
Gloves	**Tongs**
Goggles	

In addition, you should note the following:

Brushes Japanese Hake brushes and Chinese Linzer brushes are the brushes preferred by most PT/PL printers, as they are soft and

IMPORTANT POINTS TO REMEMBER

Paper companies are always changing their paper content without notice. Therefore, what may print out beautifully one day, might render unacceptable prints with the next batch of paper. Always do a test with a new batch of paper before coating a lot of sheets—even if you're working with a paper that has been your dependable favorite for many years. This is always good advice, but is especially relevant for PT/PL prints, since the sensitizer is costly.

You can spot your PT/PL prints with a soft pencil, with black India ink diluted with water, or with a watercolor pencil—anything that you find easy to use and that matches the colors of your prints. Make sure to use a test print to check that you have the proper tone before spotting on a final print. Most art supply stores have samplers that you can use. Take a test print to the store and try out different methods to see which one you like. This is will also help in matching the tones. If you are mixing your chemistry from scratch, you need to be sure to buy from a reputable company to make sure that you get the best-grade of PT/PL metals; otherwise your prints will not have a beautiful, even tonality.

generate lovely brush strokes. However, sponge brushes also work very well and are a less expensive option. If your brushes have metal on them, you can use nail polish to cover it so that no contamination will occur.

Glass Rod If you desire clean, straight edges, you can use a glass rod instead of a brush to sensitize your support.

Graduates You will need six large graduates, one for mixing each of the following five chemicals—ferric oxalate, potassium chlorate, platinum, palladium (formula 1), and palladium (formula 2)—as well as EDTA, citric acid, or hydrochloric acid.

Trays You will need five *plastic* trays for developing, clearing, and washing prints.

Storage Bottles If you are mixing sensitizer from scratch, you will need three dark brown *plastic* or *glass* bottles. In addition, you will need three extra one-gallon containers for the clearing bath.

BASE SUPPORTS

A wide range of base supports *can* be used for this process, though in general paper supports are preferred, since they don't soak up as much of the (expensive) sensitizer.

Paper Supports Smooth or hot-pressed papers, such as Crane's Platinotype, tend to provide a sharper image than coarse, textured papers, such as Arches Platine. Smooth papers also clear more easily than textured papers, which is an asset for these processes. Printmaking papers, watercolor papers, and most 100% rag papers work best. Papers that are too absorbent will dry too quickly as you are coating and may soak in too much of the chemicals, making the coating look uneven. The color of the paper should also be considered, as it will affect the outcome of the print. However, even white papers play a role in the *tone* of the print. As always, the key is to experiment.

Fiber Supports Supports that are made entirely of all-natural fibers work well for PT/PL prints. However, these soak up a lot of sensitizer, so be prepared to spend more money! I recommend getting very good on paper before pursuing fabrics.

CHEMICALS

If you want to mix the sensitizer yourself, you will need to buy ferric oxalate, potassium chlorate, potassium chloroplatinite, and sodium chloropalladite as well as either palladium chloride or sodium chloride. To make the developer, you will need one of the following: potassium oxalate, ammonium citrate, sodium acetate, potassium citrate, or sodium citrate. And to make the clearing solution, you will need some of the following: EDTA tetra sodium, sodium sulfite, hydrochloric acid, and citric acid. (*See* Preparing Your Developing Chemicals, page 114.) Most PT/PL printers buy the sensitizer from Photographers' Formulary or Bostick & Sullivan. However, Rockland now carries a kit, too. The sensitizer comes premeasured; you just need to add distilled water and shake the bottles.

LIGHT SOURCES

When you are mixing platinum or palladium chemicals or coating support, your workspace should be illuminated with subdued "white light" (such as a normal 40-watt household bulb). Regular fluorescent bulbs should be turned off at this stage because they contain small amounts of UV light. You can dry your supports with a hair dryer on a cool setting under subdued light or air dry them in total darkness.

You can expose platinum or palladium prints in sunlight or in a UV light box. Mercury vapor lamps, which are used by printmakers, are found in most vacuum frames and are very fast. Some people insist that these bulbs give the best tonal range of all bulbs. Sunlamps are not recommended for PT/PL printing because they are slow, hot, and bad for your eyes. They also create low contrast in your prints. If you choose to use these lights anyway, be sure to wear glasses to protect your eyes. (*See* Light Sources, page 18.) Exposure times can range from 2 to 5 minutes in bright summer sunlight to 2 to 8 minutes in an exposure unit.

NEGATIVES

As stated above, making PT/PL prints involves a contact print process that requires negatives the same size as the finished product. Your negatives should have a good separation of detail in the shadows and a fairly long density range. The contrast of the paper can be controlled with the sensitizer, so most negatives can be used for this process.

PT/PL prints can also be made without enlarged negatives. Photogram materials—such as glasses, beakers, plates, fruit, lace, and leaves—can create wonderful images, as can drawings made with a wax pencil or charcoal on tracing paper or acetate. Printing from a collage of small (35mm) negatives is a third option.

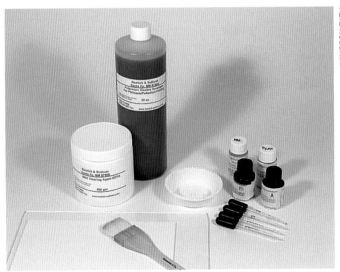

Here are a few of the materials you will need to get started: paper, glass, a cup, eyedroppers, and a Japanese Hake brush (or glass rod, as shown on page 12). You can get ready-mixed sensitizer from Bostick & Sullivan or Photographers' Formulary or mix your own from scratch.

Making Your Stock Solutions

PT/PL sensitizer can be bought separately or premixed. I strongly suggest getting the premixed sensitizer for the ease and safety of it all. However, I have also included instructions on how to mix your own sensitizer stock solutions from scratch. An alternative to PT/PL sensitizer is the Ziatype chemistry, which is available from Bostick & Sullivan. (*See* Sources, page 155.)

SENSITIZER (PARTIALLY PREMIXED)

If you are buying the premixed sensitizer from Photographers' Formulary or Bostick & Sullivan, the stock solutions come in brown bottles. These should be clearly labeled. Each chemical will need its own glass eyedropper (which should also be labeled).

FERRIC OXALATE

This solution is available ready-made. Just mark it "Ferric Oxalate/PT/PL A" and put it aside. The shelf life is from 3 to 6 months. If your solution is old, do a small test print to see if the tonal range is sufficient. If the highlights look fogged or muddy, you need new ferric oxalate.

POTASSIUM CHLORATE

This mixture must be prepared before it qualifies as your second stock solution. The bottle that will be used for this solution comes with the chemical, as described above. However, you must pour the small package of the contrast control (potassium chlorate) into the bottle and shake the solution well before it becomes the "Potassium Chlorate/PT/PL B" solution. This solution needs to be mixed at the time of purchase because the chemicals lose contrast as they age and it is better to combine the chemicals as you receive them. The shelf life is from 3 to 6 months. If you have old chemicals, do a small test print to see if the tonal range is sufficient.

PLATINUM

The platinum salt is available fully prepared; you just need to label it "Platinum/PT C." This solution does not go bad with age.

PALLADIUM

The palladium salt is also available fully prepared; you just need to label it "Palladium/PL C." This solution does not go bad with age.

SENSITIZER (FROM SCRATCH)

These stock solutions should be mixed with distilled water that is at least 100°F (under the low-light conditions of a household 40-watt bulb). Each solution should then be left to ripen for a day or two before being used to make your working solution. Do not forget safety when mixing these chemicals. Wear a mask, gloves, and goggles and use clean cups and mixing rods for each chemical. PT/PL salts (the "C" solutions) have a long shelf life. Basically, they do not go bad. However, the ferric oxalate (which is in both solutions A and B) has only a 3- to 6-month shelf life in a tightly closed brown bottle and in as dark an area as possible.

FERRIC OXALATE

This solution provides light sensitivity to the sensitizer. It needs to be mixed at least 12 hours before it is used.

50ml distilled water

1g oxalic acid

13g ferric oxalate

Pour the distilled water into a pot and heat it on a hot plate to 100°F. Transfer it to a large graduate. Gently sprinkle the oxalic acid and the ferric oxalate onto the water. Stir with a mixing rod until all the crystals have dissolved. Pour the solution into a dark brown glass or plastic bottle. Label this bottle "Ferric Oxalate/PT/PL A."

Ferric oxalate gets less contrasty as it ages and some people like to use the older oxalate (before it really starts to fog) to tone down the contrast of their prints. This would be harder to repeat as the oxalate gets older. If you're working with older chemistry, make a test print to see if you are still satisfied with the tonal range.

POTASSIUM CHLORATE

This solution controls the contrast of the sensitizer. It needs to be mixed at least 12 hours before it is used.

50ml distilled water

1g oxalic acid

13g ferric oxalate

0.5g potassium chlorate

Pour the distilled water into a pot and heat it on a hot plate to 100°F. Transfer it to a large graduate. Gently sprinkle the oxalic acid, ferric oxalate, and potassium chlorate onto the water. Stir with a mixing rod until all the crystals have dissolved. Pour the solution into a dark brown glass or plastic bottle. Label this bottle "Potassium Chlorate/PT/PL B."

PLATINUM

This is the metal salt. It is what makes this process so expensive and gives it color and tonal range. It needs to be mixed at least 12 hours before it is used.

60ml distilled water

12g potassium chloroplatinite

Pour the distilled water into a pot and heat it on a hot plate to 100°F. Transfer it to a large graduate. Gently sprinkle the potassium chloroplatinite (which is the platinum) onto the water. Stir with a mixing rod until all the crystals have dissolved. Pour the solution into a dark brown glass or plastic bottle. Label this bottle "Platinum/PT C." This solution keeps indefinitely. Some of the platinum may precipitate out of the solution when it sits at room temperature. Simply place the bottle of platinum in a warm water bath to redissolve it before use.

PALLADIUM (FORMULA 1)

This is the metal salt. It is slightly less expensive than platinum metal salt and is what gives the solution color and tonal range. It needs to be mixed at least 12 hours before it is used.

60ml distilled water

9g sodium chloropalladite

Pour the distilled water into a pot and heat it on a hot plate to 100°F. Transfer it to a large graduate. Gently sprinkle the sodium chloropalladite (which is the palladium) onto the water. Stir with a mixing rod until all the crystals have dissolved. Pour the solution into a dark brown glass or plastic bottle. Label this bottle "Palladium/PL C1." This solution keeps indefinitely.

PALLADIUM (FORMULA 2)

If sodium chloropalladite is not available, you can make a palladium solution with palladium chloride and sodium chloride instead.

40ml distilled water

5g palladium chloride

3.5g sodium chloride

Pour the distilled water into a pot and heat it on a hot plate to 100°F. Transfer it to a large graduate. Gently sprinkle the palladium chloride and the sodium chloride onto the water. Stir with a mixing rod until all the crystals have dissolved. Pour the solution into a dark brown glass or plastic bottle. Label this bottle "Palladium/PL C2." This solution keeps indefinitely.

Lower Atlas Mountains, Morocco, 2001. *When sensitizing this support I used a solution that favored palladium (19 drops PL to 5 drops PT). It was an average negative, which I exposed for 3½ minutes.*

PREPARING YOUR SENSITIZER

Mix the sensitizer under low-light conditions; a standard household lamp that is fitted with a 40-watt bulb is fine. Before you begin, make sure that your work surface is covered with newspaper. To make the stock solutions into a working solution, the individual stock solutions need to be mixed in varying amounts and ratios. These factors depend on (1) the size and (2) the contrast of your negative. (*See* Guide for Preparing Sensitizer, below.)

Oxalic acid acts as a preservative in stock solutions. Ferric oxalate forms the image in iron and then platinum and palladium while the potassium chlorate controls the contrast. By changing the proportions of "A" and "B" solutions, you can determine the contrast of your print. The "C" solution contains the metal salt.

To sensitize the paper, 22 drops of A and B combined (the proportion of which controls the contrast) and 24 drops of C

(metal) are needed to coat an 8 x 10-inch paper of average absorbency. In other words, to cover an 8 x 10-inch print when using a brush, the sum of the three solutions should always equal 46 drops. The table below lists the correct amount of drops for many other negative sizes and for contrast variations.

PT/PL solutions can be mixed together or used separately. It is a matter of choice as to which metal you use or the ratio of the two of them together. Remember that platinum is more contrasty and colder in tone than palladium. Too much platinum will give you a granular effect. Increasing the amount of palladium will warm the image color and reduce contrast, requiring that more chlorate ("B") be used. *Store the two metal solutions separately* and combine them drop by drop when mixing the actual sensitizer, varying the proportion as you see fit but keeping the total number of drops constant. Remember that the two metals together should equal 24 drops for an 8 x 10-inch print, but the ratio, which determines the tone of the print, is up to you.

GUIDE FOR PREPARING SENSITIZER

Combine the three solutions in a plastic, ceramic, or glass bowl and mix well—either by using a glass or plastic rod or by swirling the sensitizer together. If you do not want to count out so many drops, you can use the following conversion: 20 drops=1ml.

Contrasty Negative

	4 x 5	5 x 7	8 x 10	11 x 14	16 x 20	20 x 24
A	7	11	22	33	88	132
B	0	0	0	0	0	0
C	8	12	24	36	96	144

Slightly Contrasty Negative

	4 x 5	5 x 7	8 x 10	11 x 14	16 x 20	20 x 24
A	6	9	18	27	72	84
B	1	2	4	6	16	48
C	8	12	24	36	96	144

Average Negative

	4 x 5	5 x 7	8 x 10	11 x 14	16 x 20	20 x 24
A	4	7	14	21	56	84
B	3	4	8	12	32	48
C	8	12	24	36	96	144

Slightly Flat Negative

	4 x 5	5 x 7	8 x 10	11 x 14	16 x 20	20 x 24
A	3	5	10	15	40	60
B	4	6	12	18	48	72
C	8	12	24	36	96	144

Flat Negative

	4 x 5	5 x 7	8 x 10	11 x 14	16 x 20	20 x 24
A	0	0	0	0	0	0
B	7	11	22	33	88	132
C	8	12	24	36	96	144

The amounts listed here are for the brush method. If you are using a glass rod to apply the sensitizer, reduce the amount by about one print size. For instance, if you are working with an 8 x 10-inch negative and are coating the surface using the glass rod method, try using the drop amount listed below for the 5 x 7-inch negative.

You might have to play with the amounts because everybody works differently. You might need more or less than someone else making the same size print. The paper also plays a part in the amount of sensitizer you will need. A smooth, hot-pressed paper may take a lot less sensitizer than a textured, cold-pressed paper.

CONTROLLING THE CONTRAST OF YOUR PRINT

In addition to changing the amounts of solution A and B, there are other ways to control the contrast of your prints. You can use almost any type of dichromate or hydrogen peroxide instead of chlorate in solution B when mixing the working solution to aid with contrast control. However, too much will make your image grainy. This will become apparent in the highlight areas.

Below are some alternative suggestions. Whatever method you use, make sure to keep good records on what mixing proportions you used and how long you exposed your print so that you can repeat or correct what you have done. Personally, I write extensive notes on the back of each print so that I know exactly how I achieved the result.

If a higher contrast is wanted, do one or more of the following:

1. Use a paper with a hard, smooth surface.

2. Lower the temperature of the developer.

3. Double-coat your support before the initial exposure.

4. Make multiple exposures. (After the first exposure has been processed and dried, recoat the paper and expose it again using the same negative.)

If a lower contrast is wanted, do one or more of the following:

1. Use a paper with a soft, rough surface.

2. Increase the temperature of the developer. (In addition to warming the tones of a print, heated developer reduces contrast. However, it can also cause more streaks throughout the image, so be sure to slide your paper into the developer very evenly when using this method.)

3. Add a few drops of clearing bath to the developer. (However, if you do this, do not save the developer for reuse.)

Hotel 17, New York City, 2000.
This was a slightly contrasty negative. I used 18 drops of PL and 6 drops of PT to achieve a warm print and exposed the support for 4½ minutes.

PREPARING YOUR DEVELOPING CHEMICALS

There are so many different opinions about the best method for developing and clearing PT/PL prints that choosing one method can be daunting. Personally, I don't think that there is any one right way. Any of the methods below (and countless others) can work. Choose one, do a few test prints and decide if you like your results or need to try something else. Whenever you are experimenting, it is wise to change one variable at a time and, as always, keep good notes.

DEVELOPER

Many different developers can be used when making PT/PL prints. I have listed the five most common types of developer. The differences between some of the developers can be subtle. I learned with potassium oxalate and like what I get, so that is what I use. The only sure thing is that you should use distilled water (instead of tap water) when mixing developer because tap water may contain too much iron.

Store your developer in a tightly sealed bottle. If it is left in a tray for more than 24 hours, the water may evaporate and crystals will form. If this happens, pour the remaining liquid through a cheesecloth and place it in the storage bottle. Heat a little distilled water and add it to the crystals that are left in the tray until they dissolve. Then add this solution to the rest of the developer and mix well. You can continue to use this developer as usual. This is totally normal. While I advise the use of replenished developer, as always, you have to be mindful of mixing chemicals. For instance, if you are making a pure platinum or palladium print, you should not use the same developer that you used for a combination print, as it can contaminate your image with the salts that remain from the previous process.

POTASSIUM OXALATE

This is my favorite developer. However, it is an anticoagulant and a poison. Make sure that you use gloves when mixing this solution and work in a well-ventilated area.

48 ounces distilled water

1 pound potassium oxalate

Developers come as crystals packaged in their own plastic bottles that can be used to store the working solution. Pour the distilled water into a pot and heat it on a hot plate to between 100°F and 120°F. Pour the heated water into the bottle and shake it well until all the crystals have dissolved. Label this bottle "Potassium Oxalate/PT or PL Developer." (This developer should be used for either PT *or* PL processing; it should not be mixed between the two.) This solution will keep indefinitely. In fact, some say it improves with age and never throw it out. Add fresh developer to replenish as necessary.

AMMONIUM CITRATE

When used to make palladium prints, this developer will give neutral gray tones, making your image look similar to platinum prints.

48 ounces distilled water

1 pound ammonium citrate

Follow the directions for the potassium oxalate developer listed above. Then label the bottle "Ammonium Citrate/PT/PL Developer." This solution will keep indefinitely.

SODIUM ACETATE

This developer produces prints that are more contrasty than the potassium oxalate developer.

48 ounces distilled water

1 pound sodium acetate

Follow the directions for the potassium oxalate developer listed above. Then label the bottle "Sodium Acetate/PT/PL Developer." This solution will keep indefinitely.

POTASSIUM CITRATE

This developer produces prints that are more contrasty than the sodium acetate and is relatively nonhazardous.

710ml distilled water

1 pound potassium citrate

Follow the directions for the potassium oxalate developer listed above. Then label the bottle "Potassium Citrate/PT/PL Developer." This solution will keep indefinitely.

SODIUM CITRATE

This developer produces prints that are lower in contrast and colder in tone than potassium citrate.

710ml distilled water

1 pound sodium citrate

Follow the directions for the potassium oxalate developer listed above. Then label the bottle "Sodium Citrate/PT/PL Developer." This solution will keep indefinitely.

CLEARING BATHS

As with the developer, there are a number of different solutions for the clearing bath. I have listed three here—EDTA, hydrochloric acid, and citric acid. These are listed in order of my preference. EDTA is safer than hydrochloric acid. I found that the citric acid does not clear well with certain papers, but using one tray of citric acid and two trays of EDTA will work fine. Other people have found that hydrochloric acid may etch away the palladium salts, though I have not had this problem. When mixing the clearing bath, be sure to use distilled water, because tap water may contain too much iron.

Keep in mind that the thicker your support is, the more clearing bath is needed. You can adjust the "recipes" given here and increase the amount of chemicals per bath. The stronger the solution is, the faster it will work, but remember that you should not keep your print in a strong solution for very long or it may weaken the paper fibers.

I have found that a separate hypo clearing agent or perma wash bath—used in combination with any of the three following clearing baths—works well. I have used hypo clearing agent for the first bath followed by two baths of citric acid and vice versa, and this seemed to work fine. You may need to keep your support in one bath a little longer than another, but in the end, there is no obviously superior method. Do whatever works for you—as long as your paper is cleared in the end.

EDTA

EDTA stands for ethylene diamine tetraacetic acid tetrasodium salt. Mixing a clearing bath with EDTA is not an exact science. You can add from 1 to 5 tablespoons of the chemicals per tray.

944ml (1 quart) distilled water

2 heaping tablespoons EDTA

2 heaping tablespoons sodium sulfite

Wear rubber gloves when mixing this solution. Pour the distilled water into a pot and heat it on a hot plate to at least 70°F. Transfer it to a large graduate. Gently sprinkle the EDTA onto the water. Stir with a mixing rod until all the crystals have dissolved. Pour the solution into a dark brown glass or plastic bottle. Label this bottle "EDTA/PT/PL Clearing Bath." Properly stored, this solution will keep indefinitely. EDTA is not an acid. Therefore, it is safer to use than the hydrochloric acid listed below.

CITRIC ACID

This is the safest of the three clearing bath solutions, but it may not work with every support.

944ml (1 quart) distilled water

1 to 3 tablespoons citric acid

Wear rubber gloves when mixing this solution. Pour the distilled water into a pot and heat it on a hot plate to 100°F. Transfer it to a large graduate. Gently sprinkle the citric acid onto the water. Stir with a mixing rod until all the crystals have dissolved. Pour the solution into a dark brown glass or plastic bottle. Label this bottle "Citric Acid/PT/PL Clearing Bath." Properly stored, this solution will keep indefinitely.

HYDROCHLORIC ACID

This clearing bath can be tough on paper fibers, making them brittle. It can also generate hefty fumes, so make sure your workspace is well ventilated before mixing and using this solution. This is the least safe of the three choices.

944ml (1 quart) distilled water

20ml hydrochloric acid

Wear rubber gloves when mixing this solution. Acids can stain and burn, even in dilute solutions so be careful when handling this chemical. Pour the distilled water into a pot and heat it on a hot plate to 100°F. Transfer it to a large graduate. Gently pour the hydrochloric acid into the water. (It is important to add the acid to the water—*not* the water to the acid—to avoid splashes.) Stir with a mixing rod until it is mixed well. Pour the solution into a dark brown glass or plastic bottle. Label this bottle "Hydrochloric Acid/PT/PL Clearing Bath." Properly stored, this solution will keep indefinitely.

COATING AND DRYING YOUR BASE SUPPORT

Before you begin coating the base support, cover your workspace with newspaper to protect the surfaces. You can coat the support under a dim room light (i.e., a lamp that is equipped with a 40-watt bulb) or a safelight, provided that you are not near any windows or fluorescent lights. If you are using paper as the base support, you can coat it by using either the glass rod method or the brush method. (*See* Sensitizing Techniques, page 25.) If you use a sheet of paper that is bigger than your enlarged negative, it will be easier to keep the chemicals to the front and not go over the edges while you are coating. A large sheet of paper also provides some holding room, which helps you avoid leaving fingerprints in the sensitizer.

After sensitizing the support, dry it thoroughly before exposing it. (*See* Drying Techniques, page 29.) The sensitizer should be a nice orange-brown tone. If it is gray, it has been fogged. If it is dark brown, you may have burned it by using the hair dryer on too warm a setting.

Keep good notes while you are sensitizing and exposing the support so that (if you like the results) you can repeat them or (if you don't like them) you can figure out what you may have done incorrectly. If it is possible to write on the back of the support, use a pencil to note the following: the solution, the type of support, the exposure time, and the light source. If you are exposing outside, you should also write down the time of day and the season.

EXPOSING YOUR BASE SUPPORT

If you do not expose the support immediately after coating, the highlights in the final print won't be as bright as they could be. A general rule of thumb is that palladium exposure time is shorter (by about half) than platinum. Determining the correct exposure through the use of a test strip is a particularly good idea because platinum and palladium are far too expensive to waste on an untested exposure. Using a small piece of support that was coated *at the same time* as the final support, do the test strip in 2-minute intervals using opaque black paper taped to the contact print frame. Before it is developed, the exposed print will be very faint and will appear as a grayish-lavender image on a yellow background. There should be details in the highlights. Develop the print as soon as it is exposed, and make sure to clear and *fully dry*

My Mother's Family, 1990. *I used this old photograph (from 1917) to make a 4 x 5-inch negative with Plus-X film. To sensitize my support I used all palladium and exposed this average negative for 3 minutes. The slight yellow color of the paper is a stain caused by not fully clearing the image.*

the support before determining the exposure for the final print. As with most photographic processes, PT/PL prints dry darker.

Exposure time depends on the following: (1) the quality of the negative, (2) the combination of the working sensitizing solution (the more solution "B" [contrast control] used, the longer the exposure will be; the more palladium used, the shorter the exposure will be), (3) the source and quality of the light, and (4) your choice of support.

DEVELOPING/WASHING YOUR PRINT

PT/PL prints can be developed in subdued room light (i.e., with a lamp that is equipped with a 40-watt bulb). As with all of the processes described in this book, you should wear gloves and use tongs when processing prints.

Heated developer warms the tones, reduces contrast, and increases the speed of the paper so that less exposure is required. Heated developer can also cause more streaks throughout the print, so be sure to slide the paper into the developer very evenly when using this method. Make sure that the temperature stays constant between the test strip and the final print or the results will not be the same. The developer can be heated up to its boiling point.

To process a print, follow these steps:

1. Fill the tray with about 2 to 4 inches of *developer*. Immerse the print (face up) into the tray in one continuous motion. The image will pop up quickly, so any hesitation will cause a development line across the surface. Guard against air bubbles by agitating the tray for 1 or 2 minutes. If you need to dislodge any bubbles by hand, make sure that this is done while wearing gloves. There is no danger of overdeveloping the print, as the reaction will stop once it is complete.

2. Clear the print in three separate clearing baths, agitating lightly for about 5 minutes in each bath to remove the iron. (If you don't successfully remove the iron, it will eventually darken your print.) If the print still looks yellow when you think you have finished clearing, or if it looks yellow after it dries, put the print back into a clearing bath or it will darken over time. The thicker the support, the longer the clearing time will be. After several prints, or when the clearing solution becomes yellow or cloudy, dump out the first bath, move the second up to first, the third up to second, and pour a new bath for the third. This way the last bath will always remain the least contaminated, ensuring complete removal of the iron from the image. The acid will lighten the print slightly, but drying will darken it again. Do not gang prints during this stage. Acid makes the paper very fragile and it can easily scratch.

3. Transfer the print to a tray of running water and allow it to wash for 15 to 30 minutes, depending on the thickness of the paper.

You can dry the print using any one of a number of methods. (*See* Drying Techniques, page 29.)

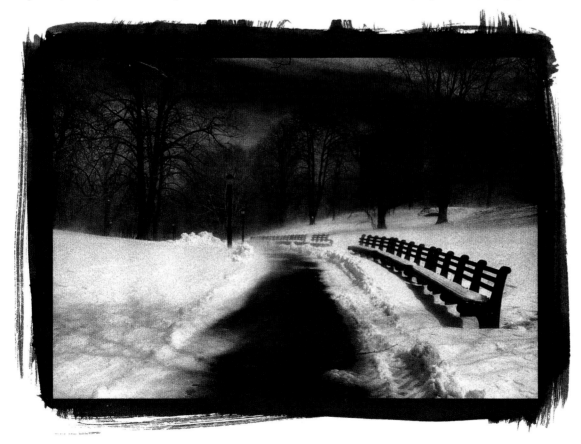

Central Park Blizzard, New York City, 1981. *The negative was slightly contrasty but I wanted to enhance the contrast further so I coated my support twice using 18 drops of PL and 6 drops of PT. I then exposed the support for 4 minutes.*

TROUBLESHOOTING

The best way to troubleshoot with PT/PL printing is to keep good notes. Most of the problems you may come across can be easily explained as long as you know what the drop amounts were, how you coated the paper, and how long the exposure was. The following section will clarify a few of the most common problems that people have as they learn to do this beautiful process.

• If you notice yellow stains in the highlights after you have processed the print, the support may not be fully cleared. (Textured papers, such as Arches Platine, are more difficult to clear than smooth papers.) Clearing the image fully is very important, as the yellow stains will get darker over time. To finish clearing the support, prewet the print for a few seconds in a tray of water, then place it back into a clearing bath. If you're using an EDTA clearing bath, you can add 2 to 3 tablespoons of sodium sulfite, which can also help.

• If the print developed unevenly, you either (1) did not have enough developer in the tray or (2) did not "swoop" the support into the developer. Make sure to buy extra developer so that you can fill the tray to at least 2 inches, and be careful to submerge the support in the developer in one quick motion. Any hesitation will cause a dark streak.

• If the paper curls while you are coating and/or drying it, you are probably using a single-weight or other type of paper that needs special consideration. Using drafting tape, secure the

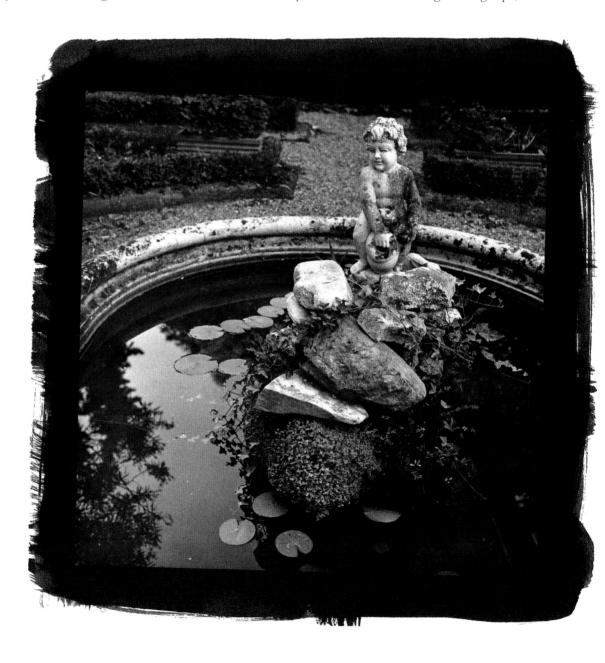

American Church Garden, Florence, 1999. *The internegative was very flat so I decided to use a double coat of palladium. I then exposed the support for 5 minutes.*

support onto a piece of glass during the coating and drying stages. Once it is partially dry, you can remove some of the tape and lift one side of the paper so the underside can dry.

- If the highlights of the finished print are gray, the ferric oxalate may have gone bad. Normally, ferric oxalate goes bad after 3 to 6 months. You can check your ferric oxalate by doing an easy fog test:

1. Mix enough emulsion to make a 4 x 5-inch print.

2. Coat the paper as you normally would.

3. Without exposing the paper, place it in the developer and clearing bath for the correct times.

4. The paper should have cleared. If you see a slight gray tone, then the ferric oxalate is fogged. (If it is yellowish, it just has not cleared yet).

- If stains of any type or color appear on the print, you may be working with contaminated utensils. Be sure to assign each utensil to a particular chemical and do not use the utensil for anything else. Also, if you have not washed your utensils (i.e., brushes, eye droppers, bowls) fully between prints, whatever chemical might be left on the utensil can become fogged and contaminate the new chemical. Keeping your equipment extremely clean is important when working with any alternative process.

- If your print is weak, you might try double exposing it. Make an exposure and run through the normal steps, then make another exposure over it to give the image more of a dimensional feel. Make sure that you register your negative with the initial print. You can use drafting tape or Scotch Magic 811 removable tape to make sure that the negative stays registered in place. Neither of these tapes will take off the emulsion. You can also buy registration marks from most art-supply stores. As with all of the processes mentioned in this book, the trick is to experiment.

- If the developer becomes particularly thick, filter it through a cheesecloth (or a coffee filter) and add fresh developer to the remaining liquid. Never throw the developer away; just keep replenishing it with new developer.

- If you have made a straight platinum print but it looks too warm, you probably used developer that you had used previously to make a palladium print. Keep your developers separate. Have one for straight platinum, one for straight palladium, and one for when you combine the two.

- If the highlights are fogged, do not immediately assume that bad ferric oxalate is to blame. It might be that you dried the print on too high a setting and burned the sensitizer. Coat and dry another piece of paper and follow the steps in the previous column to check for fogged oxalate.

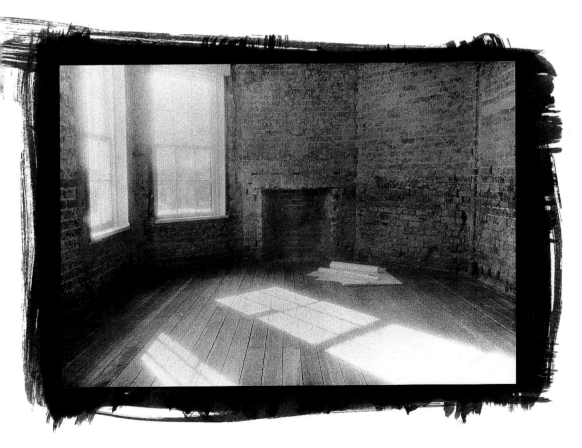

Jefferson's Loft, 1992.
I originally shot this image for American Heritage Magazine *for a story on Thomas Jefferson's summer home. The negative was slightly contrasty and I used a combination of 16 drops PT and 8 drops PL, then exposed the support for 4 minutes.*

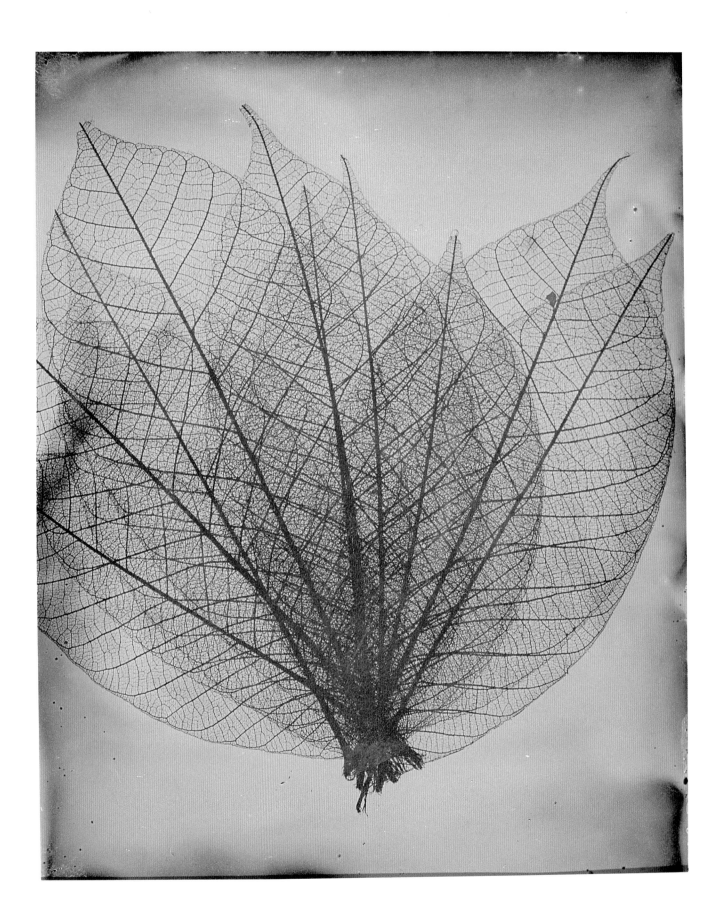

TINTYPES

TINTYPES, WHICH ARE ALSO KNOWN as ferrotypes and melainotypes, were never actually done on tin, but rather on a thin iron plate that was painted black so that the image could be seen clearly. The tintype process was similar to earlier photographic processes that were done on glass (such as ambrotypes and daguerreotypes) and that needed a black backing so that the image could be seen as a positive. There are two distinct kinds of tintypes: "wet-plate" tintypes, which contain silver halide in (flammable) collodion, and "dry-plate" tintypes, which were invented after the wet-plate process and which replaced the collodion with gelatin, creating a safer process. Both processes are positives on metal plates.

According to Beaumont Newhall's *The History of Photography*, Hamilton Smith invented tintypes in the mid-1800s. Reading other books, you will find disputes to this claim, with other inventors and dates offered instead. However, what is important is that at some point in the late 1870s the dry-plate process was introduced, making the tintype popular and available to the general public. Street photographers used the dry-plate process because it was cheap and easier to produce than the glass-plate processes. These photographers used cameras equipped with multiple lenses to make numerous small copies of the image for the sitter to give as calling cards.

There has been a renewed interest in tintypes among contemporary photographers. Tintype kits are now commercially available, so this process is becoming increasingly accessible. While it takes practice to learn to coat tintypes, it is well worth the effort, as the delight that comes from watching these beautiful little gems, with their wonderful tones and surprise colors, develop in the darkroom is a unique and gratifying experience.

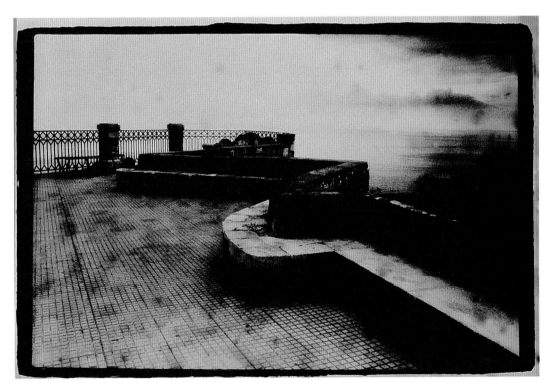

Taormina, Sicily, 1992. *To make this tintype I exposed a 4 x 5-inch color transparency for 5 minutes using an enlarger method. (Since the transparency was the same size as the plate, I contact-printed it.) The exposure was long because the transparency had a lot of red in it.*

Opposite page:
Leaves, 2000. *I bought these leaves at a paper store because they were so transparent and fragile and I knew I could eventually use them. When I finally decided to make tintypes with them, I put a few of them down on the plate and exposed it for 15 seconds at f/4.*

CREATING TINTYPES

Tintype emulsion is liquid emulsion—it comes complete in one bottle and no additional chemicals are necessary. Tintype kits come with positive reversal developer, which allows you to obtain a positive tintype image. To make tintypes you need positives (either interpositives or slides) or photogram materials. The positives should have good contrast, can be black and white or color, and should be on the thin (light) side unless you do not mind long exposures.

You can make tintypes by placing the coated metal sheet directly into the camera, by placing the positive on top of the metal to make a contact print, or by using an enlarger to project a positive onto the metal. Colors reproduce differently on tintypes than they do on normal black-and-white film: reds appear black and blues appear slightly yellowish-brown. If you do not varnish your tintype, it will tarnish or turn black in a short period of time. However, if you fix and wash the image correctly and varnish it, it can be considered archival.

GETTING STARTED

Many of the items required to make tintypes are standard darkroom materials that were discussed in Chapter 2. (*See* Basic Darkroom Equipment and Materials, page 12.)

Before you get started, make sure that you have the following items on hand:

Apron	**Gloves**
Bucket	**Mixing Rod**
Hair Dryer	**Newspaper**
Hot Plate	**Paper Safe**
Darkroom Thermometer	**Pencils**
Drafting Tape	**Pot and Pyrex Measuring Cup**
Glass	

If you are going to varnish your tintypes, you will also need cotton balls, a funnel, and a small, dark brown plastic or glass bottle. In addition, you should note the following:

Black Paint Black *flat* enamel spray paint, sprayed onto one side of the metal, will allow the image to be visible.

Metal Plates You can buy litho plates, which are used for offset printing, from most art-supply stores, but any type of metal can be used. Larger sheets can be cut to the desired size.

Graduates You will need three graduates: one large one to hold the hot water, one small one to hold the emulsion, and one small one to hold the brushes as you work.

Safelight Your safelight should be *light amber* or *red* and should be kept slightly darker than it would be for a normal darkroom.

You can use safelight bulbs or safelights that are equipped with filters and that use regular lightbulbs.

Metal-cutting Scissors These should be fairly sturdy.

Storage Bottles You will need one one-gallon dark brown *plastic* or *glass* bottle for the developer as well as two one-pint bottles for the varnish (one for mixing and one for storing). Since the fixer for this process is the same as for normal silver printing, you can use a standard bottle for the fixer.

Trays Making tintypes does not require special (plastic) trays; you can use the same trays as for normal silver printing. You will need four trays for developing, fixing, and washing tintypes. As with liquid emulsion, you cannot make tintypes in a darkroom where others may be printing standard black-and-white prints, due to contamination.

CHEMICALS
Rockland makes a tintype kit called AG-Plus that comes with the emulsion, developer, and fixer. Some tintype kits come with plates that are already prepared with black paint and are ready to be coated with the emulsion. If you do not want to use the kit, you can use any liquid emulsion product. (*See* Getting Started, page 48.) You can also make either of the optional developers. Regular fixer (with hardener) can be used to fix the image. If you want to varnish your prints, you will need gum sandarac, 190-proof grain alcohol, and oil of lavender.

POSITIVES
You can use either interpositives or slides. The positives should have good contrast, can be black-and-white or color, and should be on the thin (light) side.

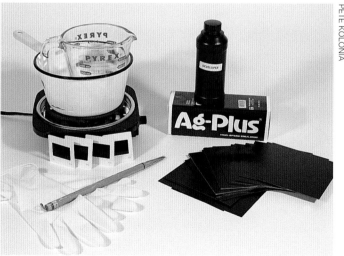

Here are a few of the materials you will need to make tintypes: hot plate, pot, Pyrex measuring cup, positives, developer, emulsion, gloves, brush, and metal plates.

Preparing Your Chemicals

Only three solutions are required to make tintypes—emulsion, (which is identical to the emulsion used to make liquid emulsion prints), reversal developer, and varnish. The first two come with the kit. The varnish is optional, but is very easy to make.

EMULSION

This solution will come, already prepared, with your kit or you can use any liquid emulsion product. No mixing is required. The tintype emulsion is a solid gel at room temperature and needs to be thoroughly warmed before you can use it. (*See* Preparing the Liquid Emulsion, page 52.)

DEVELOPER

You have a number of different options when it comes to developing tintypes. Rockland carries two different kits—the Standard Tintype Parlor Photo Kit (which includes a small bottle of pre-mixed developer) and the Bulk Tintype Kit (which includes two packages of developer—a powdered package and a small brown bottle of liquid—that need to be mixed together). Rockland said that even when the developer looks like dirt it should still work (unless it is all black). However, I got pockmarks throughout my plates, even when my coating looked perfect. Therefore, I offer the following two recipes as alternatives, should you find that you have the same problem.

Using the reversal developer is fairly straightforward. Using the Dektol developer, however, the image will look like a negative while it is in the developer, but once it is in the fixer, it will turn to a positive. Of course, if you add too much fixer to the developer, the image will not come up; if you do not add enough fixer, the image will not turn to a positive image in the final fixer bath. The shelf life of this developer/fixer combination is questionable. I have not made enough to keep longer than one week.

REVERSAL DEVELOPER

If you have purchased a reversal developer kit that will yield one gallon of solution, mix it as follows:

1 gallon of distilled water

1 reversal developer kit

Pour 3 liters of the distilled water into a pot and heat it on a hot plate to 120°F. Transfer it to a large bucket. Your kit may contain only liquid developer or it may contain both liquid and powder. If the latter, sprinkle the powdered developer into the water. Stir with a mixing rod until all the powder has dissolved. Pour the small bottle of liquid developer into the bucket and stir. Add the remaining water to equal 1 gallon. Pour the solution into a dark brown glass or plastic bottle. Label the bottle "Reversal Developer/Tintype." The mixed developer will only last 1 to 2 weeks.

DEKTOL DEVELOPER

This alternative developer recipe was discovered by Mark Osterman in a 1911 issue of *The Encyclopaedia of Photography*.

32 ounces Kodak Dektol paper developer

66 ounces distilled water

2 ounces exhausted paper fixer

Instead of making developer from scratch, dilute Kodak Dektol paper developer 1:2 in a brown storage bottle. Add 2 ounces of *exhausted* paper fixer and 2 ounces of water. Shake the bottle and let it sit for 2 days. Label the bottle "Dektol Developer/Tintype."

Jockeys, 1999. *To make this photogram I placed a stencil on top of the metal and exposed it for 15 seconds at f/4. I developed the image using Dektol developer. After the tintype was processed and dried I used pastel chalks to add color to the plate. I wanted to keep the playful feel of the stencil so I chose bright colors and bold strokes.*

VARNISH

Varnish is not included with the tintype kits. However, it is an important part of the process—especially if you want to preserve your images. The following chemicals can be purchased from one of the companies listed in the resource list. (*See* Sources, page 155.)

VARNISH

This simple varnish will help preserve your tintypes.

414ml of 190-proof grain alcohol

57g gum sandarac

44ml oil of lavender

Pour the grain alcohol into a small, dark brown *plastic* or *glass* bottle. Add the gum sandarac, secure the cap on the bottle, and shake it until all the gum is dissolved. Add the oil of lavender. Shake the mixture well. Filter this mixture several times by pouring the varnish through a plastic funnel that has been filled with cotton balls into a second small, dark brown *plastic* or *glass* bottle. It is very important that this varnish is free of any foreign matter. Pour the fully filtered varnish into a third bottle and label it "Varnish/Tintype." Keep the varnish sealed until you are ready to use it. It should last up to 3 months. Before using the varnish, heat it to 80°F to 90°F.

COATING YOUR PLATE

If your kit came with metal plates, they will be ready to be coated. However, you can also buy a thin piece of metal, cut it down to the desired size, and spray the *dull* side with *flat* black enamel spray paint. Make sure the paint is dry before you proceed.

While you are coating the plate, your darkroom should be illuminated with a *light amber* or *red* safelight. Your workspace will be slightly darker than a normal darkroom, but the safelight should provide ample illumination by which to work. The emulsion is highly sensitive to light. Be mindful of how long your material is exposed to the safelight, especially if you are coating many pieces of support. The plates will fog if they are exposed to the safelight for too long.

Not to scare you, but coating metal is a pretty difficult procedure. I suggest practicing with a "fake" emulsion that you can make up by mixing milk with a little flour. (Your "fake" emulsion should be thinner than a paste, but not a runny liquid.) This will allow you to get the hang of coating without wasting a lot of emulsion.

Make sure to wear gloves during this process, because it is sometimes easier to use your fingers to help the emulsion coat thinly and evenly to each corner. Melt the emulsion, as described earlier. (It is important to have emulsion at the right temperature. If it is too cool, you will have trouble coating the metal evenly.)

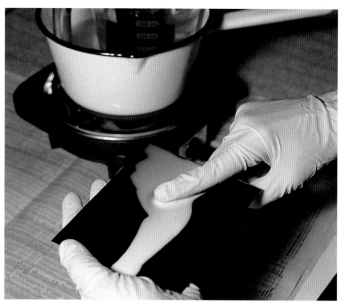

To coat the support, pour a generous amount of emulsion onto the metal. One way to disperse the emulsion evenly is by using your finger.

Pour a generous amount of the emulsion into the center of the plate. Tilt the plate so that the emulsion runs to cover one side, then tilt it in the other direction until it coats the other side. Continue doing this until the plate is evenly coated. You'll have to work quickly, because the emulsion becomes sticky and transparent as it starts to cool.

Some people use their fingers to help the emulsion along. (Be sure to wear gloves.) You must practice to see which method works best for you. In either case, let the excess emulsion run off the plate from one side back into the bottle or into a "catch bowl" so that you can reuse the emulsion. This will ensure a thin, even coat without wasting emulsion.

With the correct coating thickness, plates will appear from dark white to light gray when dry.

DRYING YOUR PLATE

There are two methods that you can use to dry plates—though either way it is best to leave the plates in total darkness while they dry. Once the plates are fully dry store them carefully in a light-tight box. (I use a paper safe.) To avoid scratches, I do not stack my plates at any point—either during the drying process or while they're in storage.

TABLETOP METHOD

Some people like the unpredictable effect that can be created by drying plates on a flat surface, such as a tabletop. Others do not like to dry their plates flat because the emulsion can "pool" in the middle, creating an uneven coating. Either allow the plate to air dry or dry the plate yourself, using the cool setting on a hair

Italian Gate, 1999. *Using an original black-and-white chrome (made with Scala 35mm film) projected in an enlarger, I exposed this plate for 2 minutes. The different colors created during the tintype process are totally unpredicatable. It depends on the amount of humidity in the room, how the plate was coated, and any colors that might be in your original.*

dryer. If you choose the latter method, place a loop of tape on the back of the plate so that it will stay put and not flip off the table as you dry it. Be careful if you are using a hair dryer because the emulsion is prone to dust and hairs, which will destroy the surface.

WALL METHOD

While this method tends to give a more even surface than the tabletop method, if you place your plate upright too soon after coating, sometimes gravity will kick in and there will be a heavier coating toward the bottom of the plate. After you have let the emulsion drip to each corner (as described in the previous section), rest the plate vertically against a wall or an upright object and leave it until it is dry. This will allow most of the emulsion to evenly coat the plate.

EXPOSING YOUR PLATE

Make sure to expose and develop your plates soon after they have dried. Do not let them sit too long. I have found that plates can fog within a day. You can expose your tintype with a variety of light sources. However, no matter which method you choose, it is best to make a test strip. This will save you time and money.

IN-CAMERA METHOD

This method makes one-of-a-kind tintypes. You can use either a view camera (4 x 5-inch or larger) or a pinhole camera. Cut the metal to the proper size for your camera *before* you apply the emulsion so that you do not have to handle the tintype plate too much and possibly scratch it with the metal-cutting scissors. Because the metal is thicker than film, you will need to be in the darkroom to load the camera; conventional large-format film holders will not work. So in order to make a tintype in camera, you must be close to the darkroom to change the plate after each exposure.

As discussed earlier, the coated plates should be stored in complete darkness. The first part of this process, however, should be performed in the darkroom, using a safelight, to ensure that the plate isn't spoiled.

1. Put the plate in the camera with the emulsion-coated side toward the lens.

2. Check to make sure that the plate is sitting firmly on the film plane of the camera. (You might want to tape it in place.)

3. Close the camera carefully so as not to damage the plate.

4. Take the camera outside and shoot your image, using the following guidelines as starting points:

Bright sun on subject:	f/16 at ½ second
Cloudy/bright:	f/8 at ½ second
Open shade:	f/5.6 at ½ second

Rutherford Park, New York City, 1999. *Using a pinhole camera, I exposed this plate for 40 minutes. The emulsion is thicker toward the center of the metal, which created the milky color. The marks in the right-hand corner are from my handling the plate roughly in the developer, which caused the soft emulsion to move.*

If you are using a pinhole camera, the exposures will be much longer. You'll need to experiment, but you may want to start with a 30-minute-long exposure. The exposure time will depend on how large the pinhole aperture is and how bright the light is.

ENLARGER METHOD

Using an enlarger does not give the same one-of-a-kind spontaneous image as the in-camera method. To some people this is a disadvantage and to others an advantage; it depends on how you like to work. While the enlarger allows you to repeat an image and make tests to get the correct exposures, you will still be creating unique images. Each tintype plate is coated differently and will create a different feel and colors throughout the picture.

There are two ways to use the enlarger to turn a positive into a tintype. You can use it to either project the positive onto the plate or to make a contact print with the plate. If you are contact-printing, use a piece of plate glass to ensure a good contact between the enlarged positive and the metal.

If you are using an enlarger to project the image, you can use any size positive that your enlarger allows. The image is further away than if you were contact-printing it, so this method requires longer exposures. Also, note that color positives take twice as long to expose as black-and-white positives. Do a test strip at 10-second intervals with the aperture wide open to determine the amount of time required to expose the image. Then make the final exposure.

If you are using an enlarger to make a contact print, you can use almost any positive—color, black-and-white, or even a "paper positive." In any of these cases, place the emulsion of the positive to the emulsion side of your plate. Do a test strip at 5-second intervals with the aperture wide open to determine the amount of time required to expose the image (Some positives may take up to 5 minutes, depending on the colors.) Then make the final exposure.

DEVELOPING YOUR PLATE

Illuminate your darkroom with a *light amber* or *red* safelight. The temperature of each of the chemicals should be *below* 70°F to avoid melting the emulsion, which can cause it to float off the support.

1. Place the exposed plate faceup in a tray filled with *developer* and agitate it frequently for 2 minutes. Portions of the plate might turn gray during development.

2. Do *not* use shortstop after developing. Instead, transfer the plate into a tray of cool, running water and allow it to wash for a few seconds before putting it into the fixer.

3. Transfer the plate to the hardening fixer bath. (Kodak's powder fixer works well, or use rapid fixer with hardener.) Allow the plate to fix for 2 to 3 minutes, agitating occasionally . The fixer should harden the emulsion so that it becomes tough and leathery to the touch.

4. Transfer the plate into a tray of cool, running water and allow it to wash for 10 minutes.

Goose, 2000. *I used a 4 x 5-inch copy transparency of a hand-painted original to make a contact print onto a tintype plate. I exposed the plate at f/4 for 1½ minutes. The black dots are pinholes that I did not take out of the emulsion before exposing.*

DRYING AND VARNISHING YOUR PLATE

Allow the plate to dry on a screen or on a tabletop, face up. If you are not happy with the results of your tintype, you can run hot water over the plate to wash off the emulsion and then reuse the metal. However, if you are happy with the image, you should varnish it. As mentioned earlier, unvarnished plates will tarnish in time and turn very dark. Varnishing not only protects the image but, if done well, it makes the tintype virtually archival.

Varnishing should be done when the plate is dry. The entire plate must be coated as quickly as possible or you will create lines or streaks through the image. Spread the varnish in the same way that you spread the emulsion, by pouring it on the plate and then tilting the plate from side to side or by using your (gloved) fingers to spread it. However, make sure that you dry the varnished plate vertically, not horizontally, so that the varnish does not pool in one spot.

TROUBLESHOOTING

- If the emulsion slides off, you either (1) used *glossy* paint or (2) coated the wrong side of the metal. Be sure to cover the metal plate with *flat* black spray paint, being careful not to leave any shiny or silver areas. Once the paint is dry, you should coat the black side of the metal with emulsion.

- If the print looks solarized, you fogged the emulsion either by having your darkroom be too bright or by leaving the tintypes out too long. Be sure to dry the tintypes in total darkness if you are air drying them. You can use a hair dryer on a cool setting to quicken the drying process, but be sure to put the tintypes in a paper safe as soon as they are dry.

- If the final tintypes present negative images instead of positive images, the developer might be too old or contaminated, or you used regular paper developer instead of the tintype (i.e., positive reversal) developer.

- If the tintype is too light, with no blacks, you have overexposed the print. Decreasing the exposure should solve the problem. If the tintype is too dark, you need to increase the exposure.

- If the print has a slight bluish tint, either (1) you did not use enough emulsion to coat the metal or (2) the developer was exhausted.

- If the emulsion is cracked, you may have damaged the plate while cutting it to size. It is better to cut the plates to the desired size *before* you coat them with emulsion.

- If the emulsion sets up too quickly and you're having trouble getting a good even coat on the tintype, your darkroom may be on the cold side. Warming the metal with a hot hair dryer before pouring the emulsion on will help solve this problem.

- If you are having problems with emulsion chipping off, the emulsion may have exceeded its shelf life. Sometimes the emulsion kits are inconsistent. Any liquid emulsion can be used (Luminos, Cachet, Bergger, etc.) instead of the material that comes with the kits.

- If the images have large pockmarks, the developer may have exceeded its shelf life. If you open the developer package and it is almost totally brown, send it back; it is not fresh.

- If the final tintype has black holes on it, there were air bubbles in the emulsion as you were coating the plate. If you discover air bubbles after coating the plate, spray it with alcohol (which will break them up). Do not leave them on the plate.

- If you thought you exposed the tintype well but it did not clear in the fixer, you may be using the wrong fixer. Make sure to get powdered fixer with hardener or add solution B (hardener) to your rapid fixer.

THE FAUX AMBROTYPE TECHNIQUE

This is not a "real" ambrotype, but a technique that will look like one. A real ambrotype is a wet-plate process that is a little more difficult. Although people (like Mark Osterman and Sally Mann) still make ambrotypes today, this method is a lot easier.

Before sizing the glass, make sure you follow the instructions for cleaning it. (*See* Sizing Techniques, page 24.) Once the glass is properly washed, you can use any sizing method you prefer. (*See* Sizing Formulas, page 22.) Then follow the coating, drying, exposing, processing, and varnishing instructions for the tintypes. Once the image is processed, put black paint, cloth, or paper underneath the glass so that it will show.

POLAROID TRANSFERS AND EMULSION LIFTS

I N 1948 EDWIN H. LAND introduced his invention, the Polaroid Land Camera. While it was based on some old concepts, it was nevertheless the first instant-print camera on the market. Because the film used by this camera incorporated a sealed pod consisting of developer-fixer and a "receiver," a positive could be seen just one minute after the film was exposed. Polaroid cameras were immediately adopted by professional photographers to aid in previsualization for lighting and setups during studio and location shoots. Today many varieties of instant film are available, generating a number of alternative processes that can be used to create one-of-a-kind personal expressions.

Taking instant film and manipulating it—by peeling the print and film apart and transferring the dyes onto another sur-face—is a starting point for creating work that is personal and unique. Any type of support—from paper to wood—can be used to enhance your technique and the style of your final images. There is no one correct way of doing things. However, this chapter will discuss the two main possibilities—Polaroid transfers and emulsion lifts. These processes can be really fun, fast, and quite unpredictable.

The Polaroid transfer and emulsion lift processes can be combined with one another. For instance, images can be written or drawn on, several images can be placed on top of one another, or these images can be combined with other processes discussed in this book. The possibilities are endless. Each method has its good and bad points. Experiment—and let your own artistic preferences guide you to create new combinations.

Portuguese Window, 2000. *I shot the original with Kodak Ektachrome film and enlarged the image in a Daylab. I let the type 59 Polacolor 4 x 5-inch film develop fully so that the emulsion lift would have a good tonal range and bright colors. Before I positioned the emulsion onto Fabriano Artistico 140-lb cold-pressed watercolor paper, I moved it around on a piece of acetate until I got the desired abstracted effect.*

Opposite page:
Moroccan Pillows, 1998. *For this Polaroid transfer I used a Daylab to enlarge the original Kodak Ektachrome slide onto type 59 Polacolor 4 x 5-inch film. I then transferred the image onto Fabriano Artistico 140-lb cold-pressed watercolor paper. After the image dried I used colored pencils to add more details throughout.*

CREATING POLAROID TRANSFERS

One of the benefits of this process is that you can choose between making Polaroid transfers from preexisting transparencies—which lets you make multiple transfers of the same image—and shooting "live" directly onto Polaroid film. Either way, each Polaroid transfer is guaranteed to be unique. If you are photographing still lifes, there may not be a big difference between working from transparencies and working from life. However, if you are photographing people, working live will change each image at the start and will create truly one-of-a-kind Polaroid transfers.

Immediately after the film has been exposed, it is prematurely peeled apart, placed on almost any support, and then rubbed so that the dyes transfer to that surface. The process is as simple as that. Some people say that warm colors transfer better than cool ones, but I think this is very subjective.

GETTING STARTED

Many of the items required to make Polaroid transfers are standard darkroom materials that were discussed in Chapter 2. (*See* Basic Darkroom Equipment and Materials, page 12.)

Before you get started, make sure that you have the following items on hand:

Canned Air	Hot Plate
Distilled Water	Pot
Glass	Scissors
Gloves	Squeegee
Hair Dryer	Timer

In addition, you should note the following:

Color Printing Filters These are used with an enlarger and the Vivitar slide printer. (The Daylab has built-in filters.)

Polaroid Film Holders Each size Polaroid film needs its own holder. This not only holds the film as you are exposing it, but it is equipped with rollers that break the pods to start the developing process. Larger (i.e., 8 x 10-inch) film requires both a film holder and a processor.

Rubber Brayer This is used to burnish the Polaroid image onto the support.

Spray Bottle This is used to spray vinegar and water onto the emulsion transfer, which brings up the contrast and tones of the image.

Support Materials A wide range of support materials can be used to make Polaroid transfers and emulsion lifts. For instance, natural materials—such as glass, rocks, metal, ceramic tile, and wood—all work well. You can also use a variety of fabrics, including silk and cotton. When you are first learning this process, you will probably find that paper is the easiest support with which to experiment. Any 100% rag hot-pressed watercolor paper will work well. My favorite papers are Fabriano Artistico 140-lb hot-pressed and Saunders Waterford 140-lb hot-pressed watercolor papers. It tends to be easier to work with hot-pressed papers because they are smoother and flatter than cold-pressed papers.

Trays Making Polaroid transfers does not require special (plastic) trays; you can use the same trays as normal silver printing. You will need two trays for the water—one for hot and one for cold—plus one tray for the gelatin. (The gelatin tray should be a tray designated for gelatin only.)

UV Protective Spray Polaroid advises using a UV protective spray to stabilize your final Polaroid transfers and emulsion lifts and to prevent the Polaroid dyes from cracking or fading.

Vinegar This is used to enhance the contrast and tones in the emulsion transfer. Because it doesn't contain additive dyes, white vinegar is the best kind.

PETE KOLONIA

Here are a few of the materials you will need to make Polaroid transfers: hot plate, pot, Polaroid film, Daylab slide printer (optional), canned air, slides, tray, glass, paper (optional), squeegee, scissors, and rubber brayer.

White Paper You will need a white piece of paper to place on top of the Polaroid film holder for focusing.

EXPOSURE UNITS

Unless you are planning to shoot your images "live," you will need either a standard darkroom enlarger or a slide printer. Even though several different options are listed, you need to pick only one.

Daylab Slide Printers At the time of the printing of this book, Polaroid had three slide printers on the market. The Daylab 35 slide printer copies 35mm slides onto 3¼ x 4¼-inch Polaroid peel-apart film. (This is similar to the old Daylab Jr. but has been improved with built-in filters.) The Daylab 35 Plus slide printer copies 35mm slides onto peel-apart film up to 8 x 10 inches. And the 120 Transparency printer copies 120 film (6 x 6-inch, 6 x 7-inch, and 6 x 4½-inch) onto peel-apart film up to 8 x 10 inches.

Enlarger A standard darkroom enlarger can be used to project any size negative onto 4 x 5-inch or 8 x 10-inch Polaroid film. If you plan to use this method, you also need color filters and a Polaroid film holder for the size film you are using. Enlargers vary; the type of enlarger you have will determine the size of the transparency you can use.

Vivitar Instant Slide Printer This is a cheaper version of the Daylab. Unlike the Daylab (which has a plug), the Vivitar takes batteries and the exposures take longer as the batteries die down. You can only use the type 669 film (3¼ x 4¼-inch film) with this machine; you do not have a choice for larger formats. In addition, filters must be placed on top of the slide you are using.

FILM

A number of different kinds of film can be used for Polaroid transfers—all of which are the "peel-apart" style of film. Your film choice will be determined by what size image you want to create. Please note that all of the films listed below can also be used for making emulsion lifts.

Polaroid There are four different options for Polacolor ER film. Use either the 59 Polacolor 4 x 5-inch instant color print sheet film; the 559 Polacolor 4 x 5-inch instant color print pack film; the 669 Polacolor 3¼ x 4¼-inch color print pack film; or the 809 Polacolor 8 x 10-inch instant color print sheet film. All four films are ISO 80.

PREPARING YOUR SUPPORT

Whether or not you size your support is an individual choice. In general, it is a good idea with Polaroid transfers—especially if you are using paper—as sizing often generates more intense colors and blacks in the final image. If you do decide to size your support, make the alternative recipe for the Knox gelatin size. (*See* Sizing Formulas, page 22.) Then size the support, following the instructions for the tray method. (*See* Sizing Techniques, page 24.)

I normally do not size my support before doing a transfer. However, I do generally work on a prepared surface—which, if I'm working with fabric or paper, means wet, and if I'm working with glass (or another kind of nonabsorbent support), means heated. I prepare my support at the same time as the Polaroid is exposing. Thin papers may fall apart in the water as they soak. Not all papers have to be wet or sized, but you can place the negative together with the paper, turn it over, then spray the paper wet before rubbing the negative and paper together for a better Polaroid transfer.

EXPOSING YOUR POLAROID FILM

As was mentioned earlier, there are different methods for exposing your Polaroid film—working with the enlarger method, using one of the slide printers, and shooting your Polaroid film "live." No matter which method you choose, the following instructions apply.

1. Adjust your film holder to the "load" (L) position and place the film into the holder.

2. Push the film in and then withdraw the film packet after you hear the "click" of the film being caught in the holder.

3. Expose the film and push the packet back inside the holder.

4. Do not remove the film until your support is ready.

5. Switch the lever to the "process" (P) position.

6. Firmly and evenly pull the film out of the holder and follow the steps described below. (*See* Making Your Polaroid Transfer, page 134.)

DAYLAB METHOD

Position the slide in the printer, making sure to reverse the slide left to right. (This is especially important if there are words or numbers in the image.) Then follow these instructions:

1. Make sure that you have the dark slide loaded so that you do not expose the film by mistake. Place a piece of white paper (thin computer paper works well) on top of the film holder so that you can see to focus. Turn the light source to "view" and open the latch so that you can focus on the paper.

2. Take the paper out.

3. Close the light-tight latch and turn the light source to "print."

4. Using the filtering system, adjust the color balance of the image. It is important to remember what the filters do: If you want to increase a color, either add that color filter or take its complement away. The more filtration you add, the longer your exposure times will be. If you are working with a color image, I suggest either testing the filters at "0" or using a filter pack of 15 blue/30 magenta/30 yellow. If you're not happy with the results, change the filter pack. For example, if your first Polaroid transfer has too much magenta in it, use a filter pack with less magenta (i.e., go from 30

to 20). Black-and-white slides require different filters than color slides. For instance, using an amber filter with a black-and-white slide will give you a sepia tone; using a light blue filter will give you a monochromatic image.

5. Determine the exposure time, using one of two tests. The first is to set the exposure dial to "0" and expose a piece of film. Pull it through the rollers, let it develop for the entire 60 seconds, then peel it apart and see if it looks good. The second method is to set the exposure dial to "0," then follow the directions below for making a transfer and determine if you need more or less time once the transfer is completed. Either way, you need to do a test using up one (or sometimes more) pieces of film. (Think of this process as making a test print.) Getting the correct exposure time can be confusing. If you decide the test is too light, you need to expose for *less* time. Adjust the exposure dial toward the "-." If the image needs to be darkened, you will need to expose for *more* time. Adjust the exposure dial toward the "+." Each line (on the Daylab models and the Vivitar slide printer) is equal to ⅓ stop.

6. Once you have set the filters and exposure, press the "start" button to expose the film.

7. Do not pull the film through the rollers and out of the holder until your paper is ready to accept the transfer.

VIVITAR METHOD
If you are using a Vivitar, you do not need to reverse the slide (as you do for the Daylab). Instead, put the slide into the printer right side up. The focus on the Vivitar is preset and there is no dark slide. When using the Vivitar, you have to use your own filters. You can buy a small gel pack of filters for color printing called color-compensating filters and cut them to the size you need. Using the filters with the Vivitar is the same as using the built-in filters with the Daylab, but you have to place the filters on top of the slide with the Vivitar system. Remember, for example, that if you want less of one color, you need to either add the complementary color or take away the offending color. Push the "print" button and expose the film, then follow the remaining instructions as outlined in the Daylab method.

ENLARGER METHOD
This method is also called "projection printing." If you are using an enlarger, do everything as if you were making a print in the darkroom, with one difference—you are making a print using a positive, not a negative. It will be similar to making an interpositive on film. In other words, while you can burn and dodge, those techniques will create effects the opposite to those created when printing. You can use any size slide (depending on your enlarger) and you can use filters as well as cropping and focusing to suit your needs.

Polaroid film is more sensitive than print papers, so you should not use safe lights. You can get everything set up with the lights on, but remember to turn everything off before removing the dark slide on the film holder. Once you are ready to make

your Polaroid, follow these steps:

1. Place the slide into the negative holder as if you were printing onto paper.

2. Place the (empty) film holder where the easel and paper will be, then project the image onto a piece of white paper placed on top of the holder so that you can see the image well while you are focusing. This will ensure that the composition is the way you want it to be and that the focus is correct. Mark the easel with tape so that you will know where to place the holder once the lights are out. I suggest either testing the filters at "0" or using a filter pack of 15 blue/30 magenta/30 yellow.

3. Turn off the darkroom lights, then load the Polaroid film into the holder.

4. Expose your test for 10 seconds at f/16.

Follow the same steps given for the Daylab method. This first exposure is just a test. You will need to develop and analyze it to decide on the correct filter pack and exposure. Remember that the more exposure you give the film, the *lighter* the transfer will be. Gauging from the results of the test print, adjust the filtration and exposure and make a final print.

IN-CAMERA METHOD
You can also use any camera that can accommodate a Polaroid back to create images. Simply put the film in the Polaroid film holder and shoot a "live" scene, as described in the step-by-step instructions in the introductory paragraph on using the Polaroid film holders. This method only works with the color print *sheet* films (59 Polacolor ER for 4 x 5-inch prints and 809 Polacolor ER for 8 x 10-inch prints).

MAKING YOUR POLAROID TRANSFER

Making Polaroid transfers successfully is all a matter of timing. On the one hand, you need to monitor the heat and wetness of the support. On the other hand, you need to monitor the "developing" process of the chemicals in the film pod. The trick is to transfer the image to the support just when each element is at the right stage.

If you have sized or wetted the support, you will want to place the image transfer on the support *before* it has had a chance to dry. If you are using a support other than paper, you might want to use the hair dryer to heat it up. The warmth of the support helps to transfer the emulsion smoothly.

You can control the color of the Polaroid transfer by how quickly you pull the negative and print apart. As soon as you pull the film through the rollers, the pod breaks and the dyes start to migrate to the paper side. The yellow migrates first, then the magenta, then the cyan. If you pull too quickly, your transfer will be yellow, too slowly and you may not have enough magenta, way too slowly and there are not enough dyes left to transfer at all.

After you have pulled the film through, wait 10 to 15 seconds, hold the film by the edges, and cut the track at the bottom of the film (between the white paper and the black metal clip). Separate the two pieces immediately, place the negative down on your support, and use the brayer to burnish the transfer image. Generally the negative should be allowed to sit on the support for 2 minutes total. (If you are using 8 x 10-inch film, let it sit a few minutes longer.) If you let it sit too long, the shadows may get heavy—though pale or high-key images might need less time. (Try 1 minute 15 seconds.) Gently peel the negative off the support. Using a spray bottle, spritz the print with a 1:1 solution of vinegar and water. This will give brighter whites and colors as well as warm the image.

Some people like the look of their "mistakes." For instance, peeling the Polaroid transfer away from the support too quickly can cause blue stains to appear where the dyes did not stick to the support. (This looks a little like solarization.) You can *intentionally* create this effect by: (1) overdrying the paper, (2) waiting more than 2 minutes to peel up the negative from the support, (3) waiting 15 seconds after you have peeled the negative and positive apart before placing it down onto the support, or (4) peeling the negative away from the support quickly so that the dyes lift back off.

The jelly within the film pods is caustic, but I find it difficult to work with gloves. If you don't wear gloves, be careful not to get the jelly on your skin. If you do, immediately wash your hands well with soap and water.

One way to make a Polaroid is by using a Daylab printer. While you are making the print you should be preparing the support.

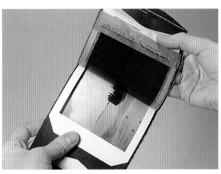

After pulling the film through, wait 10 to 15 seconds to let the film "develop," then cut the track at the bottom of the film, immediately separate the two pieces, and place the negative down on the support.

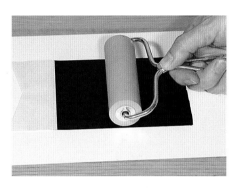

Using a brayer, burnish the Polaroid transfer in one direction on the support. This takes practice, as the right amount of pressure is important. Let it sit for about 2 minutes total, then slowly lift up the film back.

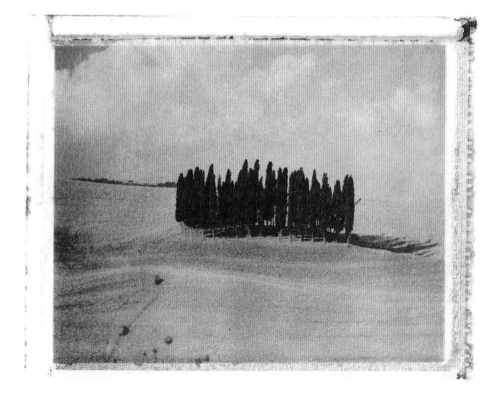

Italy Trees, 1999. *I placed the finished image on Fabriano Uno 140-lb hot-pressed watercolor paper.*

CREATING EMULSION LIFTS

This process is wonderful to use if you want to stretch or maneuver your Polaroid in some way. As with the Polaroid transfer technique, the process of creating emulsion lifts begins with choosing and preparing the support. Supports can be watercolor paper, glass, fabric, or ceramics—anything you can imagine. Glass is particularly striking, since the emulsion lift itself is translucent.

The process is simple. Unlike Polaroid transfers (which require you to work with "fresh" Polaroids), emulsion lifts are made with Polaroids that have "aged" for at least 8 hours. The Polaroids can be made by any of the four methods described earlier in this chapter. (*See* Exposing Your Polaroid Film, page 133.) The image is heated in boiling water until it starts to bubble up. Then it is lifted off its backing and manipulated before it is taken out of the water and placed on a support.

GETTING STARTED

Many of the items required to make Polaroid transfers are standard darkroom materials that were discussed in Chapter 2. (*See* Basic Darkroom Equipment and Materials, page 12.)

Before you get started, make sure that you have the following items on hand:

Darkroom Thermometer	**Rubber Brayer**
Distilled Water	**Scissors**
Glass	**Squeegee**
Hot Plate	**Pot**

Here are a few of the materials that you will need to make emulsion lifts: tray, acetate, contact paper, hot plate, pot, spatula, Polaroids, scissors, glass, and rubber brayer.

In addition, you should note the following:

Acetate or Mylar These materials are useful for retrieving the emulsion from the water and can help you place it onto the support.

Contact Paper This helps separate the Polaroid emulsion from the photo-paper backing.

Spatula This helps you lift the Polaroid out of the boiling water.

Support Materials A wide range of support materials can be used with this process. For instance, natural materials—such as glass, rocks, metal, ceramic tile, and wood—all work well. You can also use a variety of fabrics, including silk and cotton. When first learning this process, you will probably find that paper is the easiest support with which to experiment. Any 100% rag hot-pressed watercolor paper will work well. My favorite papers are Fabriano Artistico 140-lb hot-pressed and Saunders Waterford 140-lb hot-pressed watercolor papers.

Trays Making emulsion lifts does not require special (plastic) trays; you can use the same trays as for normal silver printing. You will need two trays for the water—one for hot and one for cold—and one to dampen your support.

FILM

You can use any of the films mentioned in the Polaroid transfer section (on page 133) for emulsion lifts. In addition, you can use the following films.

Polaroid Two different kinds of Polacolor Pro tungsten film work for this process. Use either the 3¼ x 4¼-inch instant color print pack film or the 4 x 5-inch instant color print sheet film. Both films are ISO 64. You can also use Polapan Pro black-and-white films, but they are harder to use and need to be boiled for a slightly longer period of time.

MAKING YOUR EMULSION LIFT

You can generate your Polaroid using any of the four methods described earlier in this chapter. (*See* Exposing Your Polaroid Film, page 133.) However, it is important that you work with Polaroids that have been drying for at least 8 hours (or that have been force-dried with a hair dryer), or the emulsion will not peel off. Cover the back of the Polaroid with contact paper, then cut off the white edges of the film. Place the film, face up, in a pot (or tray) containing hot (160°F) water and allow the film to soak for about 4 minutes. Make sure that the image stays under the water and that the water circulates. In the meantime, if you are using paper as a support, dampen it in a tray of warm water, then place it on a piece of glass and squeegee off the excess water.

Place a clear piece of acetate in a tray of room-temperature water. Once the Polaroid starts to lift up at the edges and bubble a little, remove it from the hot water and place it in the tray. Using the acetate as support, immediately start to gently peel the emulsion off the backing. It helps if you keep the emulsion under water as you push it off the backing. If the film is fresh, the emulsion will separate quickly and easily. Sometimes you can get a batch of film that will not separate as easily. Do not make yourself crazy. It is the film. Start over with a fresh batch of film.

Keeping the image underwater, flip it over onto the acetate and maneuver it into the shape you want. The areas of the emulsion with the least color may tear, so handle light areas with care. When the image is ready, use the acetate to lift the emulsion out of the water and transfer it to the support material.

With the acetate still on top, carefully rub the image (from the middle out) with the brayer. This helps remove all the water. Slowly lift the acetate off. If you have air bubbles, pop them immediately with a small pin and maneuver the film to close the holes. If the emulsion is allowed to dry with the air bubbles, they will eventually break and make larger holes.

There are numerous ways to experiment with this process. For instance, you can layer two (or multiple) emulsions on top of each other. (However, if you try this method, watch how long the paper is in the water. It will expand if left in too long and your image size may change between exposures. Sizing the paper can minimize this problem.) You can also paint on top of emulsion lifts with watercolors, pastels, or any other medium discussed in Chapter 12.

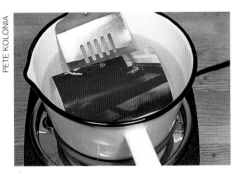

Place the prepared Polaroid in 160°F water for about 4 minutes.

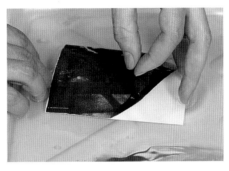

Once the film starts to bubble, transfer it to a tray of room-temperature water and gently peel the emulsion off the backing.

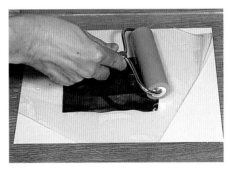

With the acetate on top, carefully remove all the water by rubbing with a brayer from the middle out. Slowly lift the acetate off.

Geranium, 1999. *I made the original with Kodak HIE 35mm infrared film, enlarged it onto 11 x 14-inch Ektalure G paper, then hand painted it. Later I made a 35mm Kodak Ektachrome slide of the print and enlarged that image in the Daylab using type 59 Polacolor 4 x 5-inch film. I let the film develop for the full 60 seconds so that I could make this emulsion lift and keep the strong colors that can be seen in the original. The finished product is on Fabriano Uno 140-lb hot-pressed watercolor paper. A hand-painted version of this image can be seen on page 141.*

TROUBLESHOOTING

While Polaroid transfers and emulsion lifts are generally easy to make, there are still plenty of things that may go wrong. Following is a list of the most common mistakes and how to fix them.

• If the negative moves around on the support when you are trying to transfer the image (when making a Polaroid transfer), you are probably using a slippery support, such as vellum. Try taping the negative down before you start to burnish it on the support. If you are using thin papers, such as Mylar, you should wet the support and place it on a piece of glass. Squeegee the excess water off and make sure there are no creases or air bubbles. This will allow you to place the transfer or lift onto the paper with ease.

• If you discover scratches on the film, you probably need to clean the Polaroid rollers. Use a lint-free cloth and warm water to clean the rollers often.

• If the end product looks flat, the film is probably outdated. Buy a new pack of film and compare the results. New film should produce images with good overall contrast. Make sure to check the film date when you are buying film. Stay away from short-dated or out-dated stock.

• If the Polaroid transfer looks mottled, the support may have been too wet. Make sure to squeegee off as much excess water as possible. Or, if you are using paper, soak it for less time.

• If you are having trouble removing the Polaroid from the support after making a Polaroid transfer, the paper may be too cold. Try to keep the paper hotter. You can use a hair dryer just before you are ready to lift the Polaroid off to reheat it. Some people suggest placing a heating pad underneath the glass to keep the paper warm. You can also try pressing harder and longer on the brayer to make sure the image contact is better.

• If the emulsion does not bubble and separate as you're soak-

Arboretum Benches, 1999. *I made the original version of this image in 1987 using Kodak HIE 35mm infrared film. I printed the image onto glossy 11 x 14-inch paper, then copied it on a copystand to make a slide (using Ektachrome film) for lectures. Neglecting to reverse the slide, I enlarged it in a Daylab onto type 59 Polacolor film and then transferred it onto Lana Royal 125-g cold-pressed drawing paper. The black-and-white image took on a sepia effect. Notice that this is reversed from the original image, which can be seen on page 42. When I was making this Polaroid transfer, the paper had cooled slightly, so as I lifted the Polaroid off the paper some of the emulsion came up with the backing, resulting in a blue stain in several areas.*

ing the Polaroid to make the emulsion lift, you may have used the wrong type of film (or a bad batch of film) or your water may be too hard. Check the list in the Getting Started section on page 136 for the correct films to use. Also, to be safe, it is best to use distilled water at all points in this process.

- If there is a jelly-like substance sticking to the back of the emulsion lift, you did not dry the Polaroid long enough before doing this process. Remember to use Polaroids that are at least 8 hours old. To rectify the problem, you can lift the emulsion out of the water, lightly remove this substance, then place the acetate back in the water and continue manipulating the image.

- If the emulsion does not stick properly to the support when you're making an emulsion lift, there may still be air bubbles between the emulsion and the support. Pop the bubbles and rewet the lift to try to get it to adhere to the support. It may be too late and you may have to use another Polaroid.

Cortona, Italy, 1999. *Here you can see how two processes can create very different effects. The work on top is a Polaroid transfer; the one on the bottom is an emulsion lift. Sometimes, when making Polaroid transfers, I make sure that I get the staining/liftoff combination by not rubbing well in certain areas. With this emulsion lift, I not only wanted to stretch the image, I ripped different areas to further distort and enlarge the image.*

HAND PAINTING BLACK-AND-WHITE PHOTOGRAPHS

THE PRACTICE OF HAND PAINTING photographs has been around since the beginning of photography. When daguerreotype studios first emerged in the 1800s, people flocked to have realistic photographic portraits made of themselves and of their loved ones. This put many portrait painters out of business—but just for a short time. Though daguerreotypes were immensely popular, people were not used to seeing their likenesses in shades of gray. They wanted *color*. Photographers soon hired the portrait painters to embellish daguerreotypes with dry powdered pigments, which they applied with camel-hair brushes, and thus the technique of hand painting photographs was born.

Hand-painted images stayed popular throughout the nineteenth and early twentieth century—until the 1950s and '60s, when color film became cheap enough for the average consumer to purchase and use. At that point hand painting all but disappeared. However, in recent years photographers have begun using paint to enhance their images in interesting and unexpected ways instead of to mimic realistic color, as had been done in the past. Photographers who hand color their images now use any medium that suits them—oil paints, acrylics, and even crayons, to name a few.

Anyone can learn to paint on a photograph. Even if you have never studied color before, you can learn the concept of putting paint on a photographic support. And then, like anything else, it is just a matter of practice to get to the point where you feel proficient and in control enough to create your own style.

Geranium, 1996. *I captured this image with Kodak HIE 35mm infrared film. The geranium recorded as pure white and needed several coats of red to get it this bright. Unless otherwise specified, all other images in this chapter were printed on Ektalure G paper and embellished using oil paints and colored pencils.*

Opposite page:
Vassarette, 1992. *I originally took this image (using Kodak HIE 35mm infrared film) for a Vassarette lingerie ad. I printed this on Ektalure G paper, which was my favorite paper because of the tonal range, quality, and texture. However, Kodak discontinued it in 2000 for environmental reasons (there was too much cadmium in the emulsion). Using oil paints and colored pencils, I colored directly onto the surface and didn't add any finishing sprays.*

CREATING HAND-PAINTED PHOTOGRAPHS

The most frequently asked question about hand painting photographs is, "How long does it take to hand paint an image?" The answer depends on two things: (1) how large the image is and (2) how detailed you want to make it. Some people work quickly or do not do a lot of detailed work. They might be able to finish a print in a few hours. I try to finish a picture within two days. I will spend an entire day painting, then go back to the image the next day to take a closer look and touch up any areas that I feel need to be redone.

You don't want to spread your work out over too long a time, however. After a week or so the colors start to become permanently embedded in the emulsion and become difficult to manipulate. For instance, if you try to put a new color on top of an area that had been painted a while ago, the result may be very blotchy; the same can happen if you try to remove a color that has had time to "set." So it is best to finish each print within a few days of starting it.

Just as painters find different materials to paint on and to paint with, so can photographers. While regular photographic paper may be among the easier supports to work with, any material that can be used as a base support for alternative processes can take some kind of painting medium. Think of your photograph as a sketch. Try different ways to put the color down on your image— a brush, cotton, your hands, anything that may free you up to start incorporating color into your image.

Throughout this book I talk about experimenting and being playful. Embellishing black-and-white or color photographs is a great place to start.

GETTING STARTED

Most of the items required to make hand-painted photographs are not standard darkroom materials, so before you get started, make sure that you have the following items on hand:

Brushes Depending on which medium you choose, brushes may be used to either apply or blend your color. If you have never painted before, it may be easier to use a small bristle brush than a soft camel-hair brush, as the bristle brush is slightly stiffer and will give you more control.

Cotton Swabs Cotton swabs are useful for applying and blending color. I like to make my own by adhering rolled cotton to the end of a skewer. Be careful to make your swabs so that they are thin enough to get into small areas, but not so thin that the skewer scratches the paper. I use a different swab for each color.

Erasers Many different kinds of erasers can be used to remove oil paint, pencil, and chalk from hand-painted photographs. I prefer the Eberhard Faber kneaded eraser (which looks like a gray square) and the Eberhard Faber Peel-Off Magic Rub eraser (which looks like a white pencil).

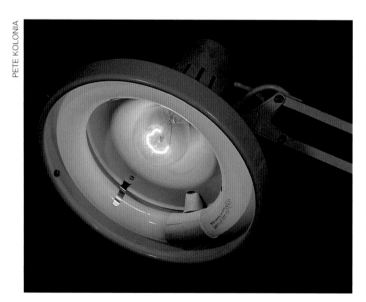

A daylight correction lamp has none of the distortions that are common with standard room lights. When both bulbs are turned on, they provide a true sense of daylight and help ensure that you achieve the colors you want.

I prefer cotton-topped skewers (instead of brushes) to apply my paint. Take a small piece of rolled cotton and fold it in half over the skewer, then twirl it in your hand to create a tight swab.

Extra Prints Make sure you have a few "bad" photographs on hand before you start to paint. These are useful for trying out your colors.

Fixative This is used to protect chalks and charcoal once you are finished with your work. If you have used oil paints along with the chalks, you need to let the print dry thoroughly before you spray it because the paint can soak up the fixative, causing bubbles to appear on the surface.

Light Source It is important to have a good light source when making hand-painted photographs. For example, a daylight correction lamp will give you true color. Stay away from fluorescent lamps, as they generate a slightly green cast.

Mat Board If you are working with oil-based colors, you will need two pieces of *white* mat board—one to use as a palette, the other to use as a backing for the print. The palette mat board should be about 8 x 10 inches and should be pure white (which allows you to see the true colors). The backing mat board should be one size bigger than the print (i.e., for an 8 x 10-inch image, you'll need an 11 x 14-inch mat board) and should be fitted with photo corners to accommodate your works-in-progress. If you are working with water-based colors, you only need the backing mat board, as you will require a plastic palette to hold your medium.

Palette Paper If you are working with oil-based colors, you will need either palette paper or wax paper to cover the mat board that you will be using as a palette.

Photo Corners These not only keep your photograph in place on the mat board as you are working, they also keep your backing clean.

Plastic Palette If you are working with water-based colors, you will need a round plastic palette to hold your medium.

Resists If you are working with watercolors or acrylics, resists can help mask areas of the print. Rubber cement, maskoid, and frisket all work well.

Solvents If you are using oils and pencils, I recommend using Turpenoid, which is a healthier alternative to turpentine. You can also use P.M. Solution from Marshall's Photo Oils, which is turpentine and vegetable oil. Solvents have many uses. They can thin oil paints so the color will be less intense, remove oil paint, colored pencils, or chalks entirely, and clean up other areas (such as borders).

Tape If you are working with water-based media, keep a supply of drafting tape or Scotch Magic 811 removable tape on hand to serve in lieu of a resist. Unlike masking tape, these tapes will not remove the emulsion on the print. However, the tape will lift off oil-based media from the image.

Wax Paper This less-expensive substitute can be used instead of palette paper to cover up your mat board. Wax paper is only required if you are working with oil-based colors.

PAINTING MEDIUMS

The first demonstration I saw of hand painting photographs was with oil paints and colored pencils. I thought this was the only way color could be added to a photographic print. As I started to really get into the process, I realized that there was no reason other types of paints couldn't be used, and I began to experiment. I have to admit that my style has stayed mostly within the oil category, but every once in a while I take out some other materials and have fun.

You can use anything to add color to a photograph. There are specific materials made for photographs, such as Marshall's oil paints, colored pencils, and dyes, Pebeo oil paints and colored pencils, Spot Pen handcoloring pens, Kodak dry dyes and wet dyes. However, you do not have to stop there. Crayons (I have

Watercolors (either in solid, liquid, tube, or pencil form), acrylic, and water-soluble markers can be manipulated with water.

Color pencils, oil paints, pastel chalks, crayons, and oil sticks can be manipulated with turpentine, P.M. Solution, or Turpenoid.

PETE KOLONIA

PETE KOLONIA

found that soybean crayons work best, but Crayolas are fine), Cray-pas (a combination of crayons and pastels), pastel chalks, acrylic paints, watercolors, oil bars, and colored pencils (such as Prismacolor) all work well. The list does not stop. I like to walk around art-supply stores and pick out things that look interesting, bring them home, and experiment.

Oil paint is the most permanent medium you can use. However, I would steer away from student-grade oil paints. While these are cheaper than professional-grade paints, they do not contain as much pigment, which means that the colors will not be as strong and the final prints will not be as archival.

PAPERS

All of the images created by the alternative processes mentioned in this book can also be hand painted, so you may find yourself painting on a wide range of support materials. However, if you are printing traditional black-and-white photographs with the intention of hand painting them, then you will want to consider your paper choice *before* you make your prints.

Some people find that they have horrible problems with one paper, then try another one and cannot believe how much easier it is to work with. Since I frequently use oil paints to hand color my prints, I prefer fiber-based matte surface papers. Glossy papers tend to work well with watercolor paints, but oil paints do not soak in evenly, so that when you blend the colors together they rub off easily. This makes it hard to put colors on top of one another and difficult to get strong shades. Pencils can also scratch glossy papers.

Resin-coated papers used to only come as glossy, semi-matte, or matte. Now there are more choices. A few companies have papers that are called Art RC, which have more texture to them than the other RC paper surfaces and therefore allow the paint to go on easier. All of the mediums go on Art RC very well and they are usually cheaper than fiber-based papers.

PAINTING ON NONSILVER PRINTS

All of the processes in this book can be combined with hand painting. The difference between painting on a silver gelatin print and painting on images made with some of the other processes described in this book has to do with how the support responds. Liquid emulsion prints can be painted in much the same way as normal silver gelatin prints, as the liquid emulsion itself acts like any silver-based gelatin. However, the base support (which, in the case of liquid emulsion prints, may be paper, glass, ceramic, etc.) must also be taken into account. For instance, if you are using oil paints on a liquid emulsion print that was made on watercolor paper and you go off the emulsion, the oil will go into the paper and permanently stain it. Watercolor may be a better choice.

Once you start painting on images made with nonsilver techniques, you'll realize that paper supports require the most attention. Since most watercolor papers stain if oil paints are applied directly onto them, you might want to experiment with sizing. (*See* Sizing Formulas, page 22.) This can be done before the image is printed onto the support or afterward, in much the same way as a painter may use gesso, which is used by artists to prime

Friend's Seminary School, 2001. *I shot this image with a Nikon N90s and a 24mm lens, using Kodak HIE 35mm infrared film. I used two coats of Silverprint liquid emulsion on twelve tiles that had been prepared with two coats of gelatin and hardener size (with chrome alum). I let the tiles dry overnight before exposing and developing them. After several days I used pastel chalks and colored pencil to add color to the tiles. Then I applied two coats of Krylon fixative and three coats of Varathane, allowing the tiles to dry 24 hours between each coat. The tiles are going to be mounted onto the wall of the school.*

canvases before applying oil paint. Some people say you *must* size your paper if you're going to be using oil paints; I disagree. It is a matter of how you want the final image to look. With practice and experimentation you will discover ways to work with alternative materials that suit your style.

EVALUATING YOUR PRINT

One of the most important steps in creating hand-painted photographs is choosing a strong black-and-white print. What exactly makes a good picture is difficult to define. People study for years to try to figure this out!

Seeing in black and white while shooting in a color-saturated world is very different from shooting color images. And shooting in black and white for the purposes of painting on the image is a whole new set of thoughts for some people. Personally, I try to balance the formal elements when I am photographing black-and-white images that I expect to hand paint. I still "see" in black and white. I try not to get distracted by the colors, concentrating on the forms, shapes, and tones of the scene, and try to keep my images as simple as possible. That way, when it is time to paint, I am able to focus on the main point of an image.

The photograph must be just as interesting in black and white as it would be with color added. How many times have you heard that manipulating a bad photograph cannot make it better? That point is indisputable. You cannot improve a boring print by adding color to it. The composition and subject matter must be interesting from the start.

Once you've selected your image, you need to decide whether to print the image yourself or have a lab print it for you. This is really up to you. Not everyone has the luxury of his or her own darkroom, but no matter what, make sure that you make extra prints of each image. When you begin to hand paint an image the worst feeling to have is worry because you only have one shot at painting it perfectly. Having extra prints around (I usually print at least three) will allow you to relax and make mistakes. A lot of great accidents happen that way.

Whether or not you do the prints yourself, make sure they have a good tonal range. In other words, your prints should have details in the white areas and a lot of middle gray tones. Printing slightly lighter and flatter than you would for a normal black-and-white print will give you a larger painting area with which to work. However, do not go overboard with this. Make sure that your highlights have some details and that your gray tones are not muddy.

Once you start to paint, make sure to have a "bad" print around to use as trial paper. (It doesn't have to be the same image as your final.) Paints don't look the same on a palette as they do on a print. By putting your color on a test print first, you can see what the true color will be. For example, the color you have mixed might look like a dark blue, but when you rub it on a print, the pigment will spread out and it will look much lighter. This happens with red in a different way. Dark red pigments often appear pink on photographs. It is important to test colors on a photographic print (rather than ordinary paper) because they look less brilliant on the latter.

PREPARING YOUR PRINT

There are three points to consider when preparing prints for hand coloring: not using hardener in the fixer, deciding whether or not to dry mount the print, and determining how (or if) to precoat the paper. The second two decisions are a matter of personal choice, but the first point is a given.

When making prints that you intend to hand color, do *not* use hardener in the fixer. Avoiding hardener in your fixer will allow the emulsion to stay a little softer, which will allow it to take the paint better. Liquid fixers come in two parts: hypo (part A) and hardener (part B). Mix your fixer as directed but leave out "part B." Some companies make powdered fixer without hardener, but you need to read the package carefully to make sure that you are purchasing the correct fixer. If you are using a lab, just tell them not to use hardener. These days, most labs print that way anyway because they are also offering their clients the use of toners that

need to be added to unhardened prints. If the lab refuses, go to another one. If you live in a small town with only one lab, find a lab in a city that accepts prints by mail. This is a very common practice; it will not be hard to find such a lab.

Another point to consider before you start to apply color to an image is whether or not to dry mount the print. If you like the way dry mounting looks, I suggest dry mounting the print first and then painting it, as the heat involved in the dry-mounting process *could* change the tones of the finished print. Personally, I do not dry mount my prints. I use photo corners on archival mat boards so that I can change the boards according to my framing needs or if a mat gets dirty from use.

The third point to consider before you get started is whether or not to precoat the print with P.M. Solution, Turpenoid, or Marshall's Extender. Some painters who just use oil paints, colored pencils, or chalks, also precoat. If you are mixing media (oil paints along with water or other types of color), then precoating is not advised because the water-based mediums will not adhere well to precoated prints.

Many people recommend precoating because they feel that they benefit from the surface being oilier (in the case of P.M. Solution, Turpenoid or Extender) or having a surface texture added (in the case of the Marshall's spray for glossy papers). However, I found that precoating can create problems. Matte surface papers and Art RC papers already have a texture to which paints can adhere. If you coat these papers, they become dust magnets, so instead of making an easier surface on which to paint, precoating actually makes the process a little messier. If you spray a glossy paper with a precoat spray and then work the area a lot (applying and then removing paint repeatedly), it will give the paper the appearance of having a different surface from area to area.

Paris Stairs, 1985. *I shot this image with Kodak HIE 35mm infrared film through a window.*

Paris Stairs, 1986. *I printed this image lighter because I knew I was going to hand paint it with oil paints and colored pencils.*

MIXING YOUR COLORS

When you first sit down with a photograph you might feel similar to an artist who is facing a blank canvas. Sometimes it is difficult to decide how you will approach adding color to an image. One thing that might help is to go through magazines and photo albums and pull out photographs or paintings that you like. They can be good sources of color inspiration to get you started, and your imagination will take you further.

You can make an infinite number of colors from the primaries (red, yellow, blue) plus white and black, but it is fun to have lots of colors in front of you for inspiration. Color wheels are wonderful resources. They can show you what color will be created if two colors are mixed together. For example, if you are doing a garden scene and you need many different shades of green, you can start with one green and add different amounts of yellow. Then go back to the original green and add different amounts of red. Do the same with amounts of blue and you will end up with hundreds of shades of green. Adding a little white or a little black will change the colors again. However, if you mix the same percentage of each of the primary colors together, the resulting mixture will be brown.

People talk about "warm" and "cool" colors. A color wheel shows that warm colors are considered to be the colors that fall from yellow to red-violet, with oranges and reds in between. Cool colors are the colors that fall from yellow-green to violet, with greens and blues in between. There are two ways to overcome the problem of a color looking too bright. The first is to add a small amount of the complementary color to the mix. The second is to put the complementary color next to it in another area. Complementary colors are colors that are opposite each other on the color wheel: yellow and violet, red and green, blue and orange, etc.

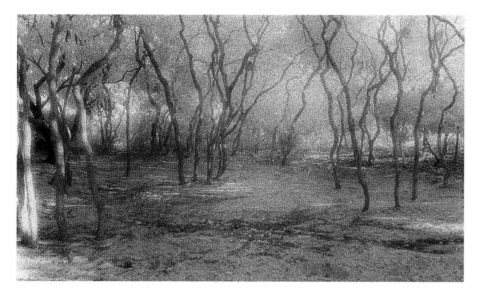

Color wheels can help you see what colors will be created when certain colors are mixed together.

Fire Island Trees, 1982. *I shot this image with Kodak HIE 35mm infrared film, then overexposed the print so that the trees would block the house in the background.*

Fire Island Trees, 1991. *I painted the color version of this image with Marshall's oil paints and pencils and oil pastels.*

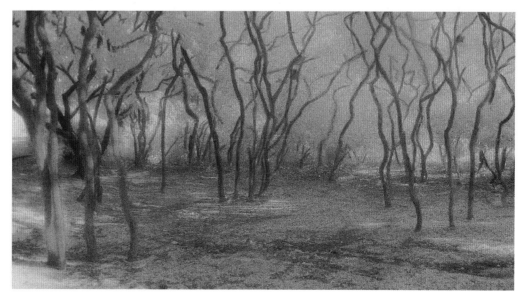

USING WATER-BASED COLORS

Watercolors come in many different forms—tubes, cakes (which are what you probably used in grammar school), pencils, markers, liquid, and paper that you set into a water bath so that the water turns the color of the paper. If you have made a color in liquid form that you like, you can pour the liquid into a jar, seal it, and save it for a later time. If your watercolor (either liquid or tube form) hardens, simply either add water directly to the substance or use a wetted brush to pick up the color.

Acrylic paints come in tubes and are great to use if you want to cover an area completely with an opaque color. For instance, dark shadow areas in prints do not reflect light. So when you paint over them with a transparent or translucent medium, they will look muddy. However, if you use acrylics, then it does not really matter—because they are opaque. While acrylics are quick to dry, it can take practice to get a smooth surface.

Watercolor and acrylic paints can be applied to both dry and wet prints. If you are using a wet print, tape the photograph onto a piece of Plexiglas to keep it flat and still. If the print dries as you're working, rub a wet cotton ball over the area that you are painting. If you want to work on a dry print, you can position it on a mat board that has been fitted with photo corners. This will keep the print flat and at the same time keep the board under your photograph clean.

Try using both the wet and dry methods to see which is easier for you. When I teach hand-painting techniques, it is always interesting to watch people discover their own style. At first people sitting next to each other tend to try the same things, but soon everybody is fine-tuning his or her own method. The best way to figure out which will turn into your style is by experimenting for a few days before you sit down to conquer a finished piece.

Watercolor pencils are fun to use because you can get so many different styles from one tool. You can use them to draw right on the print. You can leave the marks just as they are or wet them down and blend them. You can also add more color to make them brighter or add other types of paints on top of what you painted using pencil.

Rubber cement, maskoid, and frisket (which are all called "resists") are great items to have around when working with

Cartagena, Colombia, 1986. *I shot this image with Kodak HIE 35mm infrared film, then enlarged it to 16 x 20 inches. To keep the strong sunlit mood of the scene, I painted everything with translucent watercolor paints.*

9th Street, NYC, 1999. *I shot this image with a 2¼ x 2¼-inch Hasselblad camera using Kodak T400CN film. I then printed it and colored the print using watercolor paints and pencils. I was painting it for a book cover and needed it to dry within a few hours so that I could send it out. If I had used oil paints, the colors would have smudged at the printer because they would not have dried in time.*

water-based paints. Use one of these resists to cover up any areas (of a *dry* print) that you don't want paint to get into. Then let the resist dry thoroughly before you apply paint. (I find that rubber cement can be a little unruly to put down, but it is much easier to take off than either maskoid or frisket.) Once you finish painting an area, rub the resist off with your fingers or take it off with tape—and any paint that is on top of your resist will come right off along with it. Your print can be placed in water but the area with the resist will repel the water. You can reapply a resist over a dry, painted portion of a print to protect it from other colors, provided that the paint is water-based.

Here are some helpful hints for working with water-based media. It is best to start with a light shade and slowly bring the color up to a darker shade. If you have made a horrible mistake and want to start over, simply wash your print. Ninety-nine percent of the paint will come off. However, every once in a while a color will stain a print and will not come completely off. This depends on how long the paint has been on the print, whether or not a hardener was used with the fixer, and what grade of color was used (student or professional). Do not worry about your paper beading up in the wet areas. It will flatten as soon as it is fully dry.

Do water and oil mix? Mixing water and oil effects on your paper is possible—provided that you follow the right sequence. Putting oil or colored pencil down and then a watercolor will give you a result similar to what you may have experienced in art class as a kid when you drew on a piece of paper with crayon and then covered your picture with black watercolor paint—the paint that went over the crayon beads up and gives a slight polka dot effect. However, if you put the watercolor down *first* and let it dry, oil paint, colored pencils, or chalks can go right over it. The colors won't blend in the same way as they would if they were the same medium, but it may give you an effect that you will like.

USING OIL-BASED COLORS

While not all of the materials that I discuss in this section are technically oil-based, I group them together because they can all be removed the same way: with turpentine, Turpenoid, P.M. Solution, or erasers. Oil-based colors tend to be the paint of choice with most hand colorists because they are versatile and easy to use. To begin, take a piece of either palette paper or wax paper and tape it to a piece of white mat board to use as a palette. (Wax paper is cheaper than palette paper and you can throw it away after the paint dries.) If you are working on an image over several days, you can stop the paints on your palette from drying out by placing another piece of wax paper on top of them. The white board allows the true colors to show through as you mix your colors. (I use a skewer with no cotton on it, because the cotton soaks up too much paint.)

Photo oil paints have more oil and less pigment than regular artists' oils, which is why they sometimes seem more translucent. However, artists' oils can be made to look like photo oil paints by rubbing them down. Sometimes I will apply a color, rub it in with a piece of cotton, and then reapply the same color a few more times. This allows me to see the photograph through the paint as the color gets more intense. However, it is also possible to apply the color in a thick manner from the start. With this method the color will be intense and more opaque, totally covering the photographic tones underneath.

Oil bars are oil paint in the shape of a fat pencil. The bar allows you to get the look of oil paint with the ease of a pencil. If you want to get into small spaces, you can whittle the point down to a small size. Otherwise, oil bars respond just like oil paints. You can rub them in, mix them to make new colors, and take them off with Turpenoid. The bars come with a "skin" to protect the oil. You need to take a knife and peel the top layer off, otherwise the color cannot be applied. The skin grows back every day to help preserve the paint.

Colored pencils are lead pencils. However, they can be treated as if they were oils. They can be combined with oil paints—either on top of or beneath—with no ill effects. Several companies make pencils specifically to color photographs, but you can use almost any colored pencils. The most important aspect to look for is the softness of the pencil. Some brands have very hard lead that can scratch the surface of a print. Marshall's photo oil pencils, Pebeo photo pencils, and Berol Prismacolors are among my favorites. However, even these can scratch glossy surface papers if the point is too sharp and you are too heavy-handed.

Pencils are wonderful tools because, as with watercolor pencils, you can get several different effects. For example, if you simply draw onto the print, you will get a textured look. The pencil can cover an image fully or just highlight it with color. You can also take a very small amount of Turpenoid and dot it onto an area that has been toned with pencil, then take a dry cotton swab and smooth the color out. For the most part you will not be able to tell which was paint and which was pencil.

Some people like the option of paint and pencil because of the ease with which they find they can use one as opposed to the other. The pencils can be mixed to make different colors by drawing on the print and rubbing them together.

It is possible to get scratch marks even with the softest pencils, but there are several ways to get around this problem. If you are getting a lot of scratches, you might want to try using the "extender" from the Marshall's paints on the print first. Extender will remove oil paints or other pencils, so this can only be done on an area that has no other color on it. Use the smallest amount possible and rub it in as well as you can before applying the pencil. It should solve the problem. Another thing you can do is to take a very small amount of Turpenoid or P.M. Solution and do what I said *not* to do earlier—prepare the paper with it! If you do this as you work in small areas, it does not tend to make as big a mess as if you had wiped it all over the print before you started to paint. Some people dip the pencils into the Turpenoid first and then draw, but I do not like this method because I find that the pencil tip dries too quickly and the texture of the pencil changes as you go along.

Crayons are very waxy and might leave a waxy look on the print but some people like it. If you don't like this effect, try either putting extender down on your print before you color or smoothing out the image with Turpenoid or P.M. Solution after you color it. Be careful not to rub too hard, as this may take off more of the color than you intended. There is a crayon made from soybeans that is less waxy and is easier to maneuver than waxy crayons such as Crayola. Be careful about using crayons on top of oil paints, as they can lift off the oil paint. However, crayons go on top of watercolors very well.

Cray-pas are a cross between crayons and pastels. They are very cheap and are a lot of fun to use. Cray-pas respond similarly to crayons—they go on a little waxy and can come off easily—but they have a wonderful iridescent color and can give your print a nice three-dimensional look. Extender also works well with Cray-pas.

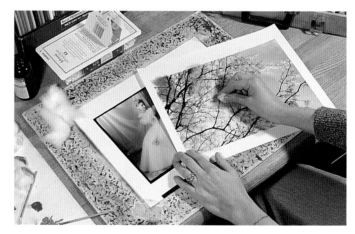

Before I start I assemble all my materials, including a "bad" print that I can use to test the colors.

Neopastels are an oil pastel. They are neither as messy nor as fragile as soft pastels, nor as waxy as Cray-pas. They can be rubbed in with your fingers or with a cotton swab.

A disadvantage to using crayons, Cray-pas, and neopastels is that they all act the same way: They may be difficult to put on smoothly and they also do not really dry. If you are overmatting your print and putting it into a frame, nothing needs to be done. However, if you are going to keep it in a portfolio or send it off somewhere—for a show, to sell, etc.—it is best to spray the print with a fixative. (*See* Finishing Your Surface, page 153.)

As far as cleaning up is concerned, rubber cement or other resists cannot be used with oil-based media because they will take off all colors that are not in the watercolor family. If you want to keep oil-based paint off an area of your print, there are other things you can do. You can use drafting tape or Scotch Magic 811 removable tape. Both of these tapes are safe to use because they will not take off color or emulsion. While Turpenoid is also good for cleaning up, using too much of it can create shiny areas and using it too many times can take the emulsion off. If you are using Turpenoid to clean up, use two small cotton swabs—one with a small amount of Turpenoid and one that is dry. You can dab the areas to be cleaned with the wet swab and then quickly dry the area with a dry swab. This will keep the area from getting too oily-looking from the solvent. Erasers also help to erase unwanted color, but I don't really like using them on the interior of the print too often. Too much use can leave a film on your paper, much like the shininess that results from the use of too much Turpenoid.

Because cotton would soak up most of the color that I need for this large area, I used a skewer with nothing on it to place my color down on the print.

I used cotton to blend the color evenly into the print. Then I used a little bit of Turpenoid on a skewer (with cotton) to remove unwanted color from the bride's dress.

A sharpened color pencil worked well to add color to some of the small areas.

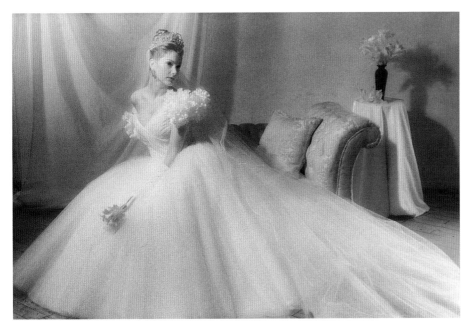

Bride, 1995. *I shot this image for Bridal Guide Magazine with Kodak HIE 35mm infrared film in a studio with strobe lighting. Note that I added color to most areas of the print with oil paints and colored pencils.*

Using Other Mediums

Any type of medium can be put down on an image. Figuring out which ones you prefer is simply a matter of practice. Since purchasing one or two colors in each medium can be an expensive proposition, you might consider taking a workshop in order to experiment with a range of materials. Try lots of different things and then decide which materials work best for you.

Retouching dyes and dry dyes that are made for color photographs can be used with water to make more subtle colors. Both of these dyes are permanent, so you need to build the colors up slowly.

Most markers are also permanent. The colors tend to be very bright and they come in a variety of point sizes, which makes them easy to draw with. Chartpack makes nonpermanent markers that can be removed with turpentine; watercolor markers can be removed with water.

When toning images, most photographers fill the tray with toner and submerge their prints. Many photographers who paint on their images, however, use toner in the same way as they use paints; instead of toning the entire print, they use a brush or cotton swab to selectively paint the toner onto the image. Some people use this technique first and then paint on top of the toned area, while others use a variety of toners as their main medium.

You might also try experimenting with household items such as tea, coffee, merthiolate (used for wounds), gentian violet (used for mouth sores), and food dyes. In other words, experiment, have fun, and know that you can use anything to add color to your images.

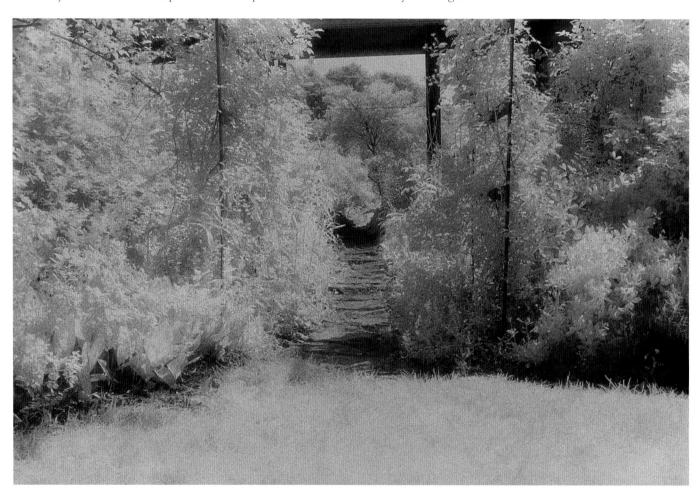

Glebe House Garden, 1997. *I originally took this image for* Colonial Homes Magazine, *using Kodak HIE 35mm infrared film. To color this garden scene I used several greens, yellows, and blues. By changing the combinations, I was able to achieve a wide range of color.*

FINISHING YOUR SURFACE

Spot your print *after* you paint it. You can use spot tone over any type of color but it is not always easy to color over spot tone. The color layer helps to blend in the spot tone much easier. If you have used crayons, Cray-pas, or neopastels to color your print, you may find that your colors don't dry thoroughly. If you plan to keep the prints in a portfolio or otherwise show them in an unframed condition, you will want to spray the print with fixative. Before applying the fixative, make sure that all of the oil paint is dry. Otherwise, the fixative will bead up. A good rule of thumb is to wait about three weeks before spraying.

Glebe House Bedroom, 1997. *The white of the ceiling was perfect so I didn't add any color to it. However, I painted the rest of the print with oil paints and colored pencils.*

GLOSSARY

Archival Having permanence. If a photographic material is archival, it will usually last for a long period of time.

Base Support *See* Support.

Blotter Book A book made of acid-free paper used for drying wet prints. Blotter books are generally a substitute for screens.

Bracketing Taking several shots of the same image using different exposures to ensure the creation of the best negative. For example, taking one photograph using the light-meter reading and then (by moving either your f-stop or shutter speed) taking a second exposure with more light and a third exposure with less light.

Changing Bag A black bag used as a portable darkroom to load and unload a camera in total darkness, or to roll film onto reels before developing it.

Cold-pressed Paper Paper that has been pressed with no heat and, therefore, has some texture.

Contact Paper Paper that is sticky on one side and is usually used to protect books.

Contact Print Frame A shallow box usually made of wood and plate glass that is used to hold negatives in perfect contact with emulsion-coated paper during an exposure.

Contrast The difference between the light and dark tones of a negative or print.

Contrasty Having many white and black tones, but few gray tones in between.

Flat Having many gray tones, but few black and white tones.

Daylab Slide Printer A portable enlarger with a color head that enlargers slides onto Polaroid film. There are several types of slide printers available at this time, all of which allow you to copy transparencies (from 35mm to 120 size) onto Polaroid film (from 3¼ x 4¼ inches to 8 x 10 inches).

Dense Negative A negative that is so dark (overexposed) that you cannot see through it or see any details.

Defoamer A wetting agent that can be put into gelatin, liquid emulsion, and other chemicals to cut down on air bubbles.

Direct Positive Film A film that is used to make an enlarged negative by a one-step process—either negative to negative or positive to positive.

Distilled Water Water that has been purified or refined to remove any unwanted metals or chemicals.

Drafting Tape Tape that is not very sticky and that can be used to hold a negative onto paper without ripping the emulsion. Scotch Magic 811 removable tape can serve the same purpose.

Duplicating Film *See* Direct Positive Film.

Emulsion A light-sensitive material coated on film, paper, or other support.

Enlarger A mechanism that allows you to project and enlarge a negative onto a support. There are two types of enlargers—diffusion and condenser. Both work equally well. However, diffusion enlargers produce a lower-contrast outcome than condenser enlargers.

Extender A Vaseline-type medium used by Marshall Oil Paints to thin oil paints. It also helps soften pencils.

Frisket *See* Maskoid.

Hot-pressed Paper Paper that has been pressed with heat and is generally smooth. Smooth or hot-pressed paper tends to give finer grain and a sharper image than coarse, textured paper.

Image Setter A machine that prints a digital negative onto film.

Insoluble Unable to be washed away in water.

Internegative An enlarged negative that is created by first making an enlarged positive (interpositive) on film and then contact-printing it with another piece of film.

Interpositive An enlarged, positive-reading image that has been transferred onto film using an enlarger. This film is

developed, washed and dried, then used to expose another piece of film to create an enlarged negative (internegative), which is used for contact-print processes.

Maskoid A red or white substance painted on an area to protect it from paint or chemicals. Also called mask or resist.

Mask *See* Maskoid.

Opaque Impenetrable to light; neither transparent nor translucent; not able to reflect light.

Paper Negative An image on paper (instead of film) that is used to expose a support. Paper negatives are usually not as sharp as film negatives and may take longer to expose.

Paper Safe A light-tight box used to hold paper or other supports that have been coated with light-sensitive materials.

Photogram A camera-less photograph that is made by placing one or more objects onto coated paper, then exposing the paper with a light source.

Plate Glass A thick piece of glass.

Polarizing Filter A filter used in front of the camera lens to eliminate or reduce glare or reflections of light.

Registration Alignment of a negative (or different negatives) on top of a previously created image on a support.

Resist *See* Maskoid.

Rubylith A red acetate-like paper that can be used to block out selected portions of an image during exposure. Rubylith is easy to cut into shapes, allowing you to mask only the areas that you want.

Sabattier *See* Solarization.

Safelight A red or amber light source that is considered "safe" because it does not affect orthochromatic film and photographic papers and is commonly used in darkrooms.

Sensitizer The mixture of chemicals that make up the emulsions that you apply to a surface to make it light-sensitive.

Sizing Solution A coating that is applied to a support to ensure proper adhesion of the sensitizer.

Solarization A reverse tonal effect that happens to tones as they are reexposed to light during development.

Soluble Able to be washed away in water.

Stock Solutions Solutions that are mixed up from a powder or liquid in order to make chemicals for storage. Stock solutions are then mixed with other chemicals or diluted with water to make working solutions.

Subbing Solution *See* Sizing Solution.

Substrate *See* Sizing Solution.

Support Material on which the sensitizer is placed (e.g., paper, fabric, wood, glass) and which is then exposed with the film or photogram material to make an image. Also called base support.

Test Strips A guide that is created by exposing a support in incremental stages. Test strips help gauge the exposure of a final print and, therefore, save both money and time.

Translucent Able to transmit light but causing sufficient diffusion to eliminate perception of distinct images.

Transparent Sheer; capable of transmitting light so that objects or images can be seen through the material.

Turpenoid A healthier alternative to turpentine that is as strong as turpentine (as a paint remover, thinner, or cleaner) but does not have an odor or vapors.

Ultraviolet Light A light that is just beyond the violet spectrum and, therefore, invisible to the human eye. Sunlight is a common source of ultraviolet light.

UV Protective Spray A substance used for stability against the ultraviolet light emitted by the sun.

White Light The visible spectrum of light. Regular room lightbulbs are considered "white light."

SOURCES

CAMERA STORES AND PHOTO SUPPLIES

Adorama
42 West 18th St.
New York, NY 10011
(212) 675-6789
(212) 741-0052
(800) 223-2500
www.adoramacamera.com

Arkin Medo
30 East 33rd St.
New York, NY 10016
(212) 686-8805
(800) 873-9306
www.arkinmedo.com

B & H Photo
420 9th Ave. (@33rd St.)
New York, NY 10001
(212) 444-6670
(800) 606-6969
www.bhphotovideo.com

Bergger Film
5955 Palo Verde Dr.
Rockford, IL 61114
(815) 282-9876
www.bergger.com
Film is carried by other photo stores as well, though it sometimes has to be special ordered.

Calumet
16 West 19th St.
New York, NY 10011
(212) 989-8500
(800) 225-8638
www.calumetphoto.com
Has 10 stores in the U.S. and more abroad; all are listed on the Web site.

Custom Photo Manufacturing (CPM), Inc.
10830 Sanden Drive
Dallas, TX 75238-1337
(214) 349-6886
(800) 627-0252
A mail-order company with a complete line of darkroom supplies, including light-tight door grilles.

Film for Classics
P.O. Box 486
Honeoye Falls, NY 14472
(716) 624-4945
www.filmforclassics.com
Carries film for old cameras and out-of-date items.

Foto Care
136 West 21st St.
New York, NY 10011
(212) 741-2990
www.fotocare.com

Freestyle Photographic Supplies
5124 Sunset Blvd.
Los Angeles, CA 90027
(800) 292-6137
www.freestylesalesco.com

K & M Camera
377 East 23rd St.
New York, NY 10010
(212) 532-1106
(800) 343-9826
www.kmcamera.com

Lensless Camera Company
30 East Mason St.
Santa Barbara, CA 93101
(805) 966-1181
www.pinholecamera.com
Carries wonderful pinhole cameras.

Pinhole Resource Co.
Star Rt. 15 P.O. Box 1355
San Lorenzo, NM 88041
(505) 536-9942
www.pinholeresource.com

Photo Warehouse
120 Bernoulli Circle
Oxnard, CA 93030
(800) 922-5484

Porter's Camera Store
P.O. Box 628
Cedar Falls, IA 50613
(800) 553-2001
www.porters.com

Silverprint Ltd
12 Valentine Pl.
London SE1 8QH
England
(011-44-171) 620-0844
www.silverprint.co.uk
Supplier of alternative as well as traditional camera equipment.

ALTERNATIVE PROCESS CHEMICALS AND SUPPLIES

Artcraft Chemicals
P.O. Box 583
Schenectady, NY 12301
(800) 682-1730
www.artcraftchemicals.com
Will make up kits or let you mix your own chemicals.

Bostick & Sullivan
P.O. Box 16639
Santa Fe, NM 87505
(505) 474-0890
www.bostick-sullivan.com
Has discussion group on its Web site and is a major supplier of alternative chemicals and supplies.

Bryant Laboratory
1101 5th St.
Berkeley, CA 94710
(510) 526-3141
(800) 367-3141
www.bryantlaboratory.com

Chicago Albumen Works
174 Front St.
Housatonic, MA 01236
(413) 274-6901
www.albumenworks.com
Carries printing out papers and more.

Great Basin Photographic
HCR 33 P.O. Box 2
Las Vegas, NV 89124
(702) 363-1900
www.greatbasinphoto.com
Carries hinged-back contact print frames.

Photographers' Formulary
P.O. Box 950
Condon, MT 59826
(800) 922-5255
www.photoformulary.com
A major supplier of alternative chemicals and supplies. Has summer workshops.

Rockland Colloid Corp.
P.O. Box 376
Piermont, NY 10968
(914) 359-5559
www.rockloid.com
Manufactures liquid emulsion, tintype kits, etc.

Seidler Chemical Company
537 Raymond Blvd.
Newark, NJ 07175
(973) 465-1122
www.seidlerchem.com
Carries nonsilver chemicals in bulk.

Tri-Ess Sciences
1020 West Chestnut St.
Burbank, CA 91506
(818) 848-7838
(800) 274-6910
www.tri-esssciences.com
Has lab supplies and nonsilver chemicals.

ART SUPPLY STORES

A.I. Friedman
44 West 18th St.
New York, NY 10011
(212) 243-9000
(800) 204-6352
www.aifriedman.com

Daniel Smith
4150 1st Ave. South
Seattle, WA 98124
(800) 426-6740
www.danielsmith.com
Carries paints and paper.

Dick Blick Art Materials
P.O. Box 1267
Galesburg, IL 61402
(800) 828-4548
www.dickblick.com
Has more than 30 stores nationwide.

New York Central Art Supply
62 3rd Ave.
New York, NY 10003
(212) 473-7705
(800) 950-6111
www.nycentralart.com
Has wonderful selection of papers from around the world.

Pearl Paint
308 Canal St.
New York, NY 10013
(212) 431-7932
(800) 221-6845
www.pearlpaint.com
Has stores throughout the U.S.

Stephen Kinsella Fine Art Papers
P.O. Box 32420
St. Louis, MO 63132
(314) 991-0141
(800) 445-8865
www.kinsellaartpapers.com
Has a good selection of papers.

Utrecht
111 4th Ave.
New York, NY 10003
(212) 777-5353
(800) 223-9132
www.utrechtart.com
Has more than 30 stores nationwide.

Cheap Joe's Art Supply
374 Industrial Park Dr.
Boone, NC 28607
(800) 227-2788
www.cheapjoes.com

Rose Brand East
75 9th Ave.
New York, NY 10011
(212) 242-7554
(800) 223-1624
www.rosebrand.com

Rose Brand West
10856 Vanowen Street
N. Hollywood, CA 91605
(818) 505-6290
(800) 360-5056
Has different types of fabrics and materials usually used for the theater, but has good prices and a good selection.

ARCHIVAL SUPPLIES

Conservation Resources International
8000-H Forbes Pl.
Springfield, VA 22151
(703) 321-7730
(800) 634-6932
www.conservationresources.com

Gaylord Bros.
P.O. Box 4901
Syracuse, NY 13221-4901
(800) 448-6160
www.gaylord.com

Light Impressions
P.O. Box 22708
Rochester, NY 14692
(800) 828-6216
www.lightimpressionsdirect.com
Carries books, too.

Spink and Gabor, Inc.
11 Troast Ct.
Clifton, NJ 07011-2131
(973) 478-4551
Makes custom boxes.

Talas
568 Broadway
New York, NY 10012
(212) 219-0770
www.talas-nyc.com
Carries papers and more.

University Products
517 Main St.
Holyoke, MA 01040
(800) 628-1912
(800) 762-1165
www.universityproducts.com
Carries archival supplies and more.

MISCELLANEOUS AND FUN STUFF

Blue Printables
1129 Cortez Ave.
Burlingame, CA 94010
(800) 356-0455
www.blueprintables.com
Carries cotton and silk that is pretreated with cyanotype sensitizer. You can buy it by the yard or as T-shirts. Fabric is ready to expose and comes with a toning kit. Also carries transparency packages with nature drawings.

Canal Surplus, Inc.
363 Canal St.
New York, NY 10013
(212) 966-3275
www.canalsurplus.com
Carries metal, leather, and textiles; calls itself "a strange art supply store."

Creative Wholesale Distributor
P.O. Box 2070
Stockbridge, GA 30281
(800) 347-0930
Carries skewers in bulk (for hand painting).

Ever Ready Blue Print Corp.
200 Park Ave. South, Suite 1316
New York, NY 10003
(212) 228-3131
Carries blueprints for architects. Similar kinds of places are in most major cities. You can buy the paper, expose it, bring it back, and have them develop it for you. Is it archival? No, but it is a lot of fun!

Grassi Sheet Metal
33 Cooper Sq.
New York, NY 10003
(212) 475-2384

Industrial Plastic Supply
309 Canal St.
New York, NY 10013
(212) 226-2010

Lab Safety Supply
401 South Wright Rd.
Janesville, WI 53547
(608) 754-2345
(800) 356-0783
www.labsafety.com
Will help you with any questions you may have on safety.

Lazertran
650 8th Ave.
New Hyde Park, NY 11040
(800) 245-7547
www.lazertran.com
Has distributors in the U.S., U.K., Canada, and Australia, and carries a unique paper called Lazertran. You can make a laser print using this paper (instead of normal copy paper) and then transfer it onto any material. Good directions come with the paper.

Masterpak
50 West 57th St., 9th floor
New York, NY 10019
(800) 922-5522
www.masterpak-usa.com
Has archival materials for packing, shipping, and storing prints and other types of artwork.

Modern Postcard
1675 Faraday Ave.
Carlsbad, CA 92008
(800) 959-8365
www.modernpostcard.com
Is a supplier of custom-made direct-mail pieces.

Oriental Culture Enterprises
13-17 Elizabeth St., #2F
New York, NY 10013
(212) 226-8461
Carries books and other cool stuff.

Plastic Land
357 Canal St.
New York, NY 10013
(212) 925-6376
www.plasticland.com
Carries plastic, Lucite, vinyl, etc.

The Set Shop
36 West 20th St.
New York, NY 10011
(212) 255-3500
(800) 422-7381
www.setshop.com
Carries studio supplies, bags, and books.

United States Plastic Corp
1390 Neubrecht Rd
Lima, OH 45801
(800) 537-9724
www.usplastic.com
Carries containers, plumbing, lab ware, bags, tubing, etc.

Hardware or home stores are also great resources. Do you have to buy expensive "photographic only" materials? How about going to Home Depot or K-Mart for plastic materials, bottles, or photofloods? These stores have the same kinds of materials for mixing cement and drip trays for washing machines as we use for chemical trays. It is amazing what you can find.

BULBS AND EXPOSURE UNITS

Atlanta Light Bulbs
1810-G Auger Dr.
Tucker, GA 30084
(770) 491-3145
(800) 822-4598
www.atlantalightbulbs.com
Has good prices.

Bulb Direct
1 Fishers Rd.
Pittsford, NY 14534
(800) 772-5267
www.bulbdirect.com
Carries a wide variety of bulbs.

Bulbtronics
45 Banfi Plaza
Farmingdale, NY 11735
(800) 654-8542
(800) 624-2852
www.bulbtronics.com
Carries UV bulbs by the case.

CL Lighting
317 Canal St.
New York, NY 10013
(212) 219-8076

Just Bulbs
936 Broadway
New York, NY 10011
(212) 228-7820
www.justbulbs.com
Is expensive, but special orders items not in stock.

NuArc
6200 West Howard St.
Niles, IL 60714
(800) 962-8883
www.nuarc.com
Is a manufacturer of mercury-vapor UV exposure units and vacuum frames, which are also carried at some photo stores.

Edwards Engineered Products
P.O. Box 4461
Lago Vista, TX 78645-4461
(512) 267-4274
www.eepjon.com
Makes exposure units, glass rods, ventilation systems, and more. Instructions on how to build your own UV exposure unit are available on the Web site.

Topbulb Gray Supply Company
5204 Indianapolis Blvd.
East Chicago, IN 46312
(800) 867-2852
www.topbulb.com
Has hard-to-find bulbs with no minimum orders. Is sometimes cheaper than local bulb stores.

BOOKSTORES

Amazon.com
www.amazon.com
Is an on-line bookseller.

Barnes & Noble
www.barnesandnoble.com
Gives student discounts.

Bibliofind
www.bibliofind.com
Is a centralized location for used-book dealers, now linked with amazon.com. Type in the book you want, and it finds who has it.

Bookfinder
www.bookfinder.com
Is a service for finding out-of-print books.

International Center of Photography Bookstore
1133 6th Ave.
New York, NY 10036
(212) 768-4682
www.icp.org
Has classes, gallery shows, and lectures.

Out of Print Book Search
(800) 539-1967
Is a phone-number-only service. You leave the name of the book you are trying to find, your phone number, address, and fax number. A rep calls you back within a few weeks. There is a $5.00 finder's fee if they find the book and you do not buy it.

Tim Whelen Photography
P.O. Box 471
The Schoolhouse, Suite 101
Rockport, ME 04856
(207) 236-4795
Is an eclectic bookseller.

Photo Eye Bookstore
376 Garcia St.
Santa Fe, NM 87501
(505) 988-5152
(800) 227-6941
www.photoeye.com
Has a wonderful selection of books as well as a new on-line gallery.

Strand Bookstore
828 Broadway
New York, NY 10003
(212) 473-1452
www.strandbooks.com
Is known for having eight miles of books. Also has several annexes, which carry rare and signed books.

IMPORTANT PHONE NUMBERS AND WEB SITES

ACD Systems
P.O. Box 36
Saanichton, BC V8M 2C3
Canada
(250) 382-5828
(800) 579-5309
www.acdsystems.com
www.acdsee.com

Produces image-management software for acquiring, viewing, browsing, managing, editing, sharing, and printing your digital images.

Cachet
3701 West Moore Ave.
Santa Ana, CA 92704
(714) 432-7070
www.onecachet.com
Manufactures photographic papers, films, and Black Magic liquid emulsion.

Epson Worldwide
(800) 922-8911
www.epson.com
Carries printers and scanners. Has support information on the Web and by phone or e-mail.

Ilford
(800) 526-0886
(201) 265-6000
www.ilford.com
Manufactures film and papers.

Kodak Hotline
(800) 242-2424, ext. 19
www.kodak.com
Manufactures film, photographic papers for hand painting, and photo dyes.

Luminos
(800) 586-4667
www.luminos.com
Manufactures photographic papers for hand painting; liquid emulsion; cyanotype and argyrotype (Van Dyke brown) print kits; ink jet papers; and more.

Pictorico Inkjet Media
AGA Chemicals, Inc.
2201 Water Ridge Pkwy., Suite 400
Charlotte, NC 28217
(888) 879-8592
www.pictorico.com
Manufactures all types of papers and film used for output from computer printers.

Polaroid
(800) 225-1618
www.polaroidwork.com
Manufactures a range of film and equipment and gives free brochures with instructions on how to do different processes with the films.

MISCELLANEOUS WEB SITES

Okay, I know there are a million out there. Basically they are available for almost every process, but I cannot list them all, so here are a few that I have found. I invite you to search for others.

Alternative Processes Web Site
www.duke.usask.ca/~holtsg/photo/faq.html
Has some very good information but a lot of mail. Is easy enough to skim through and delete. Also has everything archived so that you can see past discussions by going to http://members.xoom.com/altphotoproc/.

Andromeda's Scatterlight Lenses
www.andromeda.com
Carries Dream Optics Lenses software to add highlights to digital images.

Crane's (Paper) Web Site
(800) 5crane6
www.crane.com

Cyanotypes
www.cyanotypes.com
Has lots of information—not just about cyanotypes but about all kinds of alternative process information. The site also includes a gallery by artists from all over the world.

Daguerreotype Information
www.daguerre.org
Has daguerreotype information by way of gallery and newsletter that posts workshops and other events of interest.

Dan Burkholder
www.danburkholder.com
Has information on digital negatives.

Foto Info
www.fotoinfo.com
Has miscellaneous photo information, including tips on infrared photography.

George Eastman House
www.eastman.org
www.geh.org
Has workshops on historical techniques and wonderful museum and source.

Handpainting
www.handcolor.com

History of Gum Arabic
www.jumbo.th.com/application.html

Infrared
www.a1.nl/phomepag/markerink/mainpage.htm
Has an infrared mailing list with instructions on the above-mentioned Web site. Some of the information is a little too "scientific" and doesn't have enough art discussion, but has some useful information as well.

Library of Congress
www.lcweb.loc.gov/catalog
Has great old photos—not to use, but to know about.

Library of Congress: American Memory Photographs
www.lcweb2.loc.gov/ammem/amhome.html
Same as above. Has great photos on view.

Material Safety Data Sheet Information
www.msdssearch.com
Links to MSD sheets for hundreds of suppliers.

Mike Ware's Alternative Photography Pages
www.mikeware.demon.co.uk/
Features a number of from-scratch recipes for alternative processes as well as historical, technical, and general information.

Photo as Art Discussions
To subscribe, send a message to the following e-mail: listserv@latrobe.edu.au. Text message should read: "subscribe photoart (your e-mail address)." You will get a reply asking you to confirm your subscription.

Pinhole Photography
www.pinhole.com
Features a gallery as well as information about pinhole photography.

Researcher of Archival Papers and More
www.wilhelm-research.com

Visual Infinity
www.visinf.com
Carries Grain Surgery software to add grain to digital images.

NEWSLETTERS/JOURNALS

The World Journal of Post-Factory Photography
by Judy Seigel
61 Morton St.
New York, NY 10014

The Collodian Journal
by Scully & Osterman
186 Rockingham St.
Rochester, NY 14620

BIBLIOGRAPHY

BOOKS

Airey, Theresa. *Creative Digital Printmaking: A Photographer's Guide to Professional Desktop Printing.* New York: Watson-Guptill Publications, 2001.

Airey, Theresa. *Creative Photo Printmaking.* New York: Watson-Guptill Publications, 1997.

Anchell, Stephen. *The Darkroom Cookbook.* Boston: Focal Press, 1994.

Arnow, Jan. *Handbook of Alternative Photographic Processes.* New York: Van Norstrand Reinhold, 1982.

Barnier, John. Editor. *Coming into Focus: A Step-by-Step Guide to Alternative Photographic Printing Processes.* San Francisco: Chronicle Books, 2000.

Blacklow, Laura. *New Dimensions in Photo Imaging: A Step by Step Manual.* Newton, MA: Focal Press, 1995.

Burkholder, Dan. *Making Digital Negatives for Contact Printing.* San Antonio, TX: Bladed Iris Press, 1998.

Caponigro, John Paul. *Adobe Photoshop Master Class.* San Jose, CA: Adobe Press, 2000.

Carr, Kathleen Thormod. *Polaroid Manipulations: A Complete Visual Guide to Creating SX-70, Transfer, and Digital Prints.* New York: Watson-Guptill Publications, 2002.

Carr, Kathleen Thormod. *Polaroid Transfers: A Complete Visual Guide to Creating Image and Emulsion Transfers.* New York: Watson-Guptill Publications, 1997.

Crawford, William. *The Keepers of Light: A History & Working Guide to Early Photographic Processes.* New York: Morgan & Morgan, 1979.

Hirsch, Robert. *Photographic Possibilities: The Expressive Use of Ideas, Materials and Processes.* Newton, MA: Butterworth-Heinemann, 1991.

Laird, Sandra, and Carey Chambers. *Handcoloring Photographs: Step by Step.* Buffalo, NY: Amherst Media, Inc., 1997.

McKinnis, James. *Handcoloring Photographs: How to Create Color Images from Black and White Photographs.* New York: Watson-Guptill Publications, 1994.

Nettles, Bea. *Breaking the Rules: A Photomedia Cookbook.* Rochester, NY: Inky Press Productions, 1977.

Newhall, Beaumont. *The History of Photography.* New York: Museum of Modern Art, 1982.

Reed, Martin, and Sarah Jones. *Silver Gelatin: A User's Guide to Liquid Photographic Emulsions.* New York: Watson-Guptill Publications, 1996.

Rosenblum, Naomi. *A World History of Photography.* New York: Abbeville Press, 1984.

Stevens, Dick. *Making Kallitypes: A Definitive Guide.* Boston: Focal Press, 1993.

Stroebel, Leslie, and Richard Zakia. *The Focal Encyclopedia of Photography.* Third Edition. Boston: Focal Press, 1993.

Van Keuren, Sarah. *A Non-Silver Manual.* (self published), 1996.

Wade, Kent. *Alternative Photographic Processes.* Dobbs Ferry, NY: Morgan and Morgan, 1978.

Worobiec, Tony. *Toning and Handcoloring Photographs.* New York: Watson-Guptill Publications, 2002.

ARTICLES

Rothschild, Norman. "Under False Colors," *Popular Photography Magazine,* (September 1978): 127–133, 174.

Ware, Michael. "The Argyrotype." *The British Journal of Photography,* vol. 139, no. 6824 (1991): 17–19.

Wilcox, John Edward. "The Photo-Magic of Infrared Film," *Popular Photography Magazine,* (July 1938): 80–82.

PAMPHLETS

Eastman Kodak Company. *Applied Infrared Photography.* Rochester, NY: 1977.

Polaroid Corporation. *A Step-by-Step Guide to Unusual Instant Photography Techniques.* A Polaroid Publication for Educators. Cambridge, MA: August 1995.

WEB SITES

The Alternative Photographic Process FAQ Web site: http://duke.usask.ca/~holtsg/photo/faq.html

Mike Ware's Alternative Photography Web site: www.mikeware.demon.co.uk/

Jno Cook's Columbia College Photography Department Process Workshop Web site (X-Tech Manual: Experimental Photo/Graphic Techniques): http://jnocook.net/xtech/#37

Environmental Protection Agency Web site: www.epa.gov

CONVERSION TABLES

Temperature

To convert Fahrenheit to Celsius, subtract 32 from the Fahrenheit temperature, multiply that number by 5, then divide that number by 9.

To convert Celsius to Fahrenheit, multiply the Celsuis temperature by 9, divide that number by 5, then add 32 to that number.

U.S. Customary Dry Measurements

1 pound = 16 ounces
1 pound = 453.6 grams
1 ounce = 0.0625 pounds
1 ounce = 28.35 grams

U.S. Customary Liquid Measurements

1 gallon = 128 fluid ounces
1 gallon = 4 quarts
1 quart = 32 fluid ounces
1 quart = 2 pints
1 pint = 16 fluid ounces

U.S. Customary Liquid Measurements to Metric

1 gallon = 3.785 liters
1 quart = 0.9463 liters
1 fluid ounce = 0.02957 liters
1 gallon = 3785 milliliters (ml)
1 pint = 473.12 ml
1 fluid ounce = 29.57 ml
1 tablespoon = 15 ml/15 cc
3 teaspoons (tsp) = 1 tablespoons (tbs)
1 teaspoon = 5 ml/5 cc
1 ml = 1 cc

Metric Liquid Measurements

1 liter = 1000 ml
1 liter = 33.81 fluid ounces
1 liter = 1.057 quarts
1 liter = 0.2642 gallons

INDEX